TECHNIQUES FOR DRAWING, INKING AND COLOURING

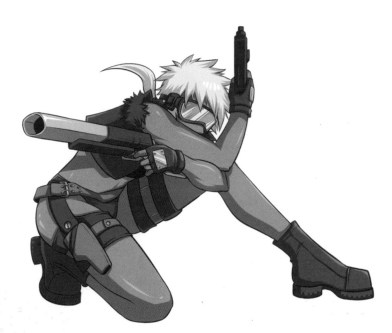

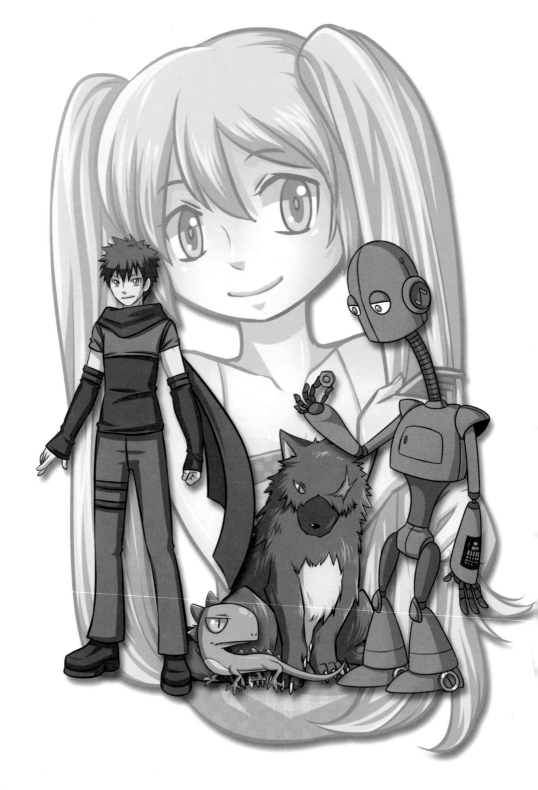

MASSIVE MANGA

TECHNIQUES FOR DRAWING, INKING AND COLOURING

YISHAN LI

Search Press

Created and conceived by Axis Publishing Limited

Creative Director: Siân Keogh
Editor: Anna Southgate
Art Director: Sean Keogh
Designer: Simon de Lotz
Production: Bili Books

ISBN: 978-1-84448-637-3

Printed and bound in China

1 3 5 7 9 10 8 6 4 2

CONTENTS

INTRODUCTION

The term 'manga' originated in Japan. It refers to the comics and graphic stories that have become hugely popular in recent years, not only with male and female readers of all ages and backgrounds, but in many countries across the globe. The genre is closely related to its film counterpart, which is known widely as 'anime'.

Traditionally, manga stories appear in magazines that can be anything from around 200 pages long to as many as 1000 pages. With colour limited to the cover and a few selected pages inside, these magazines are sold in vast quantities at low prices. It is not always possible, or practical, for the average reader to collect the magazines, so they are often left lying around in public places, for passers-by to pick up and read, much like a free newspaper in a Western café. A typical magazine may contain several ongoing serials, which are then often collected into a separate compact volume. It is these separate volumes that have now become a feature in Western bookshops.

MANGA SUBGENRES

Manga stories vary tremendously in terms of subject matter and can, in fact, be divided into various subgenres that are aimed at different readers. Among these are 'shounen' for boys and 'shoujo' for girls. Stories range from being charmingly romantic and whimsical to being quite shocking with scenes of extreme violence. Ecological and spiritual themes are also common. Popular manga subjects include sports, science fiction, horror and stories featuring traditional Japanese cultural icons, such as samurai warriors and ninjas.

Modern manga has its origins in the work of Japanese animator, Osamu Tezuka, who created the post-nuclear robot called Tetsuwan Atom (known in the West as Astro Boy) in 1951. This groundbreaking series ran for 17 years and was the first to introduce many of the, now standard, manga characteristics, such as the dominant eyes and spiky hair. Tezuka was a prolific artist and writer, creating many outstanding manga tales, including the first significant shoujo, or girls' manga, with Ribon No Kishi (Knight in Ribbons) in 1953.

Following in Tezuka's footsteps were generations of male and female manga creators. Between them, they developed the grittier, realistic stories that we see today. Many of the shounen tales revolve around the yakuza gangsters of modern Japan or are based on the historical samurai and ninja swordplay of ancient feudal Japan. Although these combat-based stories are increasingly popular in the United States and Europe, the level of violence seen in them is unprecedented and has been met with considerable criticism in the West.

Shoujo's origins can be traced back to the 1960s, and the work of Fujio Akatsuka. In 1962, he created *Secret Akko-chan*, a story about a young girl given magical powers by a mirror-dwelling spirit. Today, the magical girl genre is one of the most popular trends in shoujo manga. Among the most popular and best known of the shoujo stories is *Sailor Moon* by Takeuchi Naoko.

Sailor Moon is also an example of another manga subgenre, known as *sentai* (superteam), and in which the principal character, Tsukino Usagi, is joined by a team of sailor-suited fighters.

With characters appearing in giant mechanised battle suits, latest trends have seen

the development of a giant-robot genre of manga art and this is becoming widely popular. Of these, the *Mobile Suit Gundam* series is, to many non-Japanese fans, archetypal of this mecha manga genre. The battle-suit theme was also featured in the immensely successful *Mighty Morphin' Power Rangers* TV series, which prompted many new young readers to seek out manga comics.

MANGA AROUND THE WORLD

The popularity of manga and anime has soared and their influence can be seen around the world. American audiences, in particular, have grown in recent years, following the release of early mecha and action anime series with new soundtracks in English. Not only do fans want to read manga comics, they now also want to create stories of their own. If, like them, you would like to practise this popular art, you can use this book to develop some of the basic features and drawing principles that have helped make manga such an inspirational and groundbreaking art form.

while heavyweight watercolour papers hold wet paint and coloured inks and come in a variety of surface textures.

Again, don't be afraid to experiment: you can buy many types of papers in single sheets while you find the ones that suit your artwork best.

PENCILS

The next step is to choose some pencils for your sketches. Pencil sketching is probably the most important stage, and always comes first when producing manga art (you cannot skip ahead to the inking stage), so make sure you choose pencils that feel good in your hand and allow you to express your ideas freely.

Pencils are manufactured in a range of hard and soft leads. Hard leads are designated by the letter H and soft leads by the letter B. Both come in six levels – 6H is the hardest lead and 6B is the softest. In the middle is HB, a halfway mark between the two ranges. Generally, an HB and a 2B lead will serve most sketching purposes, with the softer lead being especially useful for loose, idea sketches, and the harder for more final lines.

Alternatively, you can opt for mechanical pencils. Also called self-propelling pencils, these come in a variety of lead grades and widths and never lose their point, making sharpening traditional wood-cased pencils a thing of the past. Whether you use one is entirely up to you

Graphite pencils are ideal for getting your ideas down on paper, and producing your initial drawing. The pencil drawing is probably the most important stage in creating your artwork. Choose an HB and a 2B to start with.

– it is possible to get excellent results whichever model you choose.

COLOURED PENCILS

Coloured pencils are effective and versatile colouring tools. A good box of pencils contains around 100 colours and will last for a long time, since a blunt pencil just needs sharpening, not replacing or refilling. Unlike with markers, successive layers of tone and shade can be built up with the same pencil, by gradually increasing the pressure on the pencil lead.

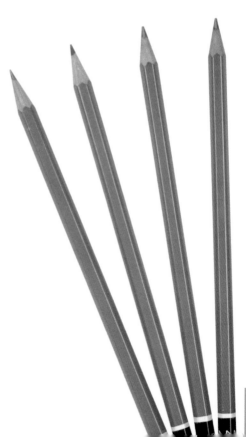

COPIC MARKERS
WARM AND COOL GREYS

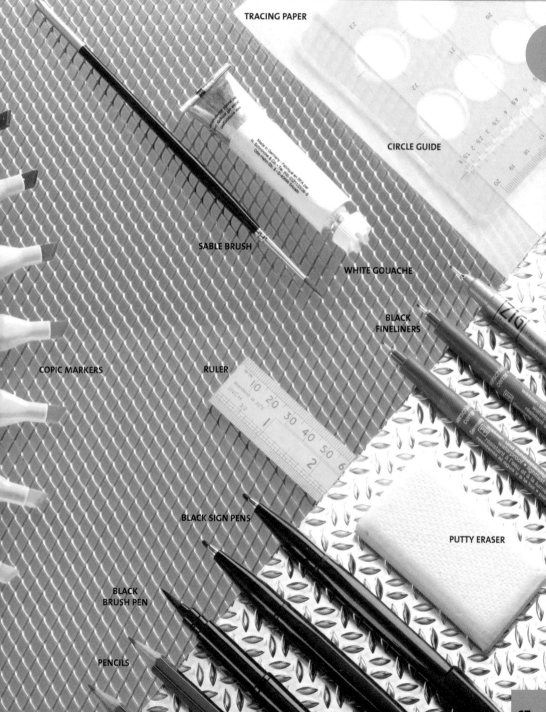

TRACING PAPER

CIRCLE GUIDE

SABLE BRUSH

WHITE GOUACHE

BLACK
FINELINERS

COPIC MARKERS

RULER

BLACK SIGN PENS

PUTTY ERASER

BLACK
BRUSH PEN

PENCILS

A good quality eraser or putty eraser is an essential item for removing unwanted pencil lines and for cleaning up your inked drawing before you start applying the colour.

Felt-tip pens are the ideal way to ink your sketches. A fineliner, medium-tip pen and sign pen should meet all of your needs, whatever your style and preferred subjects. A few coloured felt-tip pens can be a good addition to your kit, allowing you to introduce colour at the inking stage.

You can then build further colour by using a different colour pencil. Coloured pencils are also useful for adding detail, which is usually achieved by inking. This means that a more subtle level of detail can be achieved without having to ink in all lines. It is worth buying quality pencils. They do make a difference to the standard of your art and will not fade with age.

SHARPENERS AND ERASERS

If you use wooden pencils, you will need to get a quality sharpener; this is a small but essential piece of equipment. Electric sharpeners work very well and are also very fast; they last a long time too. Otherwise, a handheld sharpener is fine. One that comes with a couple of spare blades can be a worthwhile investment, to ensure that your pencils are always sharp. Along with a sharpener, you will need an eraser

for removing any visible pencil lines from your inked sketches prior to colouring. Choose a high-quality eraser that does not smudge the pencil lead, scuff the paper, or leave dirty fragments all over your work. A soft putty eraser works best, since it absorbs pencil lead rather than just rubbing it away. For this reason, putty erasers do become dirty with use. Keep yours clean by trimming it carefully with scissors every now and then.

INKING PENS

The range of inking pens can be bewildering, but some basic rules will help you select the pens you need. Inked lines in most types of manga tend to be quite bold so buy a thin-nibbed pen, about 0.5mm, and a medium-size nib, about 0.8mm. Make sure that the ink in the pens is waterproof; this won't smudge or run. Next, you will need a medium-tip felt pen. Although you won't need to use this pen very often to ink the outlines of your characters, it is still useful for filling in small detailed areas of solid black. A Pentel pen does this job well. Last, consider a pen that can create different line widths according to the amount of pressure you put on the tip. These pens replicate brushes and allow you to create flowing lines such as those seen on hair and clothing. The Pentel brush pen does this very well, delivering a steady supply of ink to the tip from a replaceable cartridge. It is a good idea to test-drive a few pens at your art shop to see which ones suit you best. All pens should produce clean, sharp lines with a deep black pigment.

Markers come in a wide variety of colours, which allows you to achieve subtle variations in tone. In addition to a thick nib for broad areas of colour, the Copic markers shown here feature a thin nib for fine detail.

A selection of warm and cool greys is a useful addition to your marker colours and most ranges feature several different shades. These are ideal for shading on faces, hair, and clothes.

MARKERS AND COLOURING AIDS

Many artists use markers, rather than paint, to colour their artwork, because markers are easy to use and come in a huge variety of colours and shades. Good-quality markers, such as those made by Chartpak, Letraset or Copic, produce excellent, vibrant results, allowing you to build up multiple layers of colour so you can create rich, detailed work and precise areas of shading. Make sure that you use your markers with marker or layout paper to avoid bleeding. Markers are often refillable, so they last a long time. The downside is that they are expensive,

so choose a limited number of colours to start with, and add as your needs evolve. As always, test out a few markers in your art store before buying any.

However, markers are not the only colouring media. Paints and gouache also produce excellent results, and can give your work a distinctive look. Add white gouache, which comes in a tube, to your work to create highlights and sparkles of light. Apply it in small quantities with a good-quality watercolour brush. It is also possible to colour your artwork on computer. This is quick to do, although obviously there is a high initial outlay. It also tends to produce flatter colour than markers or paints.

DRAWING AIDS

Most of your sketching will be done freehand, but there are situations, especially with man-made objects such as the edges of buildings or the wheels of a car, when your line work needs to be crisp and sharp to create the right look.

If you are colouring with gouache or watercolour paint, then a selection of sizes of good quality sable watercolour brushes are invaluable.

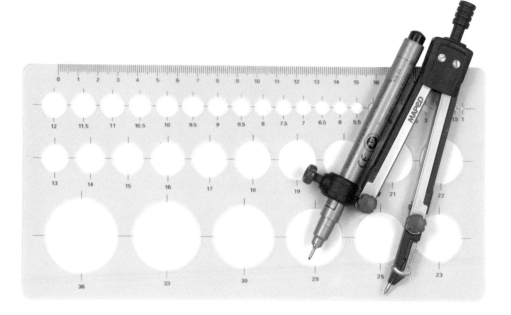

Rulers, circle guides and compasses all provide this accuracy. Rulers are either metal or plastic; in most cases, plastic ones work best, though metal ones tend to last longer. For circles, use a circle guide, which is a plastic sheet with a wide variety of different-sized holes stamped out of it. If the circle you want to draw is too big for the circle guide, use a compass that can hold a pencil and inking pen.

If you want to draw manga comic strips, a pencil and a standard 30cm (12in) ruler are the only tools you will need to plan out your panels. (It is also possible to draw them digitally on computer.) Just remember to buy a quality ruler with an edge that will suit your pencils and pens and won't chip over time. A plastic one will generally last longer than a wooden one. Creating speech bubbles inside the panels is best done by hand, but templates are available if you need help. They do make your work look neat, they are generally cheap to buy, and they

Working freehand allows great freedom of expression and is ideal when you are working out a sketch, but you will find times when precision is necessary. Use compasses or a circle guide for circles and ellipses to keep your work sharp. Choose compasses that can be adjusted to hold both pencils and pens.

do not need replacing often. You can buy them in most art shops. It is possible to order authentic manga templates from Japan, but these are not really necessary unless you want to start collecting authentic manga art equipment. You can make your own templates out of cardboard if the ones in the shops do not suit your needs.

DRAWING BOARD

A drawing board is useful, since working on a flat table for a long time can give you a backache. Lots of different models are available, but all should be adjustable to the angle at

which you want to work. They also come in a wide variety of sizes, from ones that sit on your lap or a tabletop to large work tables. If you do not want to invest in one immediately, it is possible to prop a piece of smooth, flat plywood about 60cm (24in) x 45cm (18in) on your desk. Put a small box underneath to create an angled surface.

A mannequin can be placed in different poses, helping you to visualise action and movement.

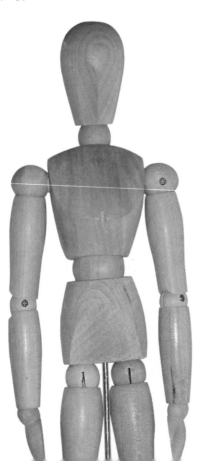

MANNEQUIN

A mannequin is an excellent tool for helping you to establish correct anatomical proportions, particularly for simpler poses such as walking and running. All the limbs are jointed to mimic human movement. They are also relatively cheap, but bear in mind that other reference materials may be necessary for more complicated movements, such as those involving martial arts. Photographic reference is often useful too.

USING A COMPUTER

When your sketches start coming easily and the more difficult features, such as texture and perspective, begin to look more convincing, you will be confident enough to expand on the range of scenes you draw. You might even begin to compose cartoon strips of your own or, at the very least, draw compositions in which several characters interact with each other – such as a battle scene.

Once you reach this stage, you might find it useful to start using a computer alongside your regular art materials. Used with a software program, like Adobe Photoshop, you can colour scanned-in sketches quickly and easily. You will also have a much wider range of colours to use, and can experiment at will. Moving one step further, a computer can save you a lot of time and energy when it comes to producing comic strips. Most software programs enable you to build a picture in layers. This means that you could have a general background layer – say a mountainous landscape – that always stays the same, plus a number of subsequent layers on

Once you have scanned your line artwork you can use computer programs, such as Adobe Photoshop, to colour your drawings and add some original material as well. The choice is a matter of personal preference. The speed of a computer makes adding colour to manga easy, once you have learnt the process.

which you can build your story. For example, you could use one layer for activity that takes place in the sky and another layer for activity that takes place on the ground. This means that you can create numerous frames simply by making changes to one layer, while leaving the others as they are. There is still a lot of work involved, but working this way does save you from having to draw the entire frame from scratch each time.

Of course, following this path means that you must invest in a computer if you don't already have one. You will also need a scanner and the relevant software. All of this can be expensive and it is worth getting your hand-drawn sketches up to a fairly accomplished level before investing too much money.

You can input a drawing straight into a computer program by using a graphics tablet and pen. The tablet plugs into your computer, much like a keyboard or mouse.

heads and faces

A person's face says a great deal about their personality and this is an important factor when drawing animated figures. In manga art, there are plenty of opportunities for creating characters with different attitudes and expressions. This chapter shows how to draw a basic head shape from various angles, and the many ways in which you can add facial features to capture gender, mood and personality.

FACES AND AGE

All faces begin with the same very basic oval shape, divided vertically and horizontally into four sections. These guides make it easier to position the facial features. You can adapt the shape of the basic oval depending on the age and gender of your character.

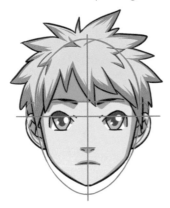

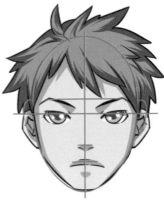

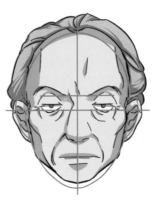

A child's face is, on the whole, shorter and rounder than that of an adult. In manga art, the eyes of a child are more exaggerated – almost as tall as they are wide.

In young adults, the face fills the oval guide more fully. Eyes are slimmer and tend to be more realistic in appearance. Adult men have a strong jaw line.

This drawing shows typical features of an older manga male. The hairline has receded, the eyelids are heavy, and the jaw line has more definition.

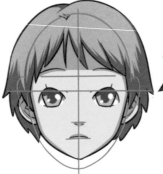

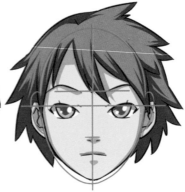

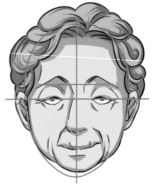

Manga characters are usually quite androgynous. This girl has slightly larger eyes than the boy above, and thinner eyebrows.

The adult female has softer features than the male. The face is more rounded at the chin, and the cheeks slightly fuller.

The face of the older manga woman is fuller than that of the man. Her nose is slimmer and she still has a good head of hair.

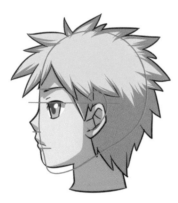

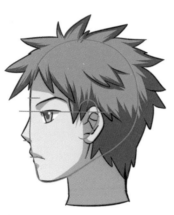

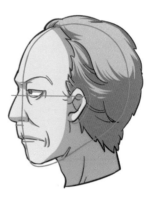

A similar oval shape is used for drawing side profiles. Childlike features are simple, with the emphasis on the large eyes.

This adult male has a sharper profile than the boy. His face is longer, the chin more pointed, and his nose is better defined.

Older manga characters are often more realistic. This man has a rounded nose and chin and small, deep-set eyes.

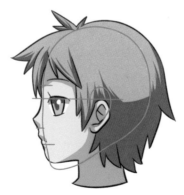

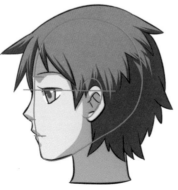

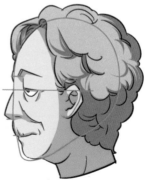

Similar to the boy above, this girl has neat features with sparse detail. Her face is slightly more rounded, the eye a little bigger.

Like the adult male, the adult female's profile fills the oval guide. Her eye and chin are more rounded than that of the male.

The older manga woman has a plumper, more rounded face than the man. Her neck is thicker and her cheeks fuller.

THREE-QUARTER VIEW

Drawing a face from the three-quarter view also works using an oval guideline, but this time it is slightly tilted. The important thing here is to draw the vertical guide (with a slight curve at the forehead) one-third of the way across the face. This will help to get the perspective right.

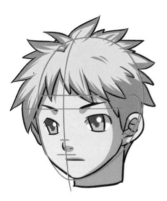

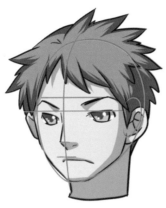

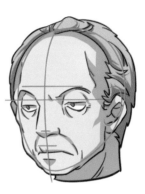

The large eyes of the manga boy are wide set. The light is coming from the left, so any shading needs to be on the right.

When drawing the adult male from this angle, it is important to capture the squarer lines of the jawbone.

The heavy lines of the older manga man give an impression of the bone structure beneath the skin. The forehead is exposed.

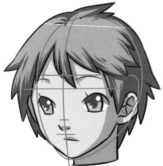

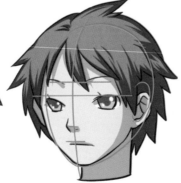

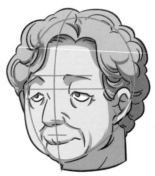

The girl's eyes are rounder than the boys. Like him, she has a very simple nose and mouth. Shading helps to make them realistic.

As with the full-face view, the young woman's jaw line is softer and smoother than that of the young man.

Note how the fuller face of the older woman spills out beyond the oval guide. This profile face is squarer than the others.

FACES AND ANGLES

You can draw a face from any angle, but it is important to get the proportions and perspective right. Start with a basic oval each time and consider where the vertical and horizontal guidelines might need to be in order to help you get it right.

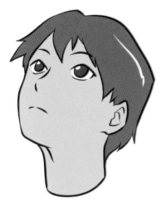

A three-quarter view looking upwards. The vertical guide should be one-third in from the left, with the horizontal guide drawn as an upward curve.

This is a straightforward three-quarter view, as demonstrated on the opposite page.

A three-quarter view looking down. The horizontal guide should be drawn as a downward-facing curve.

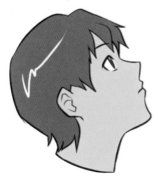

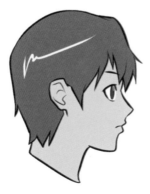

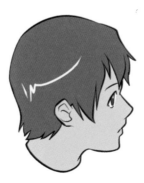

A side view looking up. The vertical guide is central, while the horizontal guide should tilt from bottom left to top right.

The guides for a side view are the same as those face on. Here, the vertical guide helps to position the ear.

This character is seen slightly from above and there is slight foreshortening of the face.

FACE SHAPES

Most manga characters are lean and youthful. Younger faces tend to be fuller and older faces more human looking. In all cases, characteristics can be exaggerated to make the shape of the face more in keeping with the intended personality.

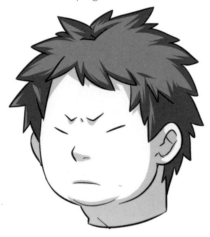

left The fuller face of a young character. His facial features are tiny, exaggerating the roundness of his cheeks. He has a wide neck and smooth jaw line. He does not look threatening or harmful in any way.

right This is the face of a more mature adult male, with hollow cheeks and a pointed chin. All of his facial features are narrow, the eyes and eyebrows slanting upwards.

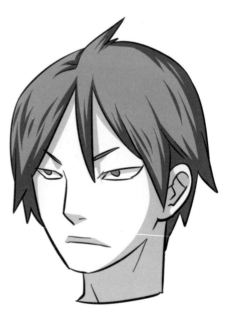

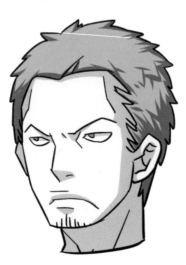

left The character on the left has a more rugged appearance, achieved by giving him a much squarer face. His eyes are deeper set and he has a firmer jaw line.

GIRL'S FACE FRONT VIEW

Here are the basic steps for drawing a young girl's face, face on. The same process can be used for any manga character, but remember to adapt the shape of the face and change the facial features depending on the kind of character you are creating.

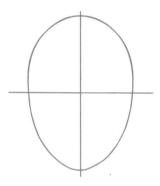 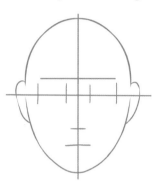 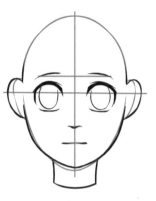

Draw your oval and divide it equally vertically (for symmetry) and horizontally (to provide a guide for positioning the eyes).

Now divide the oval into thirds horizontally. All facial features lie in the bottom two-thirds. Divide the face vertically by five.

Draw in facial features. The eyes dominate here. The eyebrows sit on the top-third horizontal guide, the nose on the second.

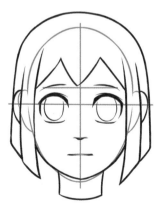 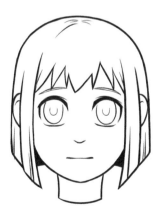 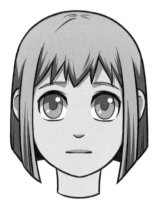

Draw a rough outline for the girl's hair. It should stand proud of your oval guide, to give an impression of volume.

Draw in the finer details – pupils in the eyes, individual strands of hair. Go over your basic outline in ink. Erase any unwanted pencil.

Use typical manga colours to finish. Work in flat colour first and then add lighter or darker tones and highlights.

MAN'S FACE SIDE VIEW

You can follow these steps to draw any face side on. This example shows a young man. He has sharp masculine features, and is quite human looking. Adapt the shape of the face to suit any character you like, changing facial features accordingly.

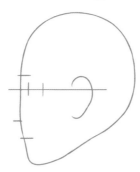

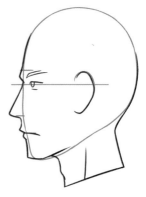

Start with a pencil outline of a tapered oval, tipped slightly to one side. Mark the centre line on the horizontal axis.

Divide the profile of the oval into thirds and mark the position of the eye on the horizontal guide, a little way in from the edge.

Draw in basic features. The eyebrow should sit on the top-third horizontal guide. Give shape to the nose and neck.

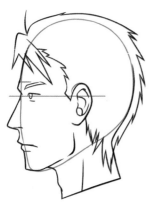

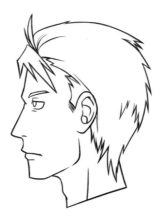

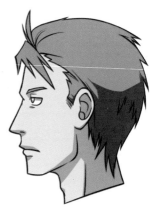

Draw in an outline for the hair, making it stand proud of the oval guide for an impression of volume. Add detail to the ear.

Go over your drawing in ink, adding more detail to the eye and giving more texture to the hair here and there.

Colour your work, paying close attention to the direction of the light. Use flat colour before working on the shaded areas.

GIRL'S FACE *THREE-QUARTER VIEW*

A young girl seen from the three-quarter view. You can use the same steps for drawing a face looking in the opposite direction, but it is essential that you remember to move the position of the vertical guideline, as this is the key to getting the perspective right.

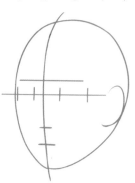

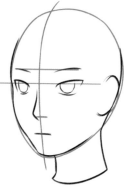

Draw a tapered oval with the usual horizontal guide. Then draw the vertical guide one-third in from the far side of the face.

Divide the face into equal thirds horizontally. Divide the face into fifths vertically, allowing for perspective.

Give more shape to the face and draw in the features. The nose should be in partial profile, the ear should rest on the oval guide.

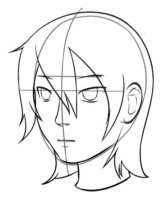

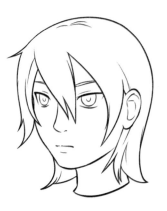

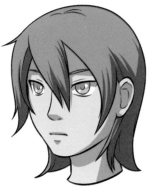

Draw in an outline for the hair. Make it stand proud of the oval guide to give the impression of volume. Add detail to the ear.

Go over your drawing in ink, adding more detail to the eyes and giving more texture to the hair in places. Keep it simple.

Colour your work, using flat colours. Pay close attention to the direction of the light. Add lighter tones and highlights.

MAN'S FACE LOOKING UP

This face is drawn from a three-quarter view, so the principles for placing the vertical guide are the same as those on page 31. Although the horizontal guide remains halfway down the face, it should have an upward curve to it. This will help to position the eyes correctly.

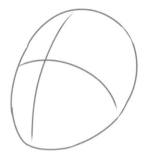 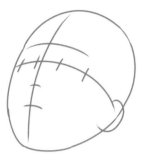

Draw a basic oval, tapered and tilted back slightly. Draw in the vertical and horizontal guides as described above.

Divide the face into equal thirds horizontally and into fifths vertically. Allow for perspective as you do so.

Position the facial features. Notice how the ears are lower than the eyes and not level with them, as in the previous faces.

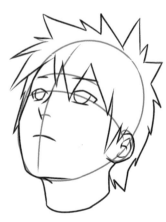 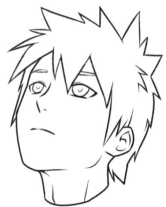 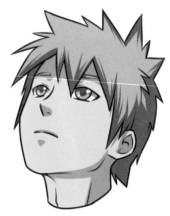

Draw in an outline for the hair. Make it stand proud of the oval guide at the top and back to aid perspective. Add detail to the ear.

Go over your drawing in ink, adding more detail to the eyes and giving more texture to the hair in places.

Colour your work, paying close attention to the direction of the light. Use flat colour before working on the shaded areas.

WOMAN'S FACE LOOKING DOWN

This woman is looking down and is viewed from a three-quarter view. Like the example on page 31, you can make her face the other way, but be sure to change the position of the vertical guide . The horizontal guide needs a downward curve to help with the positions of the eyes.

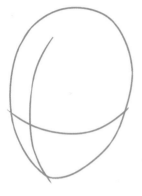

Draw a basic oval, tapered and tilted slightly to one side. Draw in the vertical and horizontal guides as described above.

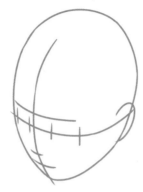

Divide the face into thirds horizontally and fifths vertically. Note that the top third is bigger than the remaining two.

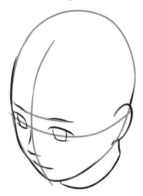

Position the facial features. The perspective here means that the ears are higher than the eyes and not level with them.

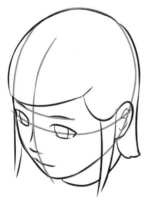

Draw in an outline for the hair. Notice how the hairline hugs the oval guide, because of the downward-looking perspective.

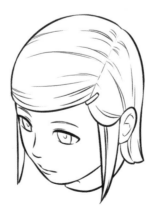

Go over your drawing in ink, adding more detail to the eyes. Give more texture to the hair and draw in a parting.

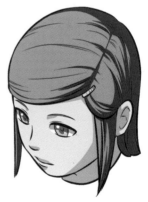

Colour your work using flat colour. Pay close attention to the direction of the light when it comes to the shaded areas.

EYE STYLES

The eyes are almost always the most important facial feature in manga art. Very often they are exaggerated in size and shape and dominate the face. You can use size, shape and colour to great effect when building on the personality of a character.

Children: Eyes are at their biggest in manga children, almost as tall as they are wide and with huge pupils. Boys' eyes (left) are more angular than girls' (right).

Teenagers: Although smaller than those of children, teenage eyes are still exaggerated. They retain distinctly angular (boys) and rounded (girls) forms.

Young adult: Mature manga characters tend to have more realistic eyes. The differences between male (left) and female (right) are less pronounced.

Older adult: There is more shaping to the eye socket in the older manga and a change in eyebrow colour. Notice how much smaller the pupils are.

DRAWING EYES

These are the two sorts of eye you are likely to use most – the larger-than-life youth's eye and the half-realistic adult eye. You can use these models to draw eyes for all your male and female characters, just remember to keep female eyes more rounded and male eyes more angular.

BIG FEMALE EYES

 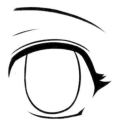 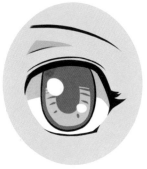

Start with a partial outline. The eye is almost as tall as it is wide and has a large oval iris, part-obscured by the thick upper lid.

Draw minimal lines for the upper lid and eye socket. For female characters, draw out the outer corner to suggest lashes.

Go over your work in ink and colour the image. Use a striking shade for the iris and add bright highlights to give it more depth.

SLIM MALE EYES

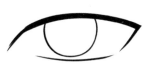 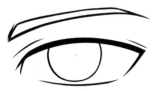

Begin with a partial outline, keeping the shape long and thin, with slight angles at the corners. Draw a part-obscured iris.

Draw in the eyebrow, making sure it echoes the shape and angularity of the eye. Add lines to suggest the eye socket.

Go over your work in ink and colour the image. Shade the eye where the lid casts a shadow and add bright highlights. ·

NOSE STYLES

There are several different styles to choose from when it comes to giving your manga character a nose. They range from a single line to mark the bottom of the nose, to the full-blown, human-style variety. You need to consider perspective carefully.

Drawing just the curve at the bottom of the nose is a simple option. Adding nostrils (left) is also an option. These are typically used for children.

Teenage noses tend to have a more angular quality, drawn using very simple lines (right). Casting a shadow to one side (left) helps define the shape.

Adult noses are more realistic in appearance. The shapes are drawn more fully. These types of nose work better when drawn with nostrils.

The noses of older manga characters are the most realistic of all. They can be smooth (left) or bony and gnarled (right).

MOUTH STYLES

Manga mouths are often little more than a line drawn below the nose, but there are a number of alternatives to this. Once you start to draw different scenarios for your manga characters, you will also want to draw on a range of different expressions.

Simple male mouth, drawn using just one line. The shading above and below helps define the lips.

Female mouth, lips parted and visible teeth. The basic outline relies on colour for shape.

A simple open mouth, shouting or gasping maybe. The outline is basic and there are no lips.

A fuller male mouth. The ink lines are stronger and give more shape to the lips.

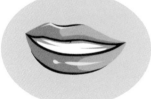

Fuller female lips. The outline is strong and almost complete for a more realistic effect.

Seen from the side, this mouth reveals a vicious snarl. The lips are barely visible.

An more realistic male mouth. Although incomplete, the ink lines give real shape to the lips.

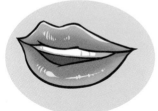

A human-looking female mouth. The outline is complete and gives shape to the full lips.

A laughing mouth, wide open with all the teeth visible. There is no need for lips.

EAR STYLES

When it comes to drawing ears, there are variations for a range of ages and scope for adapting them to suit any character you like. Of all the facial features in manga art, the ears tend to look the most realistic and you need to be able to draw them from a variety of different angles.

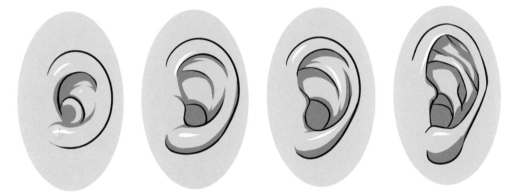

left to right The simplest style of ear is that of the chibi – the youngest character. The ear is almost round and has very little detail. In older children the ear is still simple, though longer. Young adults have more realistic ears, elongated in shape and with more detail. For the older manga characters a wholly realistic ear works well. This tends to have more shape and detail.

EARS AND ANGLES

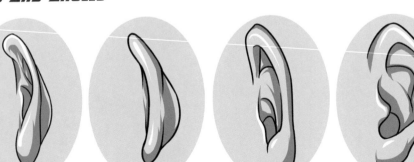

left to right Capturing the appearance of an ear accurately can be very difficult. They are awkward shapes and complex to draw from certain angles. You need to take perspective into account, which often involves foreshortening. These examples show the ear drawn variously from behind, a three-quarter view and side on. Notice how shape and visibility change.

FACIAL EXPRESSIONS

Once you have mastered basic face shape and features, you can have great fun giving your characters more expression. Depending on the scenario you are creating it pays to be able to portray a wide range of emotions as well as personal characteristics.

This sad boy has mournful eyes with heavy lids and downward-sloping eyebrows. The corners of his mouth also turn down.

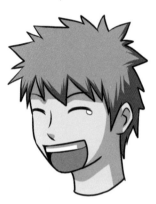

This boy is crying with laughter. His eyes are closed and eyebrows raised. They mirror the open-mouthed smile.

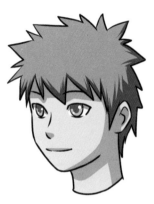

A small, tight-lipped smile shows a serene happiness. The softly rounded eyebrows echo the curves of the bright eyes.

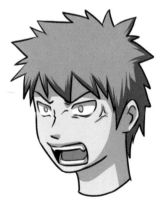

There is real anger here. All of the features are flared and angular. The eyebrows and facial lines show a tight expression.

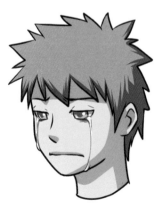

With tears streaming down his face this boy's eyes are heavy and looking down. Straight lips and eyebrows convey sadness.

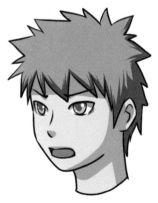

This boy looks anguished or alarmed. His mouth is part open, as if exclaiming or shouting, and his brow is furled.

ANNOYED MAN

This man's features are exaggerated so that the eyes and mouth are open wide, but angular rather than round. His knitted eyebrows arch steeply at the corners and his jaw is square. The hair pulled back away from the face makes the man's expression all the more severe.

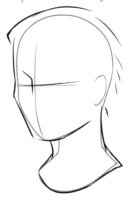

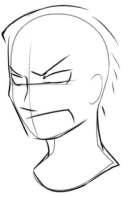

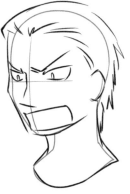

This is a three-quarter view. Start with your pencil guides and begin to sketch in a basic outline of the man's face.

Note the man's angular profile. The wide-open mouth fills the bottom third of the face and the eyebrow stretches up to the hair.

Draw in the man's hairline across the forehead. Emphasise his annoyance by making the pupils in his eyes small and narrow.

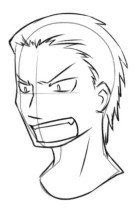

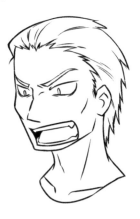

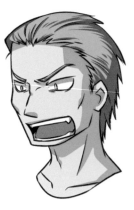

Refine the outline of the hair and begin to work more on the mouth. The stretched lips are barely visible, all teeth are bared.

Add shadow in the mouth, giving shape to the tongue, and draw in the bottom teeth. Draw in the eyebrows and the cheekbones.

Go over your artwork in ink and colour the image. The light is coming from the left, so any shading should be at the rear.

HAPPY GIRL

Closed eyes and a smiling mouth are one of the simplest ways to convey happiness in manga art. Facial features are generally small and basic. The girl's soft, flowing blonde hair emphasises her benign appearance.

Start with pencil guides and sketch in a basic outline of the girl's face and hair. She is young, so her face is soft and rounded.

Draw outlines of her features, which will remain little changed. Her eyes sit on the horizontal guide, her nose is slight.

Work on the hair. It is thick and shoulder length. The tresses are heavy looking with a slight wave. She has a deep fringe.

Draw in more detail on the ear, keeping it simple so that it complements the other features. Finalise the shape of the mouth.

Draw feint lines above the eyes to suggest eyelids. Add a couple wrinkles to emphasise that the eyes are smiling. Add teeth.

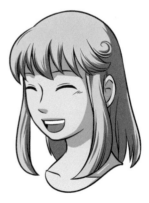

Go over your artwork in ink and colour the image. Keep your colours flat. Work in darker tones for the shaded areas.

ANGRY GIRL

From the upward-sloping eyes and eyebrows, to the square lines of the mouth and jaw, to the pointed chin and shaggy hair, everything about this girl's expression is spiky. Her angry look completely fills her face.

Start with pencil guides and sketch in a basic outline of the girl's face and hair. Keep your lines simple at this stage.

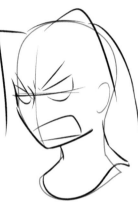

Draw in the angled features. Rounded at the bottom, the eyes rise sharply from the centre of the face, as do the eyebrows.

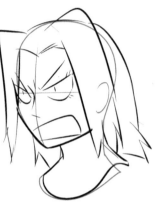

Add narrow pupils and spiky eyelashes to emphasise the angry look. Begin to draw the uneven lengths of hair.

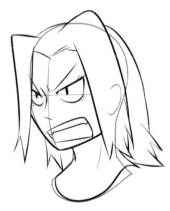

Finish the eyes and start to work on the mouth. This girl is shouting: her tongue and top teeth are visible.

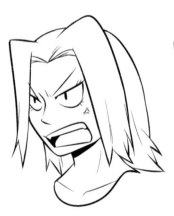

Go over your drawing in ink and work in dark areas of shade in the mouth and below the chin. Erase any unwanted pencil lines.

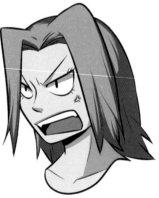

Add colour to your drawing, paying close attention to the direction of the light. Use flat colours before adding shadow.

CRYING BOY

This boy is young and childlike. His eyes are shut tight and his mouth drawn long and narrow in despair. The tears streaming from his eyes are exaggerated and, together with his spiky hair and soft features, they emphasise the boy's vulnerability.

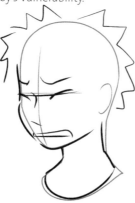

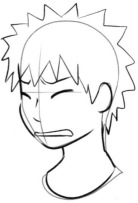

Start with pencil guides and sketch in a basic outline of the boy's face and spiky hair. Keep the jaw line soft and rounded.

Use thick lines to draw the closed eyes and furrowed brow. Draw in the mouth, a narrow strip right across the face.

Work on the boy's hair, keeping it proud of your guides, and draw a spiked fringe. Give more shape to the ear and nose.

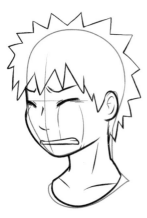

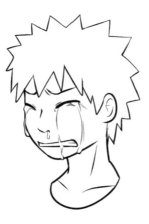

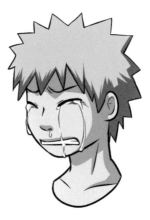

Add more detail – the shape of the boy's neck and collarbones. Begin to trace the lines of the tears as they streak his face.

Go over your drawing in ink and erase the pencil. Exaggerate the tears, making them thicker and three-dimensional.

Colour your image, keeping the colours flat to start with. Work in darker tones for the shaded areas in the hair and neck.

SURPRISED GIRL

The main features of this expression are the wide-open eyes, staring in disbelief. They are slightly downturned, and this is echoed in the shape of the girl's mouth. Her floppy hairstyle offers a frame for the expression and draws the attention of the viewer in.

Start with a pencil guide and draw a basic outline. Make the face fill your oval shape and keep the hair nice and thick.

Draw in the eyes and mouth, centred on the horizontal guide. The eyes can be as tall as they are wide, with arched eyebrows.

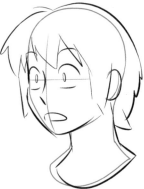

Add small pupils to emphasise the girl's surprised look. Start to draw the hair in detail, keeping it close to the face.

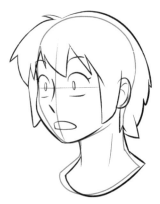

Add a few lines of detail to the ear, but keep it simple, so that you do not divert attention away from the face.

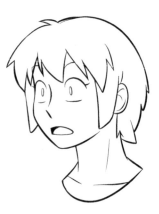

Go over your drawing in ink and erase unwanted pencil lines. Add shadow in the mouth area, but do not draw lips or teeth.

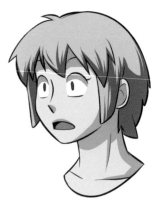

Add colour to your drawing, paying close attention to the direction of the light. Use flat colours before adding shadow.

EVIL EXPRESSION

You can have a great deal of fun making evil characters, as they can be less human-looking than others. You can exaggerate their features, if you like, to make them look other-worldly. The trick with an evil expression is to use short, sharp, straight lines.

Begin with your pencil guide and draw a basic outline of the face. Keep the size small and neat. Draw a few sweeping hair lines.

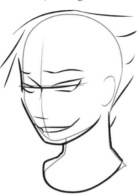

Add facial features. Here they are stretched out to make them long and narrow, emphasising the character's evil streak.

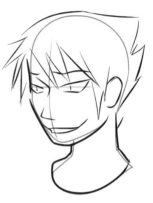

Draw the man's hair. Use short, straight lines to give him a spiked fringe and pull it back and away at the rear.

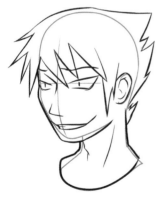

Finish by adding minor details to the ear, making it more pointed than usual if you like. Mark lines on his neck for more definition.

Go over your drawing in ink and erase any unwanted pencil lines. Use the ink to draw out the corners of the mouth.

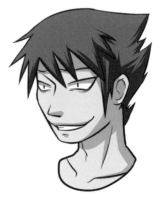

Add colour to your drawing, keeping it flat and simple. The man has a pale complexion and there is minimal shading.

GALLERY

The key to creating convincing manga characters with a range of expressions lies in being able to draw the facial features accurately. The eyes are always important, but you can also convey different emotions and characteristics through the mouth, face shape and hair style.

hateful

right This character is beyond reason. His wide, frowning featureless eyes and square blaring mouth suggest real anger and intimidation.

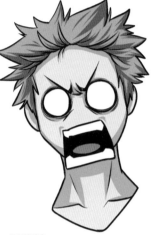

angry

below This boy's short spiky hair emphasises his aggressive facial expression. The colours are cold.

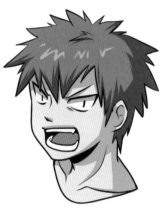

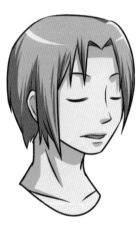

serene

left This girl has soft straight lilac hair. Her eyes are closed as if in contemplation. The whole look is one of calm.

dreaming

below This character has a dreamy, faraway expression. Her benign look is emphasised by the girly hair accessory.

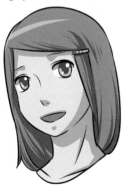

doubtful

right The look on this boy's face is one of uncertainty. His eyes and eyebrows are arched in a sideways quizzical look.

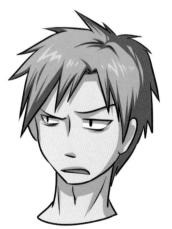

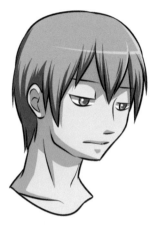

playful

right This character has a softness to him, and a boyish charm. He has bright but gentle eyes and a playful smile.

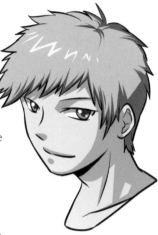

forlorn

above The downward looking eyes and slim downturned mouth belie a sadness that is only emphasised by the lank loose-hanging hair.

surprised

left This girl is gasping in surprise. Both her mouth and her huge, wide-open eyes have a slight downward look to them.

disappointment

right There is disbelief in this girl's expression, as if she is facing a great disappointment. She opens her mouth to speak, but cannot find the words.

hurt

above Someone has wronged this character and she is looking downcast and hurt. Frowning eyebrows and a quivering mouth emphasise the look.

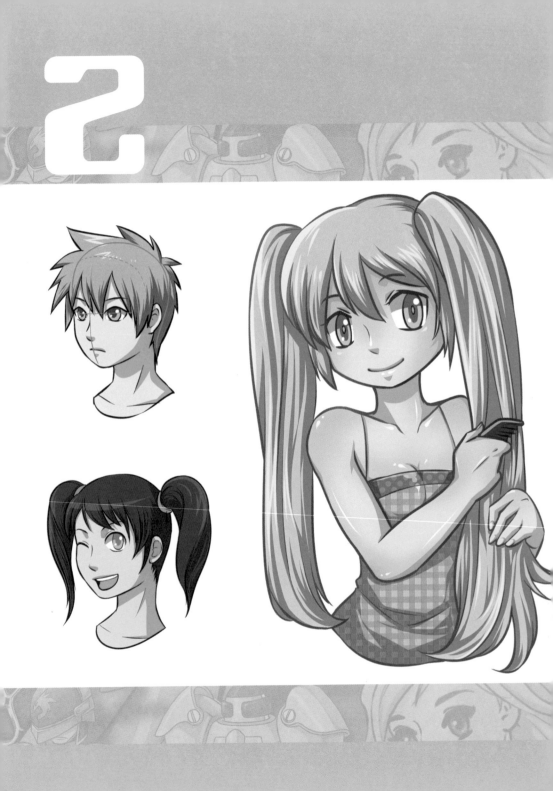

hair

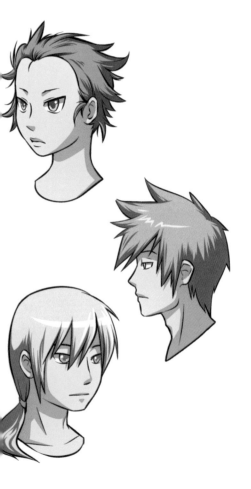

The real fun in creating manga characters lies in choosing their crazy hairstyles. Long or short, straight or wavy, spiky, loose or tied – anything goes for both boys and girls. Better still, you can experiment with an unlimited range of colours. In this chapter you'll find steps for drawing lots of different styles for every look imaginable. You'll also learn how to colour hair and add highlights for a truly authentic finish.

SHORT HAIR BASICS

Many of your male characters, and some of your females, will have short hair. The key to getting the look right is to follow the basic shape of your oval guide. Drawing a dotted hairline across the skull will help to get a realistic fringe and a more three-dimensional appearance.

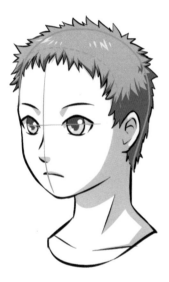

left This boy has spiky hair, made by drawing short, jagged lines all the way around the oval guide. The texture of the hair is achieved through clever shading.

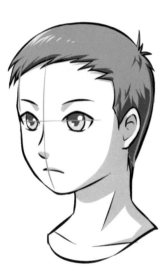

right Here is the same boy with straight hair. See how it hugs the oval guide at the crown and back of the neck. The fringe sweeps forward and across the forehead.

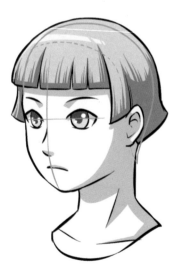

left Short hair on girls can be both masculine and feminine. The bob is a classic girl's cut, and can be drawn either with a fringe or all one length and tucked behind the ears.

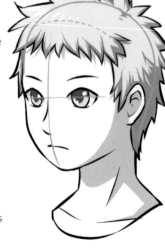

right Spiky hair on girls can be drawn longer than on boys. This gives it a softer, more feminine look. See how the colouring helps to create the texture.

MALE SHORT HAIR

Hair doesn't get much shorter than this! The short crop is a neat hair cut, almost always used for male characters. Note how the line of the hair follows the oval guideline very closely, and sits on the dotted hairline across the forehead.

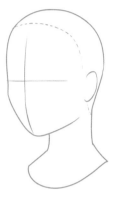

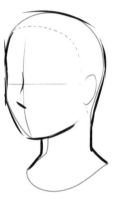

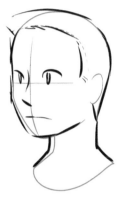

Begin with a pencil outline of the man's head, seen from the three-quarter view. Draw in your basic guidelines.

Give more shape to the face. Draw in a simple nose and square off the chin. Start the outline for the hair.

The hair should sit on the hairline, but stand proud of the oval guide for the man's profile. Draw in the facial features.

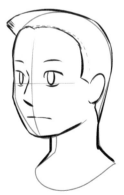

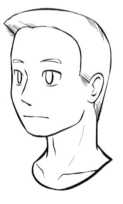

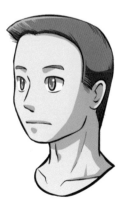

Firm up the outline of the hair, adding a few lines to suggest texture. Draw the eyes in greater detail. Add some eyebrows.

Finish the eyebrows and give shape to the neck. Go over your outline in ink. Erase unwanted pencil lines.

Add colour using flat tones before working on shadows and highlights. Pay attention to the direction of light.

FEMALE SHORT HAIR

When drawing short hair on a female character, it is sometimes important to keep it looking feminine. The example below shows a tight-cropped hairstyle where a slight curl helps to achieve a softer look. The colouring also helps.

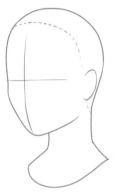

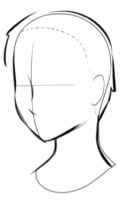

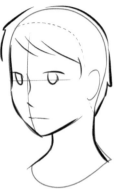

Draw your basic oval shape, with three-quarter view guidelines. Mark the hairline across the top of the head with a dotted line.

Work on the shape of the profile to soften the girl's features. Draw the outline of the hair, keeping it close to the back of the head.

Mark in some basic facial features and a couple of lines to capture the sweep of the fringe across the forehead.

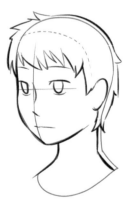

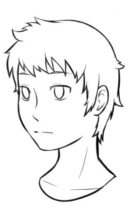

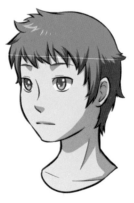

Now work on the hair in greater detail. Little tufts here and there really soften the look. Use short, loose lines to draw them.

Make some of the tufts longer than others – at the sides, where they frame the girl's face. Use ink to finalise your drawing.

Colour your work. Use subtle dark tones along the fringe and towards the rear of the head. Add minimal highlights.

BOY WITH SHORT SPIKY HAIR

Compare this short hairstyle with the one opposite. They are similar in length, but the boy's version is much more spiky. You can see, too, that each character's facial features help to emphasise their look: soft, warm eyes in the girl, harsh angular eyes in the boy.

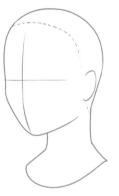

Draw your basic oval shape, with three-quarter view guidelines. Mark the hairline across the top of the head with a dotted line.

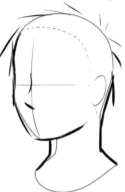

Draw a basic outline of the boy's profile and add rough lines to suggest the hair. See how these follow the curve of the head.

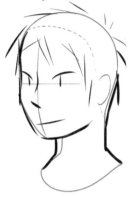

Use your guides to position the boy's facial features. Draw the outline of his spiky fringe, using sharp, straight lines.

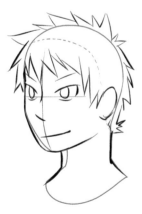

Work on the outline of the boy's hair, making the spikes uneven for greater emphasis. Give him angular eyes and eyebrows.

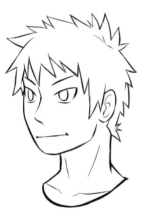

Add any final details – the boy's collarbones, for example. Square up the jaw and finish the ear. Go over your drawing in ink.

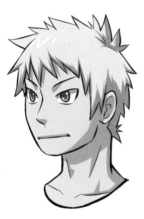

Colour your artwork. The harsh features are emphasised by the cold hair colour. There is a strong contrast between light and dark.

SHORT CLEAN-CUT HAIR

This is a great hairstyle for a character who is in the service of an employer or some sort of organisation. Soft and rounded, it is not a haircut that exudes power, despite the look of anger on the man's face. It would work well with a uniform.

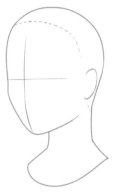

Draw your basic oval shape, with three-quarter view guidelines. Mark the hairline across the top of the head with a dotted line.

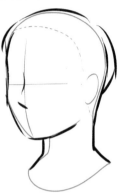

Draw a basic outline of the man's profile and add a smooth line for the hair. See how it follows the oval guide.

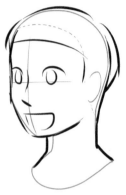

This man has a high fringe, drawn simply as a straight line across the forehead. Position the man's facial features.

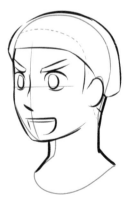

Draw in the eyebrows. Like the man's hair, they are thick. Note how they rise at an angle, because the man is angry.

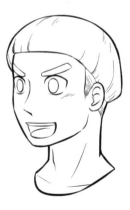

Draw any final details – inside the man's mouth, for example. Finish the ear and go over your artwork in ink.

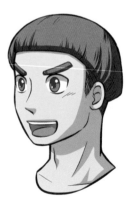

Colour your image, considering the direction of light. The hair is thick and glossy. Use dark tones to pick out a few individual hairs.

DRAWING MEDIUM-LENGTH HAIR

Medium-length hair tends to be about chin length. It can be straight or wavy, and suits both male and female characters. As for short hair, it helps to have the same guidelines that you use for drawing faces as well as a dotted guide for the hairline.

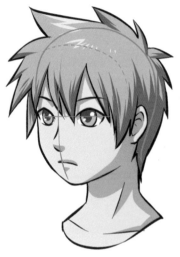

left A boy with thick, soft, layered hair. There is more volume than you get with short spiky hair, and this is achieved by drawing the outline a little proud of the oval guide.

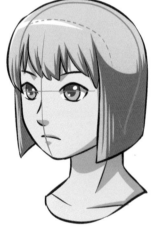

right A girl with a chin-length bob. The simplicity of the cut is enhanced by the striking hair colour and the uneven fringe.

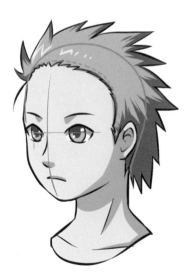

left A boy with swept-back spiked hair. Note how the cut sits on the dotted hairline, but stands well proud of the oval guide. Although spiked, this remains a soft look.

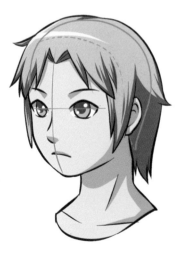

right A girl with a waif-like look. Framing her face, the style has been achieved through subtle layering. The soft look is enhanced by the muted colour.

SHORT SCHOOLGIRL HAIR

This is a typical bob cut, with the hair the same length at the sides and rear of the girl's head and a long fringe. The hair is straight and thick. It is the volume of the hair that gives it a softer appearance. The hair has a glossy sheen, apparent in the lighter tones.

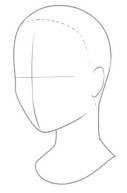

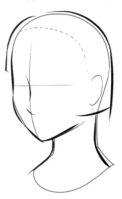

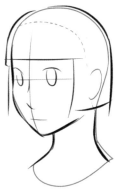

Draw your basic oval shape, with three-quarter view guidelines. Mark the hairline across the top of the head with a dotted line.

Draw a basic outline of the girl's profile and add a smooth line for the hair. See how it follows the oval guide quite closely.

This girl has a long fringe, drawn simply as a straight line across her forehead. Mark in some basic facial features.

Work some detail into the fringe, to show that it is made of many individual strands of hair. Draw the eyes in greater detail.

Draw any final details – giving the lips more definition, for example. Go over your artwork in ink and erase any pencil lines.

Colour your image, considering the direction of light. Be sparing with the darker tones, so that the glossy nature of the hair shows.

BOY'S MESSY HAIR

This cut is a longer version of the spiked hair on page 53. The lines are softer and there is more volume. This, together with the warmer, more friendly facial features, particularly the large round eyes, give the boy a gentler appearance.

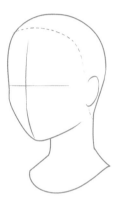

Draw your basic oval shape, with three-quarter view guidelines. Mark the hairline across the top of the head with a dotted line.

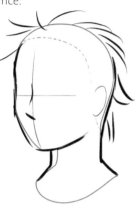

Draw a basic outline of the boy's profile and add sweeping lines to suggest the hair. They should sit on the oval guide.

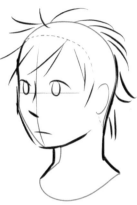

Add the outline of his floppy fringe, using loose, curved lines. Use your guides to position the boy's facial features.

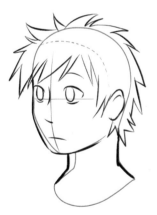

Work on the outline of the boy's hair, keeping it shaggy and uneven. Give him wide round eyes and arched eyebrows.

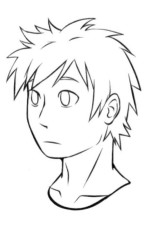

Finish the eyebrows and give shape to the neck. Go over your outline in ink. Erase unwanted pencil lines.

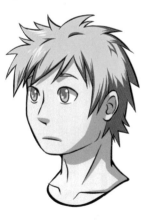

Colour your artwork, using flat colour before adding darker tones for shaded areas and a few subtle highlights.

GIRL'S MESSY HAIR

Quite often, a hairstyle can give a character greater interest or more personality. Here, this backswept unruly style, gives the girl a certain air of mystery. Her angled eyes are more masculine than feminine, which adds to the interest.

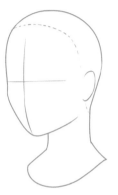

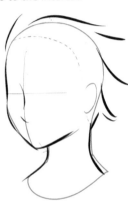

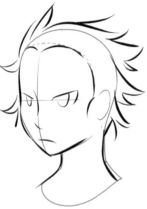

Draw your basic oval shape, with three-quarter view guidelines. Mark the hairline across the top of the head with a dotted line.

Add a basic outline of the girl's profile and add sweeping lines to suggest the hair. Keep them loose and free-flowing.

Position facial features, making the eyes more angular. Work on the hair. Note how it is swept back, away from the face.

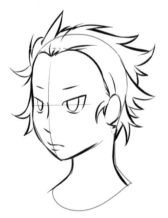

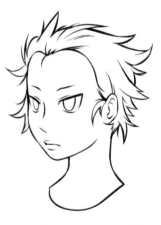

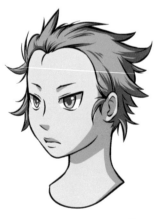

Continue to work on the hair, keeping it loose and windswept. Draw a few strands tucked behind the ear at the side.

Finish the eyes and ear and give more shape to the neck. Go over your outline in ink, and erase unwanted pencil lines.

Colour your artwork, using flat colour before adding darker tones for shaded areas. There are no bright highlights to add.

COMBED-BACK HAIR

This is a neatened male version of the style opposite. It has the same length and is swept back away from the face. It is a good style for the mature adult, as demonstrated here, but would also suit a young, sophisticated self-confident man.

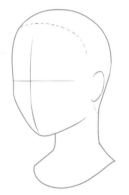 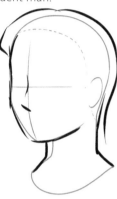 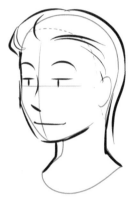

Draw your basic oval shape, with three-quarter view guidelines. Mark the hairline across the top of the head with a dotted line.

Draw in a basic outline of the man's profile and add strong lines to suggest the smooth sweep of the hair.

Position the man's facial features and add more lines to the hair. It should sit on or near the hairline guide, sweeping backwards.

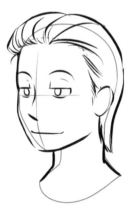 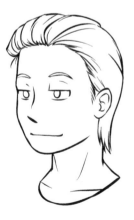

Continue to work on the hair, keeping it neatly backswept. Finish the facial features, keeping them quite realistic.

Finish the eyes and ear and give more shape to the neck. Go over your outline in ink, and erase unwanted pencil lines.

Colour your artwork, using flat colour to start with. Work carefully to get a good mix of light and dark strands.

DRAWING LONG HAIR

Long hair can mean anything from shoulder length. There is more scope here for a wider range of styles. Not only can you get to work on more intricate curls and colouring, but there are also plenty of opportunities for pony- and pigtails and all manner of accessories.

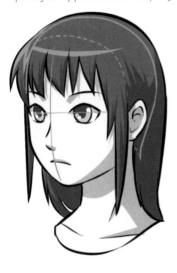

left Long hair is most often drawn on girls. Here the style is simple and straight. There is subtle layering where the hair frames the face.

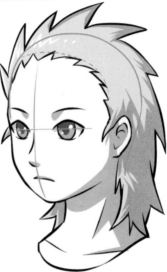

right This is a more masculine look and could be used for boys as well as girls. The hair is thick and spiky, cropped short at the hairline and pushed to the back.

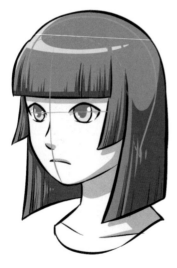

left This adaptation of the bob cut creates a harsh appearance. The lines are straight, rigid and angular. There is a certain coldness here, emphasised by the choice of hair colour.

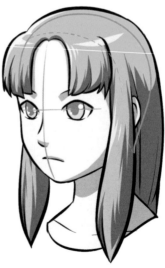

right The softest look of the four, this hairstyle is very feminine. The tresses hang freely at the sides and rear, while the fringe falls into a natural parting.

GIRL'S LONG HAIR

This girl's long hairstyle gives her a very natural look. Swept back from the forehead, the hair is clipped at the sides and hangs freely at the back. The way that the hair sits on the girl's shoulders gives the impression that it is longer at the back than we can see.

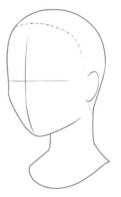 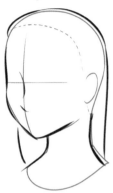

Draw your basic oval shape, with three-quarter view guidelines. Mark the hairline across the top of the head with a dotted line.

Add in a basic outline of the girl's profile and her hair. This style follows the oval guide closely across the top of the head.

Position the girl's facial features and draw the hair framing her face. It sits on the hairline guide and hangs loose at the sides.

Give shape to the hair, separating the tresses as they drape over the girl's shoulders. Draw her eyes in greater detail.

Finish the facial features and draw in the clips that stop the girl's hair from falling into her face. Go over your outline in ink.

Colour your artwork, using flat colour to start with. Most of the shading is to the rear. Add a few subtle highlights.

GIRL'S LONG MESSY HAIR

This is an unruly look that maintains a feminine air, largely thanks to the choice of colour. The shaggy tresses are achieved with bold, jagged lines whose curved elements help to keep the overall outline looking softer than it would if drawn using straight lines.

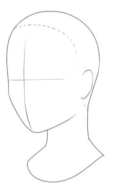

Draw your basic oval shape, with three-quarter view guidelines. Mark the hairline across the top of the head with a dotted line.

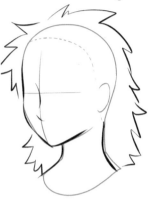

Work on the girl's profile and a basic outline of her hair. The shaggy look stands proud of the oval guide for more volume.

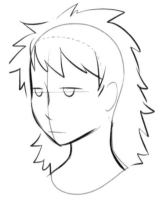

Position the girl's facial features and draw in the fringe. It flops over the forehead, framing the face at the sides.

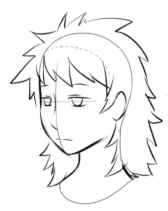

Give shape to the hair, using bold sweeping lines to draw separate locks. Keep the lines short. Draw the eyes in greater detail.

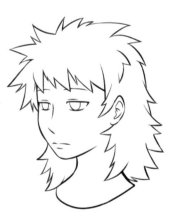

Finish the facial features – the ear for example. Go over your outline in ink and erase any unwanted pencil lines.

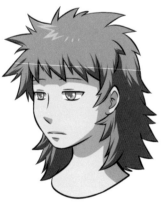

Colour your artwork, using a soft flat colour. Work darker tones into the fringe and to the rear. Add a couple of highlights on top.

BOY'S LONG ARTY HAIR

You can be reasonably inventive when it comes to designing long hair for male characters. This example has an asymmetrical fringe that partially obscures his face and a short ponytail to the rear. Despite these features, this is nevertheless a masculine look.

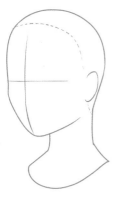

Draw your basic oval shape, with three-quarter view guidelines. Mark the hairline across the top of the head with a dotted line.

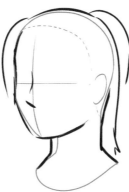

Draw a basic outline of the boy's profile and his hair. This style follows the oval guide closely across the top of the head.

Position the facial features and draw the fringe in greater detail. Notice how it is cropped close to the head on the near side.

Draw the boy's eye in greater detail, making it angular. Work on the cut ends of the hair, giving them more shape.

Finish the facial features – the ear for example. Go over your outline in ink and erase any unwanted pencil lines.

Colour your artwork, using flat colour to start with. Most of the shading is to the rear. Add some darker tones to the fringe.

DRAWING CURLY HAIR

The most important aspect of drawing curly hair is making it look three-dimensional, and there are two ways of achieving this. The first is to keep your ink drawing simple, allowing the lines to spiral and overlap in places. The second is to use different tones when it comes to adding colour.

For a loose curl, start with a simple wavy line. Keep it vertical and vaguely S-shaped. This marks an outside edge of the curl.

Draw a second wavy line a short way from the first, exaggerating the curves slightly. This marks the other outside edge.

Build on the curl by adding a few more wavy lines. Echo the shape of the first two lines, without overlapping them too closely.

Draw the lines a little closer together towards the end of the curl. See how the hair begins to look more realistic.

Go over your drawing in ink and add some feint lines for more detail. These will act as guides when it comes to adding colour.

Apply a flat colour to your work. Use your guidelines to add the darker tones that emphasise the shape of the curls.

PUTTING IT TOGETHER

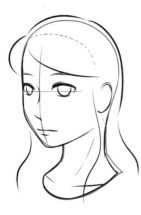

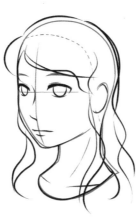

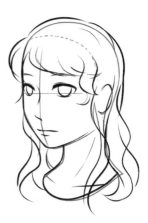

Start with a basic outline of the hair. This style is shoulder length, with a deep fringe. Use a few soft lines to capture the shape.

Work on the individual curls by adding soft, wavy lines that intertwine and overlap with those of the initial outline.

Continue to build on the hair in this way. When it comes to the fringe, keep your lines simple and sweeping in the same direction.

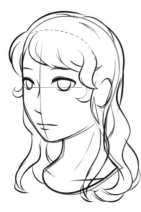

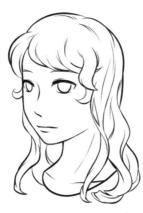

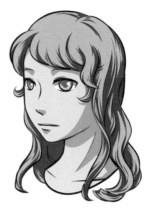

Work on the ends of the curls, giving each a more defined shape. Draw a few feint lines to mark the crown of the head.

Add any final details – such as the curls that obscure the ear and go over your drawing in ink. Erase any unwanted pencil lines.

Colour your artwork, using flat colour initially. Your darker tones should follow your ink lines in order to emphasise the curls.

DRAWING RINGLETS

This is a very stylised look, principally for female characters. The idea is to draw each individual tress as a tight, spiralling ringlet. Once you have practised this a few times, you will have no trouble getting the ringlets to look uniform in size and shape.

Start with two roughly parallel lines. They do not have to be dead straight, but should follow a slight curve instead.

Now mark even sections down the length of your artwork, giving them a diagonal slant from left to right.

Modify your parallel lines, stepping them on the inside edge of the tress and rounding them more on the outside edge.

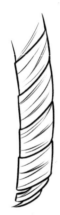
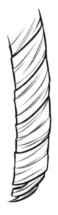

With your basic ringlets drawn, add a number of feint lines in each one to suggest individual hairs running through them.

Go over your drawing in ink and give more shape to the very last ringlet at the bottom. Erase any unwanted pencil lines.

Colour your image. Note how the shading is achieved using very subtle tones to make the ringlet round and three-dimensional.

PUTTING IT TOGETHER

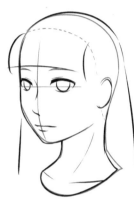

Start with a very basic pencil outline of the shoulder-length hair and deep fringe. You just need a suggestion of the shape.

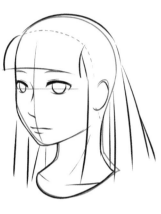

Draw in pairs of parallel lines – one pair per ringlet of hair. They should frame the girl's face at the sides.

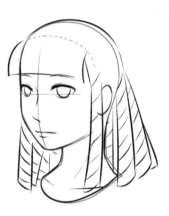

With the ringlets drawn, start to mark the diagonal lines. Note that they slope in opposite directions either side of the head.

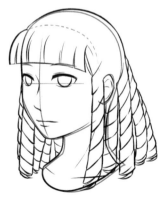

Modify the parallel lines of each tress. Remember that the inside edges are stepped. Draw in the thick, curved fringe.

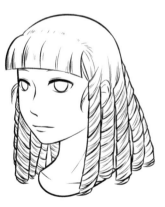

Go over your drawing in ink and work in the many feint lines that suggest the individual hairs running through the tresses.

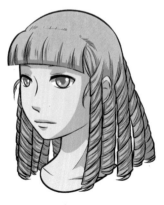

Colour your artwork. Use a strong flat colour before working in the darker tones. Try to make it look three-dimensional.

DRAWING WAVY HAIR

This is not all that different from the curly hair on pages 64–65. There is less volume here, which is achieved by making the curls in the wavy lines a little shallower. This is a style that can be used to great effect on both male and female characters.

For a single tress, start with a simple wavy line. Keep it roughly vertical, but draw in a couple of soft squiggles.

Draw a second wavy line next to the first. Follow the shape of the soft squiggles without repeating them exactly.

The idea is to draw a single tress that looks twisted here and there down its length. Your lines need to meet at a point at the bottom.

Continue to add similarly shaped lines to build up the volume of the tress. Don't overdo it – you want to achieve soft waves.

Go over your drawing in ink and add some feint lines for more detail. These will act as guides when it comes to adding colour.

Apply a flat colour to your work. Use your guidelines to add the darker tones that emphasise the wavy nature of the hair.

PUTTING IT TOGETHER

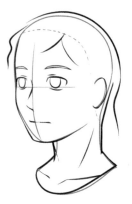

Start with a basic outline of the hair as it frames the top of the boy's head. The outline follows the oval guide closely.

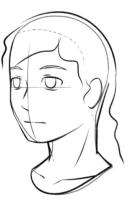

Draw the outline of the deep fringe and of the longer hair at the back of the neck, which is roughly shoulder length.

Add further lines that mirror the shapes of the ones drawn in the previous step. Remember to bring them to a point at the end.

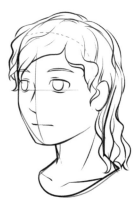

Continue to work in this way, building and better defining the individual tresses of wavy hair. Use the fringe to frame the face.

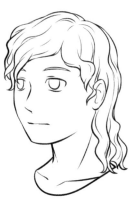

Go over your drawing in ink and erase any unwanted pencil lines. Add a few feint lines for a more detailed finish.

Colour your artwork. Use a flat colour of your choice. Add darker tones and subtle highlights to emphasise soft waves.

DRAWING PONYTAILS

There are various different ways to draw a ponytail. It can be high or low depending on the desired look. High ponytails really only suit female characters, whereas a low ponytail can be unisex (the lower the better for male characters). You can also opt for bunches on girls.

left The high ponytail works best with very long hair. This version sits right on the crown so that the hair is raised high above the top of the head.

right An alternative style for the high ponytail, this version combines with a deep fringe. The overall effect is softer.

left A low ponytail, with all of the hair pulled back and away from the face.

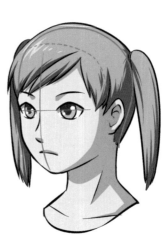

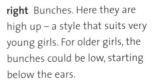

right Bunches. Here they are high up – a style that suits very young girls. For older girls, the bunches could be low, starting below the ears.

HIGH PONYTAIL

The high ponytail is one of the few hairstyles that can only really be worn by women. Having said that, it can make a character appear quite harsh in personality. Here, the style is combined with a tufted fringe for a softer, more feminine look.

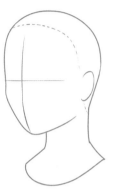

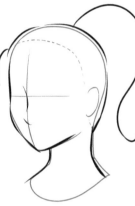

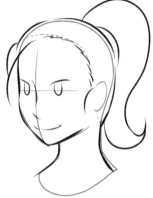

Draw your basic oval shape, with three-quarter view guidelines. Mark the hairline across the top of the head with a dotted line.

Draw a basic outline of the girl's profile, including her hair. It is pulled back tight across the head, so it rests on the oval guide.

Complete the ponytail. It should have a natural curve that ends in a point. Draw in the girl's eyes and mouth.

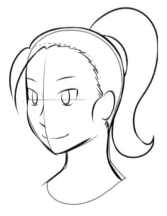

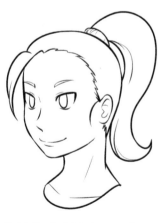

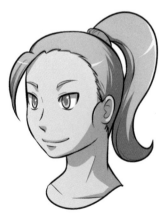

Work on the fringe, giving it a nice, soft curve. Finish the line of the hair across the forehead. Draw the eyes in greater detail.

Finish the facial features and go over your outline in ink. Draw in the hairband and mark a few feint lines in the ponytail.

Use flat colour to finish the image. Add darker tones to colour the shaded areas. Add highlights to capture the gloss.

BUNCHES

Bunches are probably the cutest of all the different types of ponytail. They suit chibis and schoolgirls. In older female characters, they can be used to emphasise a cheeky personality. That is the case here, where the bunches are tied high up to exaggerate the look.

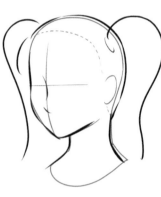

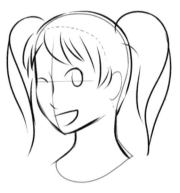

Draw your basic oval shape, with three-quarter view guidelines. Mark the hairline across the top of the head with a dotted line.

Now add in an outline of the girl's profile, including her hair. Keep your line close to the oval guide across the top of the head.

Give more shape to the bunches, drawing sweeping lines that meet at a point at the bottom. Position the eyes and mouth.

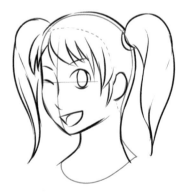

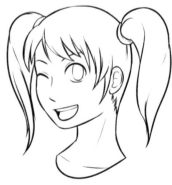

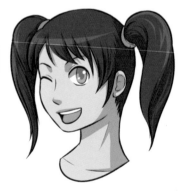

Work on the fringe. Make it uneven and use it to frame the face at the sides. Draw the eyes in greater detail.

Finish the facial features and go over your outline in ink. Draw in the hairbands and mark a few feint lines in the bunches.

Colour the image using darker tones for shaded areas. Add highlights where the bunches and fringe catch the light.

DRAWING HAIR FROM THE BACK

These characters are viewed from a three-quarter angle from the rear. This is achieved in the same way as the three-quarter angle (face on, see page 31). In this case, the hair, and not the facial features, take up two-thirds of the oval vertically and the face is seen in profile.

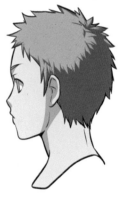

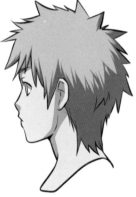

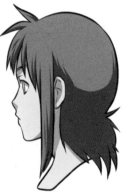

This short, spiky style is achieved by following the initial oval guide with a jagged outline. The rear of the head is in shadow.

Here the spiked hair is longer, which you can do by making your lines stand well proud of the oval guide.

This is an asymmetrical style, cropped tight across the head, while loose and long at the sides, back and fringe.

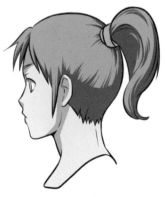

Note how the character's face is obscured in this three-quarter view. The hair is drawn thick and long all the way around.

This style shows how to draw soft gentle curls falling around the shoulders. Note how the crown of the head is prominent.

A high ponytail from the rear, showing how all of the hair is gathered up from the neck and away from the face.

DRAWING HIGHLIGHTS

Highlights can be used to dramatic effect on any hairstyle of any colour. There are two things to remember. The first is that highlights need to reflect the direction from which the light is coming. The second is that they are most likely to feature on curved shapes.

left Here, the girl's hair as been coloured black. At the moment it is a uniform, flat colour and, as such, does not look very realistic.

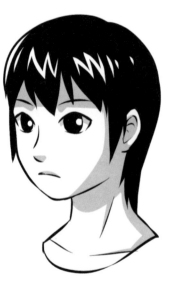

right Very bright highlights show how the curved fringe catches the light. The bold strokes capture the glossy nature of the thick hair.

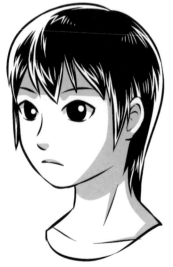

left The direction of light has shifted slightly and is, perhaps, less intense. See how the highlights are evenly distributed across the top of the head, as if the light is from above.

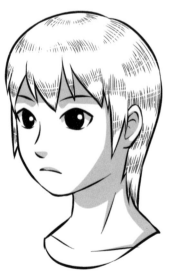

right The girl's hair is now almost exclusively white, drawn in bands radiating from the crown. This is useful for drawing the hair of older characters.

BLACK HAIR COMPLEX HIGHLIGHTS

Having established how to draw basic highlights, it pays to know how to render more complex highlights so that they look realistic. The key for all hair colours is to start with a flat colour of a middling tone. This way, you can build on the look by adding both lighter and darker shades.

It is a good idea to practise on a trial area first. For black hair, start with a flat wash of a dark-grey tone. Now use black for the

shaded areas, filling blocks of colour as well as drawing finer lines to suggest individual strands of hair. Complete the

effect using white for highlights in the same way. Use the natural curves as guides and consider the direction of the light.

PUTTING IT TOGETHER

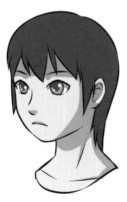 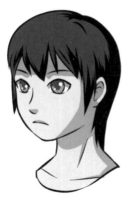 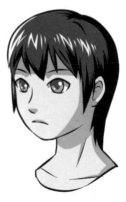

Start with a mid-tone grey. Use this to fill the hair as a solid area of flat colour. Keep it as uniform as possible.

The light is from the left. Use solid black towards the rear of the head and under the fringe, graduating as you come forward.

Use bold, jagged lines for the white highlights. Note how they follow the curve of the fringe for a more realistic finish.

BLONDE HAIR COMPLEX HIGHLIGHTS

Highlights on blonde hair work in pretty much the same way as those for black. And, as long as you use two tones of the same colour, plus white, you will be able to create complex highlights for any of the lighter hair colours you choose, from sky blue to lilac and lemon yellow to pink.

Practise on a trial area. For blonde or pastel-coloured hair, start with a flat wash of a mid-tone. Now use a darker tone for

the shaded areas, filling blocks of colour as well as drawing finer lines to suggest individual strands of hair. Complete the

effect using white for highlights in the same way. Use the natural curves as guides and consider the direction of the light.

PUTTING IT TOGETHER

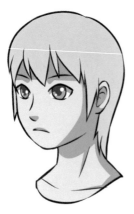

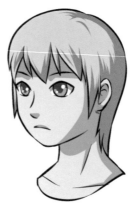

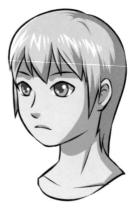

Start with a mid-tone yellow. Use this to fill the hair as a solid area of flat colour. Keep it as uniform as possible.

The light is from the left. Use dark yellow towards the rear of the head and under the fringe, graduating as you come forward.

The highlights follow the curve of the fringe as it catches the light. Use bold, jagged lines to render these realistically.

BROWN HAIR *COMPLEX HIGHLIGHTS*

Brown hair often lacks the high contrast that is characteristic of black or blonde hair, and so the highlights are more subtle. This is also true for some of the darker, more matt colours common in manga art – the dark blues, purples and greens, for example.

To practise, it is a good idea to start with a wash of subtly blended browns. Use two mid-tone shades to achieve this.

Now introduce a darker tone. Instead of using solid blocks, apply a brushstroke effect to achieve a more graduated look.

Then you can use the natural curve of the hair as a guide for adding lighter shades of the same colour for the highlights.

PUTTING IT TOGETHER

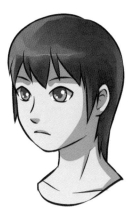 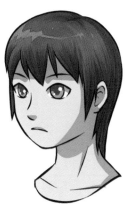

Start by building a blended wash of colour using two or three shades of brown. The darker ones should be towards the rear.

Use lighter shades of brown to show where the curve of the hair catches the light – in this case, across the fringe.

GALLERY

You can use the principles on the previous pages to draw and colour any hairstyle you like. Use your imagination to create characters where the hair says as much about them as the clothes they are wearing. There really are no limits.

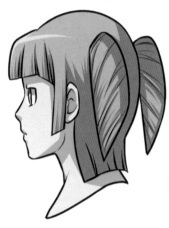

high ponytail

right Thick black hair tied back into a high ponytail and with a loose fringe swept from one side of the face to the other. There is no direct source of light, so there are no bright highlights.

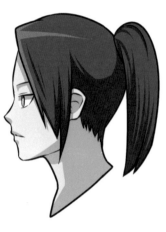

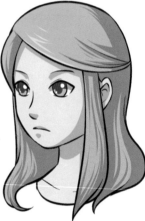

futuristic

above Both the colour of the hair and the styling of it help to give this look a futuristic edge. It is close cropped with a short fringe and wing-like ponytails.

stepped bob

below This is a popular manga look, the shoulder-length hair set in two ridged tiers, topped by a deep straight-cut fringe.

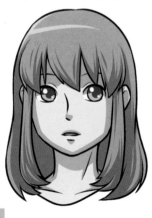

girl next door

above More human-looking in terms of styling and colour, this shoulder-length hair is tied loosely at the back.

simple

left A simple style in a bold colour. The shading sees darker tones in the underside of the hair and deep within the fringe.

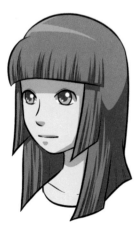

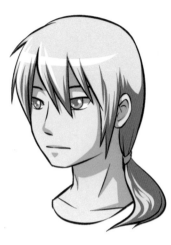

laid back

left This shows how a ponytail can be used successfully on a male character. As long as the hair is tied low, it will create the right laid-back look.

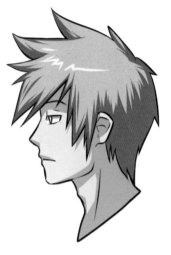

raven-like

right Both the colouring and styling of this cut would suit a half-man, half-bird character: the close cropping is reminiscent of a bird's feathers.

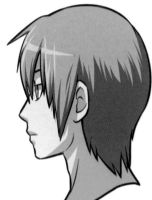

sweeping spikes

above This boy has long and thick spikes brushed forward from the crown. Notice how the shading mirrors the shapes of the spikes for maximum effect.

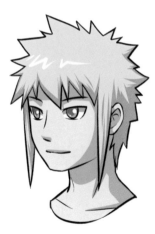

spikes all round

right Most suitable for the younger male characters, this kind of cut brings a certain unruly air to the character.

exaggerated spikes

above Based on the spiked haircut (right), this could be used for older boys and teenagers. The tresses at the sides are really exaggerated.

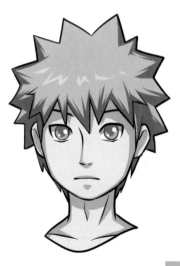

GALLERY

When considering a hairstyle for a manga character, it is not only important to think about gender, but also age, personality, status and profession. The most successful drawings will be those in which the hair appropriately complements such characteristics.

neat bun

right A neat bun at the back of the head, or one on each side, can be worn by young female characters. The look is not out of place in a dance studio or arty environment.

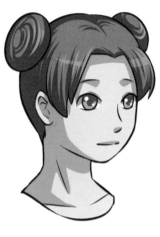

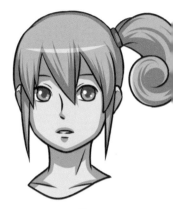

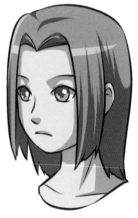

simple styling

left This simple cut, with centre parting, is perhaps suitable for a young office worker or teacher.

jaunty ponytail

above A high ponytail tied at the side would suit a fun, youthful character, like a waitress or student.

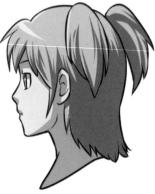

dressed up

right This look requires a little more effort to style and might be reserved for special occasions – say a party or hot date.

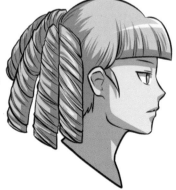

fun and funky

above This is best used on a young woman and might suit someone who plays in a band.

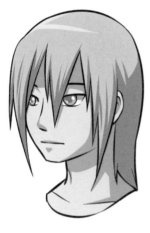

male student

left Long, lank and unstyled, this is definitely the look of a teenage boy – a student or band member, perhaps.

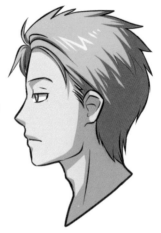

mature

above Neat and sophisticated, this swept-back look is the preserve of the more mature adult male.

sweeping spikes

right The hair is brushed towards the centre line all the way from front to back. It would suit a youthful character.

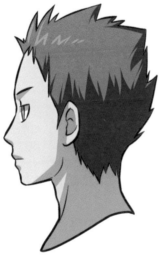

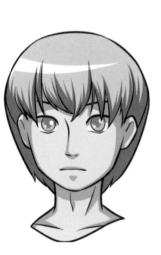

innocence

above This simple, rounded hairstyle betrays a certain innocence in the character. This is emphasised by the soft, muted colouring.

trendsetter

right Both the style and the colouring suggest someone who is avant-garde. The deep fringe partially obscures the face, while the ponytail is short and spiked.

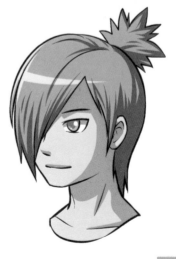

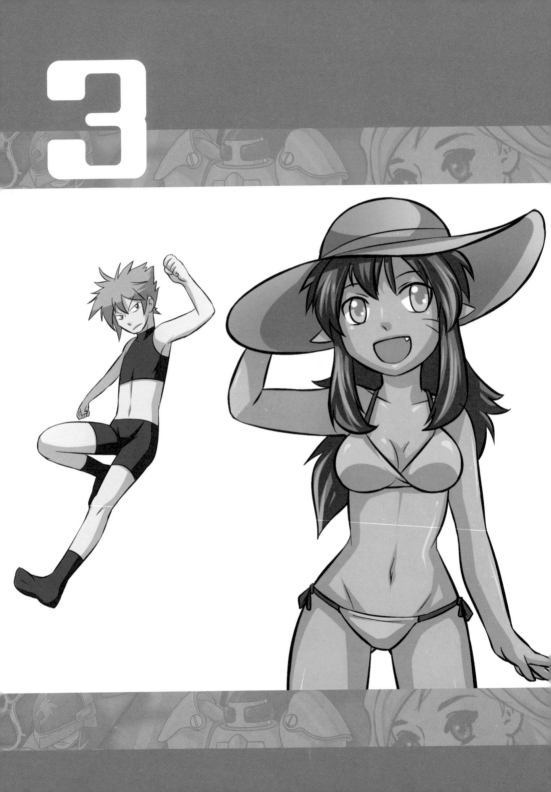

3

body

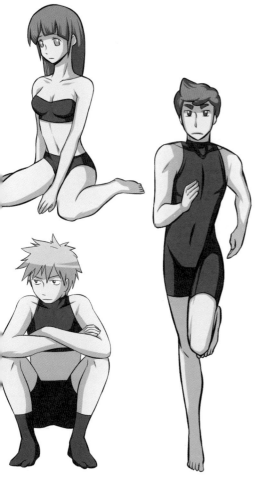

Once you are able to draw male and female figures accurately, you will find yourself inventing all kinds of stories for them. This section of the book looks at proportion and poses. It demonstrates how manga bodies vary and shows how to draw all manner of poses from standing and sitting to running, dancing and kicking a football. Armed with the basics, it will not be long before you are creating poses of your own.

BODY COMPARISONS

Compare the male and female versions of the manga characters depicted on these pages. You will see straight away that the male versions tend to be a little taller than their female counterparts, yet there are a good number of similarities to take note of, too.

below The elderly. In terms of proportion, older characters tend to divide into fifths. The head makes up one-fifth, the torso two-fifths and the legs two-fifths. The shapes of their bodies are not as well-defined as in younger characters, and they wear loose-fitting clothes.

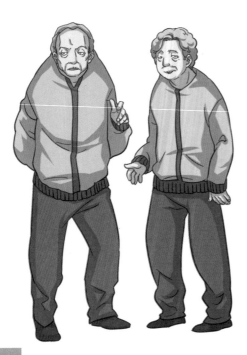

above The mature adult. Body proportions work on sevenths, here, where the head is one-seventh, the torso roughly two-and-a-half, and the legs roughly three-and-a-half. Figures are lean and muscled in men and more shapely in women.

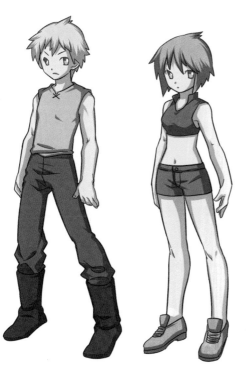

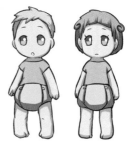

above Chibis. Physically, there are no differences between male and female chibis – this has to come down to hair and clothing. Proportionally, their heads make up one-third of their body size.

above Teenagers. Differences between male and female characters begin to emerge as they enter their teenage years. Boys are a little taller and more muscular than girls, while girls are slimmer with natural curves and well-defined waistlines. Facial features in girls tend to be softer. Proportions are the same as for the mature adult.

right Manga children. Boys and girls are almost identical and usually only distinguishable by their clothing and hairstyles. Boys tend to have less shapely limbs and thicker necks. Proportions are the same as for the elderly.

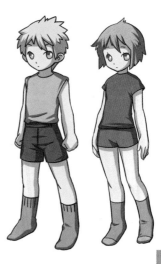

BODY TYPES

In manga art, characters are almost always healthy looking. Even if they are not youthful, their bodies tend to be in good shape. For the purposes of this book, we have selected three body types per gender. There are obviously many variations, but these offer a good starting point.

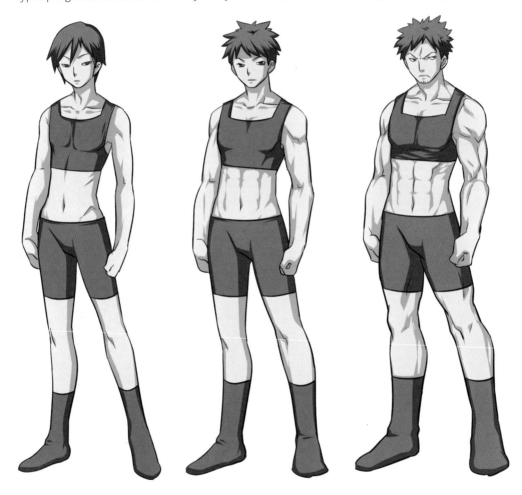

Typical teenage male. His proportions are exaggerated a little, making him taller and skinnier than a human teen.

An adult male. His proportions are more in keeping with a human. He has sturdy legs and well-developed muscles.

A muscled adult male. Super fit he is a power house of strength. His anatomy is still well-proportioned.

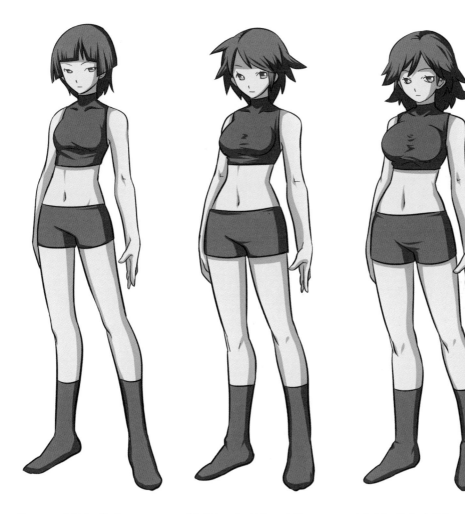

Teenage girl. Like the boy opposite, her proportions are exaggerated. She is tall and skinny, almost androgynous.

Adult female. Although the proportions are more human here, the woman still has an impossibly thin waist.

A full-bodied adult female. Her anatomy is realistic in terms of proportion, with a slightly exaggerated chest and waist.

BODY PROPORTIONS

When it comes to drawing manga characters, it is important to get the figure right in terms of proportion. This provides a skeleton on which to build. Depending on the age of the character, these proportions will change, but the same rules apply to males and females.

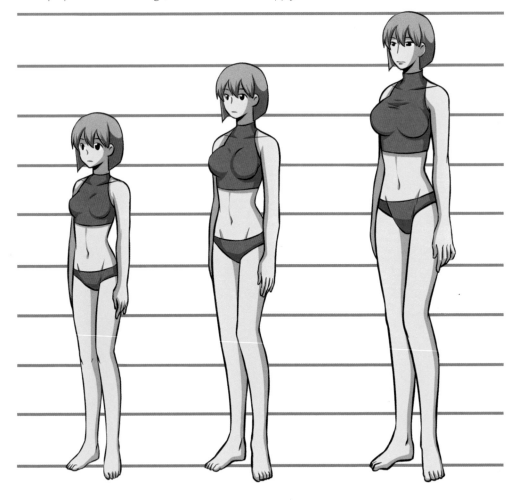

The younger the character, the larger the head in proportion to the rest of the body. Head size is the same in all three examples.

Legs generally make up just over half of the full height in adults. In chibis and the elderly they are just under half full height.

Regardless of age or size, the waist falls halfway between the bust and hips. Arms reach down to the mid-thigh.

SIMPLE ANATOMY

The body can be drawn as a series of simple geometric shapes. Use ovals or circles for the head and joints. Working in this way, you'll soon start to see the relationship between different parts of the body and how these change with movement.

right Seated figure, seen from a three-quarter view. The challenge here is to keep the foreshortened thighs in proportion.

below A dancing figure. All of the limbs are stretched with the movement, as the figure clearly balances on tiptoe.

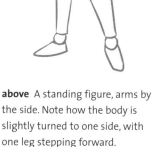

above A standing figure, arms by the side. Note how the body is slightly turned to one side, with one leg stepping forward.

above An athletic leaping or running figure. You can see how the arms and legs are working together to pull forward.

MALE STANDING

This man is standing in a relaxed pose. His feet are roughly hip-width apart and his arms hang loosely by his sides. The steps below can be used for any character of any age and gender. You may have to adjust the proportions slightly.

Build on your structure using simple geometric shapes to draw the body parts. Use ovals or circles to link your shapes together at the joints.

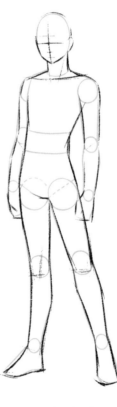

Draw in the man's eyes and an outline of his hair. Start to define his skeletal structure, drawing in details like the collarbone, pelvis and kneecaps.

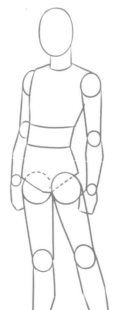

Sketch a very rough structure of your man using a pencil. Think carefully about the proportions. The hands should reach the mid-thigh area.

Use your structural work to draw a solid outline. Think about his muscular make-up. Draw in guides for positioning the man's facial features.

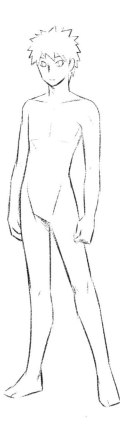

Once you are happy
with your pencil
drawing, go over just
the outline of the man's
body in ink.

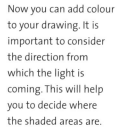

Now you can add colour
to your drawing. It is
important to consider
the direction from
which the light is
coming. This will help
you to decide where
the shaded areas are.

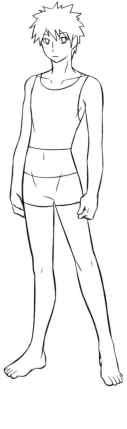

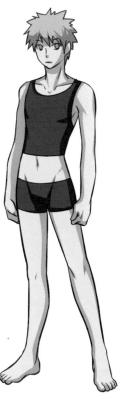

Work on the upper
body now. Draw in the
man's chest and round
his shoulders a little.
Give more shape to the
arms and hands.

Using pencil again,
draw the man's clothes.
He is wearing simply a
vest and shorts. You
need only draw an
outline, which you can
then go over in ink.

SEATED FEMALE

This is quite a typical female pose, halfway between sitting and kneeling on the floor. It is suitable for young girls and early teens, who tend to be more supple.

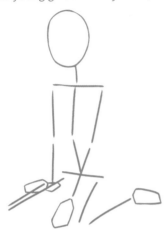

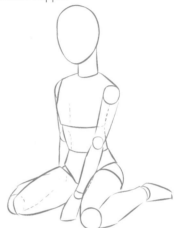

Use a pencil to sketch a basic structure. The upper body is straightforward, but you really have to think about the positions of the girl's legs.

Use simple geometric shapes to draw the body parts, linking them together at the joints with circles or ovals. Think about perspective.

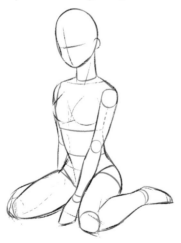

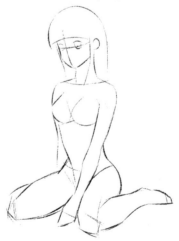

Use this structure to draw a solid outline. Think about the girl's muscular make-up as you do this. Draw in the guides for positioning facial features.

Draw in the girl's eyes and an outline of her hair. Give more shape to her body, drawing her chest more accurately.

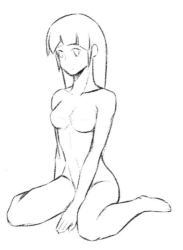

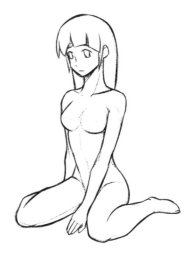

Work on the abdomen now, adding a feint line to mark the ribcage. Give more shape to the legs and arms. Consider the perspective again.

Once you are happy with your pencil drawing, go over just the outline of the girl's body in ink. Take care to follow your sketch accurately.

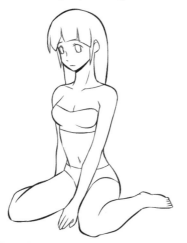

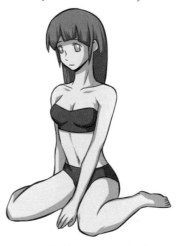

Now draw the girl's clothes, using pencil. Her outfit is simple. You need only draw an outline, which you can then go over in ink.

Now you can add colour to your drawing. Use flat colour to start with. You can then build on the areas of light and shade.

RUNNING BOY

The key to getting this character right is being able to capture the movement of his running. You need to understand how the limbs work together in order to drive the body forward. It might help to have a few photographic references as guides.

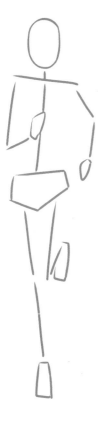

Draw geometric shapes for the body parts, linking them together at the joints with circles or ovals. You need to think about body shape and perspective.

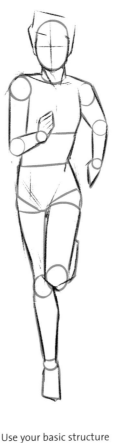

Really work on the positions of the boy's limbs. You need to think about the effects of foreshortening in order to draw them accurately.

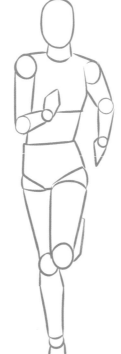

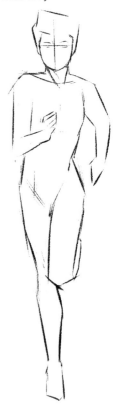

Start with a basic pencil structure, paying particular attention to the positions of the arms and legs.

Use your basic structure to draw a solid outline. Make the boy more athletic in appearance. Draw in guides for the hair and facial features.

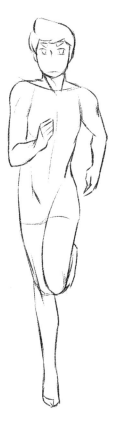

Once you are happy with your pencil drawing, go over just the outline of the boy's body in ink. Take care to follow your sketch faithfully.

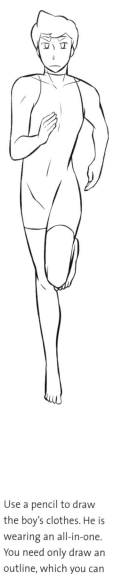

Now you can add colour to your drawing. Use flat colour to start with. You can then build on the areas of light and shade. Take care not to lose the muscular physique beneath the Lycra clothing.

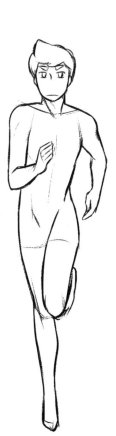

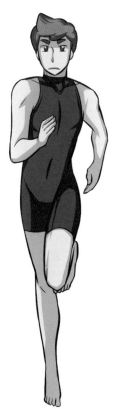

Build on the athletic shape of the boy's body. Make his arms and chest more muscular and round off the bent knee.

Use a pencil to draw the boy's clothes. He is wearing an all-in-one. You need only draw an outline, which you can then go over in ink.

GIRL IN MODEL POSE

This is a very feminine pose and really only suitable for a teenage girl or a young woman. The success of the drawing lies in getting the proportions right. Here, the long legs are made to look longer still, because the near leg is on tiptoe.

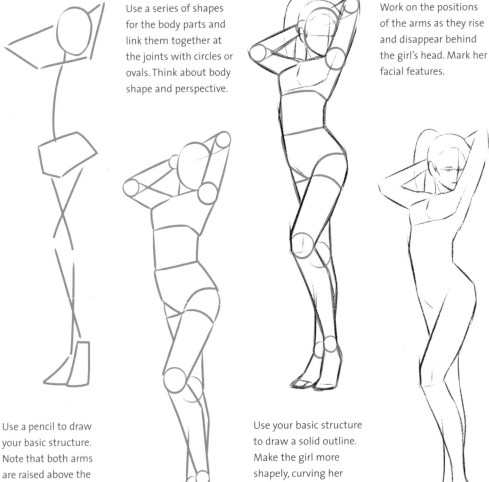

Use a series of shapes for the body parts and link them together at the joints with circles or ovals. Think about body shape and perspective.

Work on the positions of the arms as they rise and disappear behind the girl's head. Mark her facial features.

Use a pencil to draw your basic structure. Note that both arms are raised above the head, the spine is arched and the near foot is on tiptoe.

Use your basic structure to draw a solid outline. Make the girl more shapely, curving her spine and rounding her hip. Draw in guides for hair and facial features.

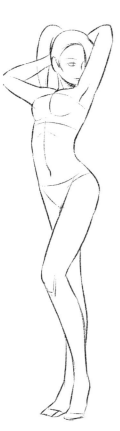

Once you are happy with your pencil drawing, go over just the outline of the girl's body in ink. Keep your lines smooth.

Colour your drawing, using flat colours to start with. You can then build on the areas of light and shade.

Build on the girl's skeletal structure, better defining her armpit, ribcage, elbows and knees.

Use a pencil to draw the girl's underwear. It is tight-fitting, so follow the natural curves of the body. Draw an outline that you then go over in ink.

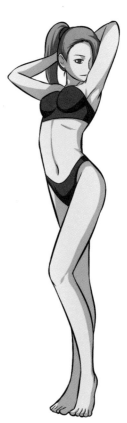

BOY JUMPING

This is a very dramatic pose, bursting with movement and energy. The boy is young and you need to be able to demonstrate this, capturing the agility of his limbs as he moves. This pose would suit a number of characters, both male and female.

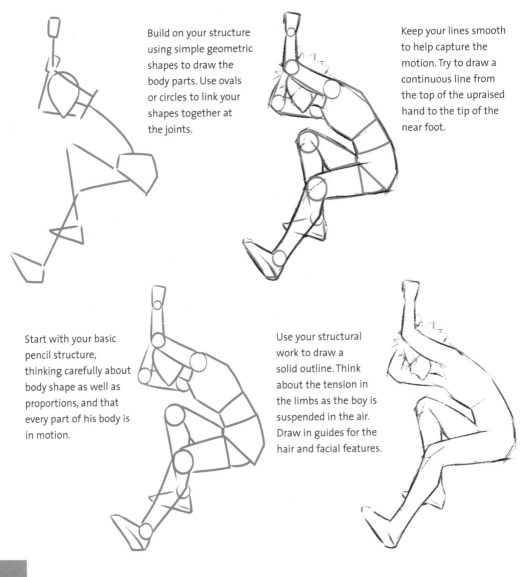

Build on your structure using simple geometric shapes to draw the body parts. Use ovals or circles to link your shapes together at the joints.

Keep your lines smooth to help capture the motion. Try to draw a continuous line from the top of the upraised hand to the tip of the near foot.

Start with your basic pencil structure, thinking carefully about body shape as well as proportions, and that every part of his body is in motion.

Use your structural work to draw a solid outline. Think about the tension in the limbs as the boy is suspended in the air. Draw in guides for the hair and facial features.

Once you are happy with your pencil drawing, go over just the outline of the boy's body in ink. Remember to keep your lines smooth and sweeping.

Colour your drawing. Use flat colours to start with, after which you can build on the areas of light and shade.

Build on the boy's skeletal and muscular structure, particularly around the shoulder area and ribcage.

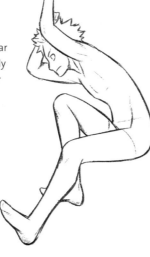

Use a pencil to draw the boy's T-shirt and shorts. Note how the bottom of the shirt is lifted by the force of the motion. Try to capture this.

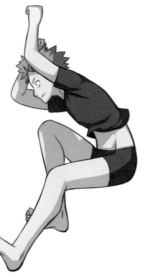

DANCING GIRL

This is a wonderful balletic pose. The girl is bright and cheerful and light on her feet. You need to be able to capture the idea that the girl is in motion. This will give your finished picture a more fluid look. You can apply the steps to a range of dance poses.

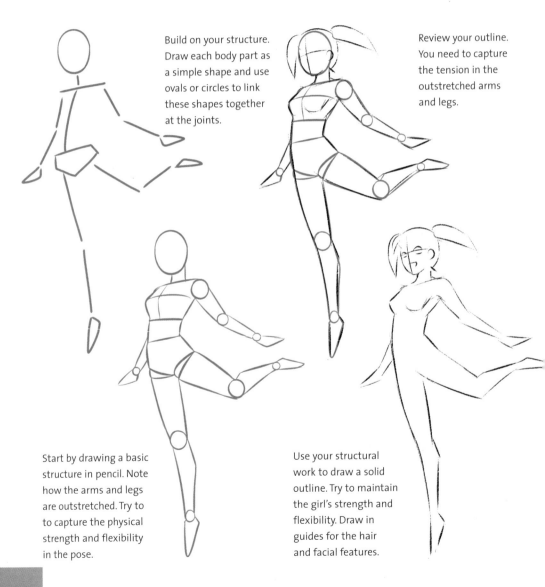

Build on your structure. Draw each body part as a simple shape and use ovals or circles to link these shapes together at the joints.

Review your outline. You need to capture the tension in the outstretched arms and legs.

Start by drawing a basic structure in pencil. Note how the arms and legs are outstretched. Try to to capture the physical strength and flexibility in the pose.

Use your structural work to draw a solid outline. Try to maintain the girl's strength and flexibility. Draw in guides for the hair and facial features.

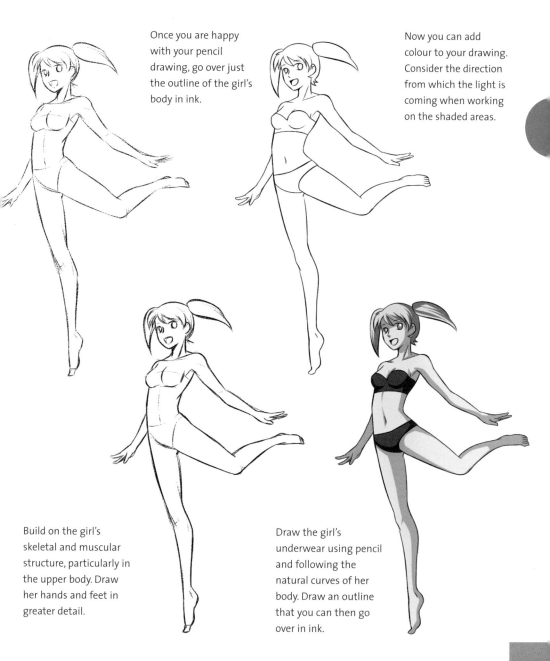

Once you are happy with your pencil drawing, go over just the outline of the girl's body in ink.

Now you can add colour to your drawing. Consider the direction from which the light is coming when working on the shaded areas.

Build on the girl's skeletal and muscular structure, particularly in the upper body. Draw her hands and feet in greater detail.

Draw the girl's underwear using pencil and following the natural curves of her body. Draw an outline that you can then go over in ink.

man playing football

This pose is all about the action of kicking a football, with the character still in motion as he watches the ball pound into the back of the net. You need to judge the positions of the limbs carefully in order to capture the movement.

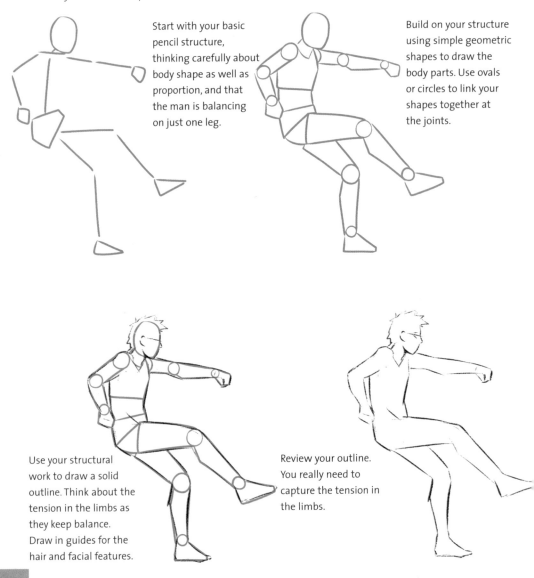

Start with your basic pencil structure, thinking carefully about body shape as well as proportion, and that the man is balancing on just one leg.

Build on your structure using simple geometric shapes to draw the body parts. Use ovals or circles to link your shapes together at the joints.

Use your structural work to draw a solid outline. Think about the tension in the limbs as they keep balance. Draw in guides for the hair and facial features.

Review your outline. You really need to capture the tension in the limbs.

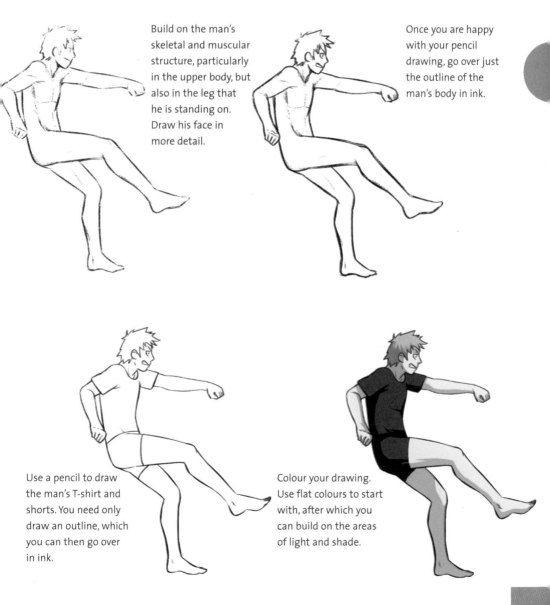

Build on the man's skeletal and muscular structure, particularly in the upper body, but also in the leg that he is standing on. Draw his face in more detail.

Once you are happy with your pencil drawing, go over just the outline of the man's body in ink.

Use a pencil to draw the man's T-shirt and shorts. You need only draw an outline, which you can then go over in ink.

Colour your drawing. Use flat colours to start with, after which you can build on the areas of light and shade.

GIRL SQUATTING

This is a simple seated pose, half kneeling, half squatting on the floor. It can be used with any characters, male or female, young or old.

Use a pencil to sketch a basic structure. The upper body leans forward slightly, with the legs bent at the knees and tucked underneath.

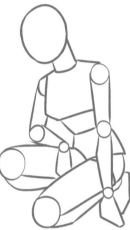

Use simple geometric shapes to draw the body parts, linking them together at the joints with circles or ovals. Think about perspective.

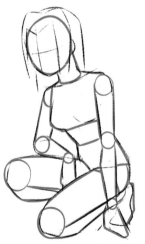

Use this structure to draw a solid outline. Think about the girl's muscular make-up as you do this. Draw in the guides for hair and facial features.

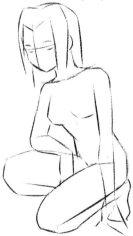

Draw in the girl's eyes and an outline of her hair. Give more shape to her body, drawing her abdomen more accurately.

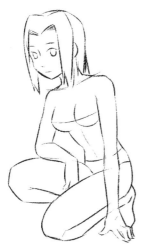

Still on the abdomen, add feint lines to mark her clothing. Give more shape to the legs and arms. Consider the perspective again.

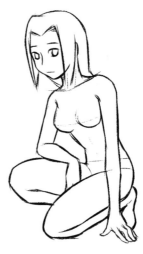

Once you are happy with your pencil drawing, go over just the outline of the girl's body in ink. Take care to follow your sketch accurately.

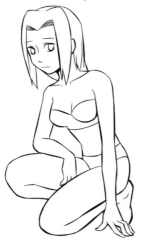

Now draw the girl's clothes, using pencil. Her outfit is simple. You need only draw an outline, which you can then go over in ink.

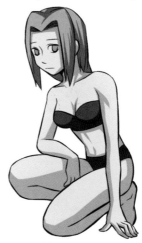

Now you can add colour to your drawing. Use flat colour to start with. You can then build on the areas of light and shade.

BOY SITTING ON FLOOR

This is a very comfortable pose, seated cross-legged on the floor, and with the arms resting gently on the knees. A suitable pose for both genders.

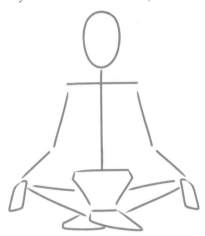

Use a pencil to sketch a basic structure. The back is rigid and upright and both legs are crossed in front of the boy.

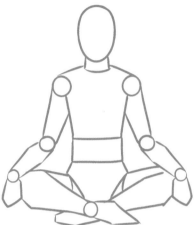

Use simple geometric shapes to draw the body parts, linking them together at the joints with circles or ovals. Think about perspective.

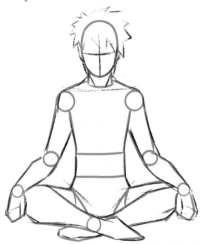

Use this structure to draw a solid outline. Think about the boy's muscular make-up as you do this. Draw in the guides for hair and facial features.

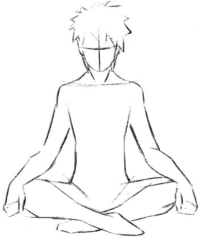

Give more shape to the boy's body, drawing his arms and legs more accurately.

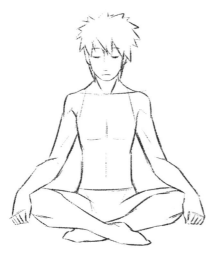

Work on the abdomen now, adding feint lines to define his muscles. Draw in facial features and the boy's fingers.

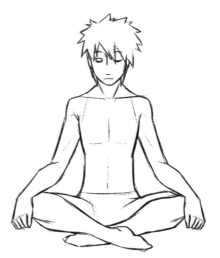

Once you are happy with your pencil drawing, go over just the outline of the boy's body in ink. Take care to follow your sketch accurately.

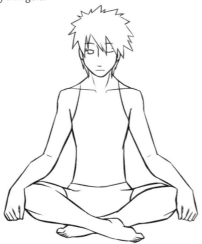

Use a pencil to draw the boy's clothes. He is wearing a vest and shorts. You need only draw an outline, which you can then go over in ink.

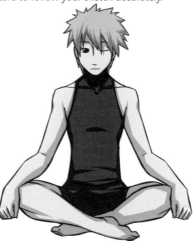

Add colour. Use flat colour to start with, then build on the areas of light and shade. Do not lose the muscular physique beneath the Lycra clothing.

GIRL BENDING

This is a very casual pose, with the girl bending down as if she has dropped something or is about to pick something up. As the one hand goes down towards the floor, the other rises up to counterbalance the action.

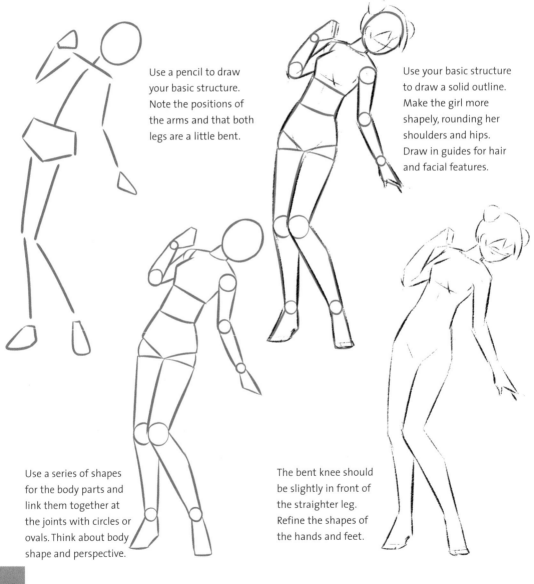

Use a pencil to draw your basic structure. Note the positions of the arms and that both legs are a little bent.

Use your basic structure to draw a solid outline. Make the girl more shapely, rounding her shoulders and hips. Draw in guides for hair and facial features.

Use a series of shapes for the body parts and link them together at the joints with circles or ovals. Think about body shape and perspective.

The bent knee should be slightly in front of the straighter leg. Refine the shapes of the hands and feet.

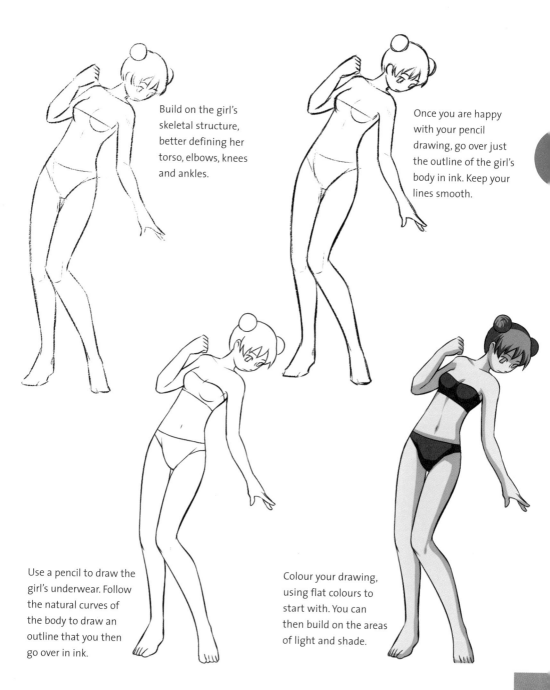

Build on the girl's skeletal structure, better defining her torso, elbows, knees and ankles.

Once you are happy with your pencil drawing, go over just the outline of the girl's body in ink. Keep your lines smooth.

Use a pencil to draw the girl's underwear. Follow the natural curves of the body to draw an outline that you then go over in ink.

Colour your drawing, using flat colours to start with. You can then build on the areas of light and shade.

GALLERY

Once you have mastered the few basic poses demonstrated on the previous pages you can start to broaden your catalogue of designs. Experiment with poses of all kinds so that you can build stories around your characters. Always think carefully about perspective.

standing pose

below Seen from a three-quarter view from the rear, this girl's physique is somewhat exaggerated. Her back has a pronounced arch.

kick boxer

right There is real power and energy in this pose. The girl's legs are dead straight, showing just how strong they are, and she has a muscular torso.

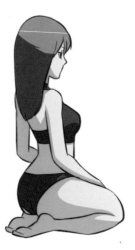

coquettish pose

below This young lady has a seductive air about her. The tricky part here is getting the shape of the left hand right.

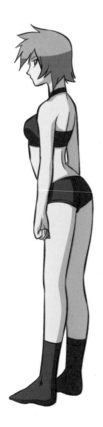

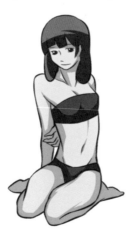

kneeling pose

right This is a neat, compact pose, with the feet comfortably tucked beneath the bottom. Perspective is key here.

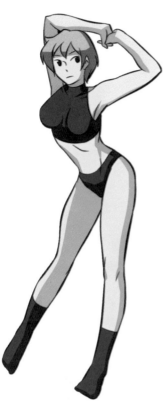

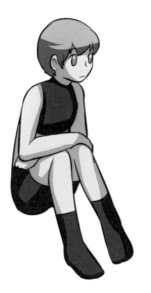

resignation
right Sitting with her knees drawn up and arms folded in front, this girl looks as if she has given up. It is a relaxed pose and there is no tension.

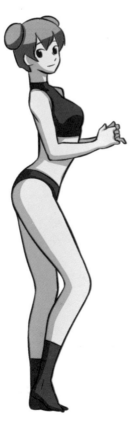

temptress
below Wide-eyed and sultry, this character is very laid back with arms tucked behind her head. There is an air of vulnerability about her.

long stretch
above This girl is stretching up high. She has longer legs than usual, but the upraised arms counterbalance this.

attention-seeking
right This girl has a perfect hourglass figure and is striking a cheeky pose. She is looking for some attention.

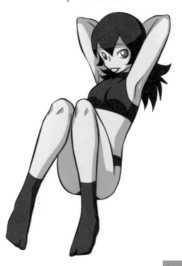

GALLERY

While a number of poses suit only men or just women, the vast majority can be adapted for either gender. The main things to consider are proportion and build. Men generally tend to be leaner (if skinny) or more muscular (if well-built) than women.

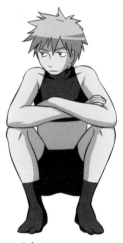

resentment

right This boy is cross about something. He is sitting with his knees drawn up and his arms folded in determination.

bashful

below Leaning back slightly, and with her hands held behind her back, this girl looks shy. Her inclined head and turned-in feet emphasise the look.

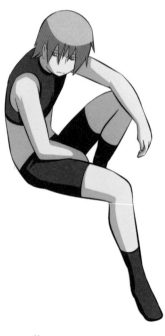

anguish

below There is a tense anxiety in this girl's face that is reflected in her pose. Her back is rigid and her hands clenched.

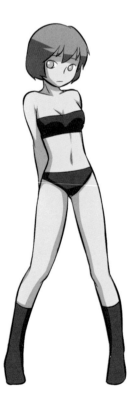

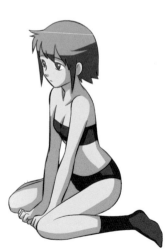

sullen

above There is no tension in this seated pose. The boy's shoulders are sagging and his arms drape across his legs.

seductive pose

right Though seductive, this woman also looks expectant. Her legs are crossed with toes pointing down, her back is rigid.

on the attack

below Leaping through the air with clenched fists, this man has a sense of real purpose, echoed in his angry expression.

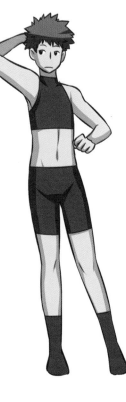

lost

below Scratching his head in wonder, this boy is lost or confused. The uncertainty in his facial expression says it all.

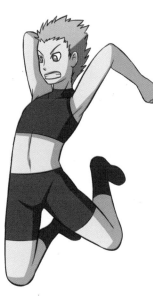

triumph

right Punching the air as he leaps up from the ground, this young man has just scored a well-earned victory.

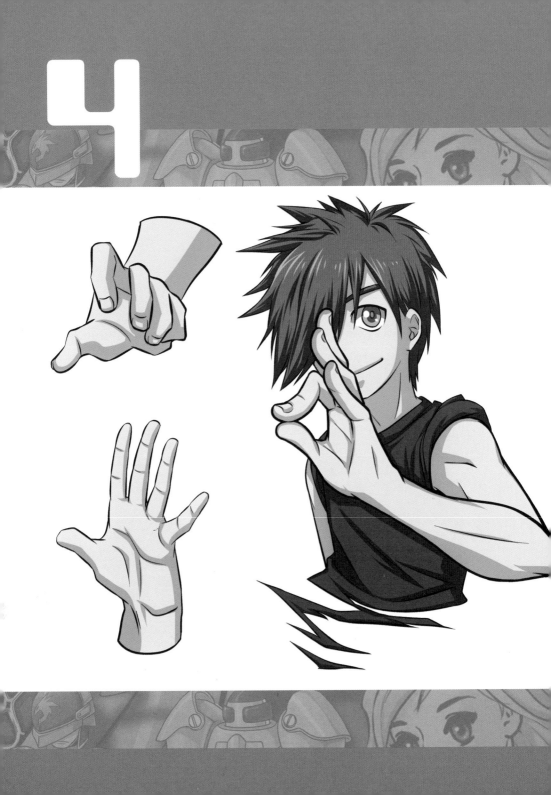

hands and arms

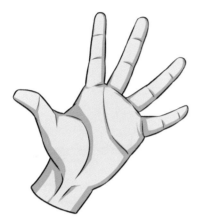

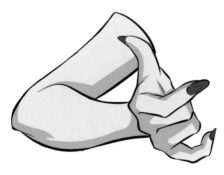

It can be challenging to draw hands and arms convincingly. Hands are particularly difficult, because they make awkward shapes when they change position. In this section of the book, you will learn how to draw hands and arms in a range of poses, from holding a ball to painting nails, and from a variety of different viewpoints. Once mastered, you can adapt these examples to come up with poses of your own design.

arm anatomy

In order to draw arms accurately, you need to know a little bit about anatomy. Even though you are drawing the outside of a person's arm, the success of your image will rely on being able to give a hint of the skeletal and muscular structure beneath the skin.

left Here is the skeletal make-up of the arm, from shoulder to fingertips. You can see the proportions of the upper arm to lower arm, and the relative size of the hand. You can also see the joints clearly – a ball and socket at the shoulder and the hinge joint at the elbow.

left Muscular make-up will vary from character to character. However, you can see clearly that the arm is most muscular in the upper half, with the biceps and triceps muscles. Note that the fingers have no muscles.

ARM COMPARISON

As you create your manga stories, you will want to depict male and female characters of all ages and with varying body types. Here are a handful of arm styles for you to practise, and from which you can develop your own.

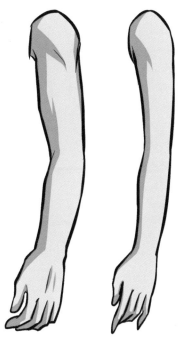

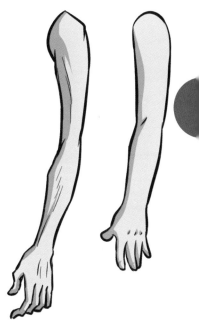

below Fat and thin. The main difference between these two arms is size. Although they are the same length, the example on the left is fatter and less shapely. With the slimmer example on the left, you get more idea of the muscular structure below the skin and you can see the knuckles on the fingers. These are lost on the fatter version.

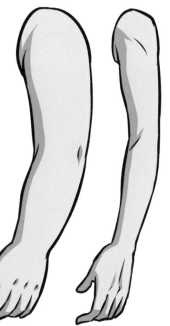

above Average arms of the adult male and female. You can see that both are well-defined, with a clear indication of the muscular and skeletal structure beneath the skin. The male version (left) has more muscle and a larger, squarer hand. The female version (right) is more shapely, with slender fingers.

above Old and young. This is a fun exercise in what happens with age. The older arm (left) is long and sinewy. You can see much more of the skeletal structure than in the adult male. The child's arm (right) is shorter and has puppy fat. The hand is chubby with short fingers.

OPEN PALM

Hands are extremely difficult to draw. Here is one of the simplest poses – the open palm. Raised high in the air, the hand is flat and the fingers are splayed. As with all parts of the anatomy, success lies in getting a good structure from the beginning.

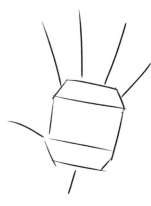

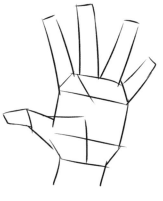

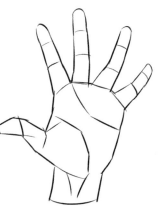

Start with a pencil outline. Draw the palm as three geometric shapes, as shown. Add simple lines for the fingers and thumb.

Build on your structure. Draw the fingers, bearing in mind their relative length. Work on the shape of the thumb.

Give more shape to the fingers now, curving the tips and marking out the joints. Work on the lines of the palm and wrist.

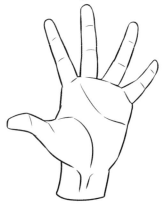

Finish the thumb and smooth out any lines. Go over your drawing in ink, and erase any unwanted pencil lines.

Now you can colour your image. Choose a lifelike skin tone for a flat wash. Use a darker tone for creases and under the thumb.

OPEN HAND

The face-down hand is harder to draw than the palm-up version. This is because you really need to capture the three-dimensionality of the knuckles. It may help to use your own hand as a reference for this, and for getting the proportions right.

Draw a basic outline using pencil. Draw the front of the hand as a rough five-sided shape. Add simple lines for the digits.

Build on your structure. Draw each of the fingers and work on the shape of the thumb. Mark out the wrist.

Give more shape to the fingers now, curving the tips and marking out the joints. Give more shape to the hand.

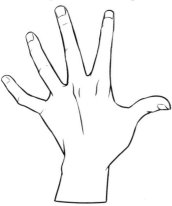

Finish the digits, giving them fingernails. Draw a few lines for knuckles. Go over your drawing in ink, and erase any pencil.

Now you can colour your image. Choose a lifelike skin tone for a flat wash. Use a darker tone in the shaded areas.

FIST

The balled fist is a very powerful hand signal, and one that is very useful in manga art. It can be used to arm sparring characters during scenes of violence in a story. Drawn punching the air, it can also be used to express a well-won victory.

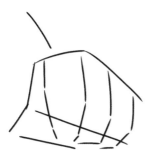

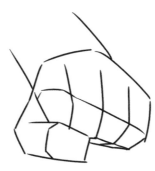

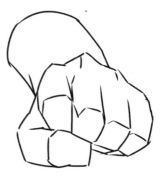

Start with a pencil outline. Draw the fist as a rough oval, with a protrusion for the thumb. Add simple lines to mark the digits.

Define the digits better, considering perspective as they bunch in the palm of the hand. Draw an outline of the wrist.

Work on the bunched fingers now, curving the joints and shaping the powerful profile of the knuckles.

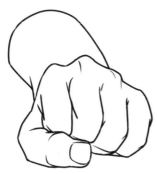

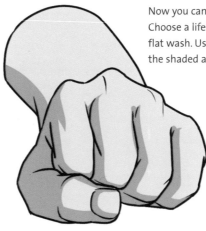

Now you can colour your image. Choose a lifelike skin tone for a flat wash. Use a darker tone in the shaded areas.

Finish the thumb and smooth out any lines. Go over your drawing in ink, and erase any unwanted pencil lines.

OPEN HAND SIDE VIEW

The open hand seen from the side is quite a difficult pose to draw, as the success of it relies on getting the perspective right as well as the proportions. The pose can be used for a character needing to support their weight on a surface or breaking their fall when stumbling.

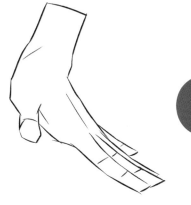

Draw a basic outline using pencil. Use a simple geometric shape for the hand and straight lines for the digits and wrist.

Work on the perspective. The thumb and forefinger are in the foreground while the rest of the hand recedes into the distance.

Give more shape to the hand and, in particular, the thumb, which is foreshortened. Mark the joints on the fingers.

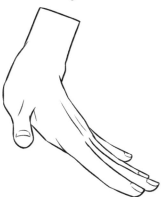

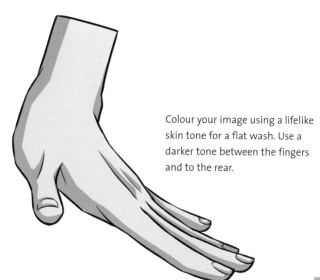

Finish the digits, giving them fingernails. Smooth out your lines. Go over your drawing in ink, and erase any pencil.

Colour your image using a lifelike skin tone for a flat wash. Use a darker tone between the fingers and to the rear.

POINTING FINGER

Once you have mastered the balled fist pose on page 120, you can adapt it to draw the pointing finger pose. It is important to get the perspective right here, and to keep the digits in proportion to the size of the palm of the hand.

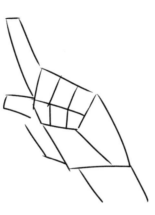

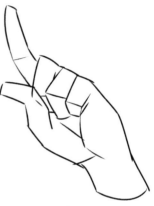

Draw a geometric shape for the hand and straight lines for the pointing finger, thumb and wrist. The other digits are like hooks.

Define the digits, considering perspective as some bunch in the palm of the hand. Draw the thumb and pointing finger.

Work on the bunched fingers now, curling the joints into the palm. Give shape to the palm, defining the creases better.

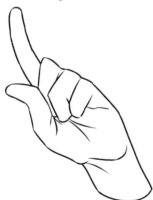

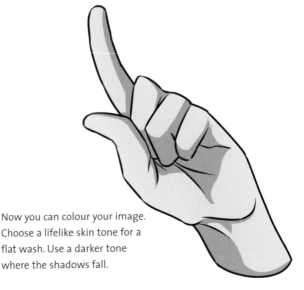

Finish the thumb and smooth out any lines. Go over your drawing in ink, and erase any unwanted pencil lines.

Now you can colour your image. Choose a lifelike skin tone for a flat wash. Use a darker tone where the shadows fall.

FINGERS PICKING UP

This is the most complicated hand pose in the book, but it is also a very useful one, as it can be adapted for all manner of scenarios and situations. One way to think of building the structure is as a series of cubes that you join in sequences.

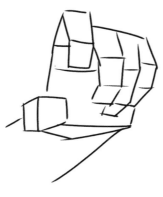

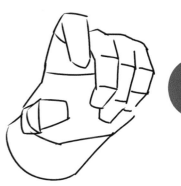

Begin with a basic pencil outline Use simple geometric shapes for the hand and short straight lines for the digits and wrist.

Work on the perspective. The thumb and forefinger are in the foreground while the rest of the hand recedes into the distance.

Give more shape to the hand and, in particular, the thumb and forefinger, which are foreshortened.

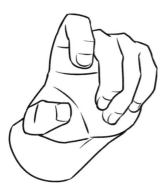

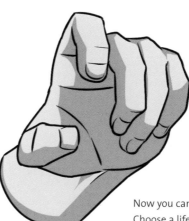

Finish the digits, giving them fingernails. Smooth out your lines. Go over your drawing in ink, and erase any pencil.

Now you can colour your image. Choose a lifelike skin tone for a flat wash. Use a darker tone in shaded palm of the hand.

ARMS NATURAL POSE

This is the simplest pose for the arms – hanging down by the sides of the body. Follow the steps on pages 118 and 120 respectively for the open palm pose or clenched fist.

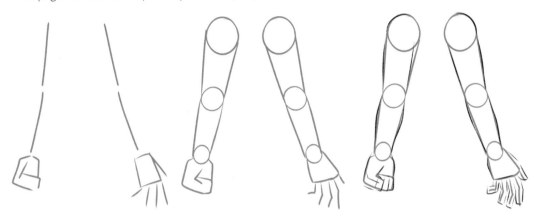

Start with a very simple pencil sketch. Draw straight lines as guides for the arms, and the first step for each hand pose.

Draw the arms as simple geometric shapes, linked at the joints by circles. Continue to work on the hands.

Use your guide to develop the shape of the arms to make them more realistic. These are quite muscular masculine arms.

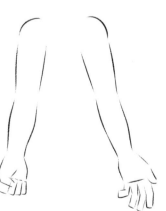

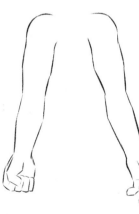

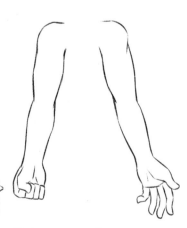

Turn you attention to the hands. Start to work on the perspective of the clenched fist and define the palm of the open hand.

Continue to work on the hands, rounding off the tips of the fingers and thumbs. Make sure their relative sizes are true.

Work your way up the arms, developing a more realistic shape – narrow at the wrists and elbows and rounded shoulders.

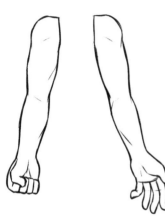

Once happy with your outlines, go over your work using ink. Draw in the odd line to suggest the muscular make-up.

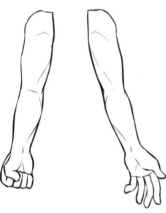

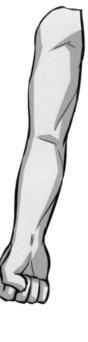

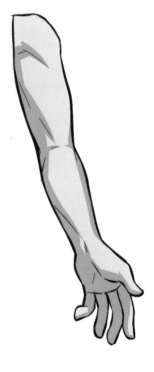

You are now ready to colour your image. Add any finishing details in ink and erase unwanted pencil lines.

Colour your image. Choose a lifelike skin tone for a flat wash. Use a darker tone to emphasise the shapes of the muscles.

HOLDING A BALL

Another useful pose, the ball in this example can be swapped for all manner of objects depending on your story. Paying attention to perspective is key. You need to make sure that the hands are going to look realistic once the object has been placed in them.

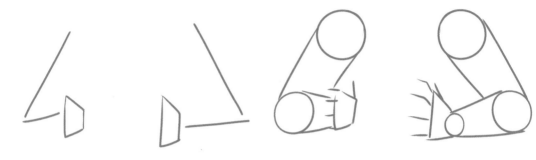

Start with a basic structural sketch using pencil. Draw straight lines as guides for the arms with simple geometric shapes for hands.

Now draw the arms as simple geometric shapes, noting that the forearms are foreshortened here. Use circles for the joints. Add lines for fingers.

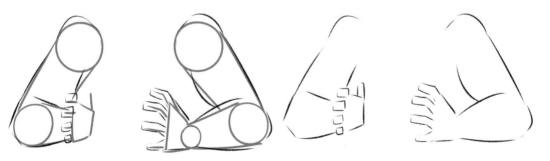

Use your guide to develop the shape of the arms to make them more realistic. These are quite muscular masculine arms. Build on the shapes of the hands.

Turn your attention to the hands. Keep an eye on the perspective here, as you imagine the ball between the hands and how the fingers grasp it.

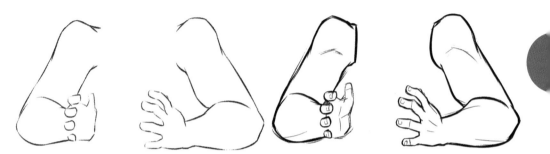

Continue to work on the hands, rounding off the tips of the fingers and thumbs. Keep them looking as realistic as possible.

Add fingernails, knuckles and palm details. Work your way up the arms, developing the muscular build – firm up the triceps and biceps.

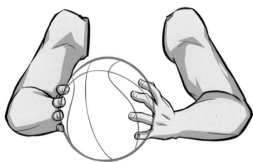

Once you are happy with the pencil marks go over them carefully in ink. Clean up the drawing by erasing any unwanted pencil lines.

Colour your image. Choose a lifelike skin tone for a flat wash. Use a darker tone to emphasise the shapely muscles. Sketch in the ball.

PAINTING NAILS

This is quite a complicated image. Not only do both hands have different poses (based on the open palm, page 118, and the fingers picking up, page 123), but the arms are crossed in front of the body and foreshortened. Getting the perspective right is key here.

Start with a basic structural sketch using pencil. Think very carefully about the positions of the arms and the shapes the hands are making.

Draw the arms as simple geometric shapes, noting that the forearms are foreshortened. Use circles for the joints. Modify the shapes of the hands.

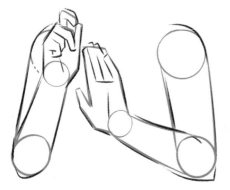

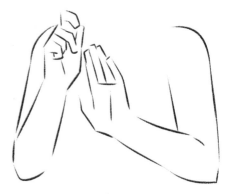

Use your guide to develop the shape of the arms to make them more realistic. They are quite feminine. Draw in each of the fingers and thumbs.

Continue to work on the hands, making sure that the perspective is working. The hand with the nail polish needs to appear slightly further back.

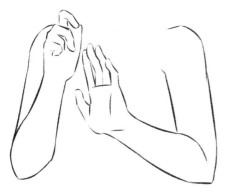

Round off the tips of the fingers and thumbs. Bend one or two of the fingers to give them a more realistic pose.

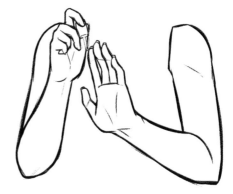

Add fingernails, knuckles and palm details. Draw in the nail polish. Work your way up the arms, giving them more shape.

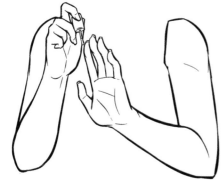

You are now ready to colour your image. Add any finishing details in ink and erase the unwanted pencil lines.

Colour your image. Choose a lifelike skin tone for a flat wash. Use a darker tone in the shaded areas so that your image looks three-dimensional.

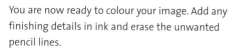

HIP-HOP HANDS

These hip-hop hands make for a fun pose. The example here is for a male character, but you can easily adapt the arms for a female character by making them more shapely and less muscular. The fingers would also be more slender.

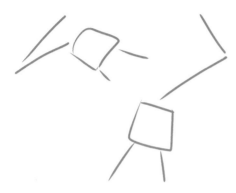

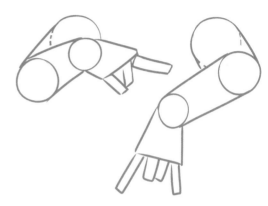

Start with a basic structural sketch using pencil. Draw the arm guides as zigzags to capture their movement. Use geometric shapes for the hands.

Use geometric shapes to draw the arms, taking any foreshortening into consideration. Use circles for the joints. Modify the shapes of the hands.

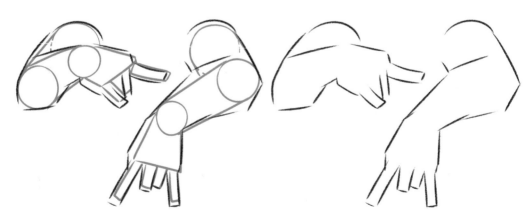

Use your guide to develop the shape of the arms to make them more realistic. Work on your outline to make the image look three-dimensional.

Continue to work on the outline, checking that the perspective is working. Note that one hand is slightly further back than the other.

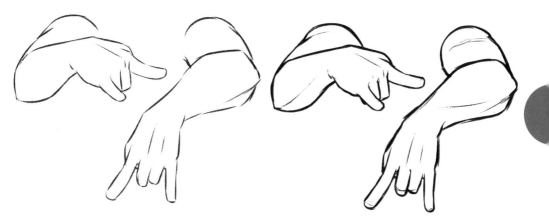

Round off the tips of the fingers and thumbs. Bend one or two of the fingers to give them a more realistic pose.

Add fingernails and knuckles. Work a little more on the arms, giving them more shape. Add a few lines to suggest the muscular structure.

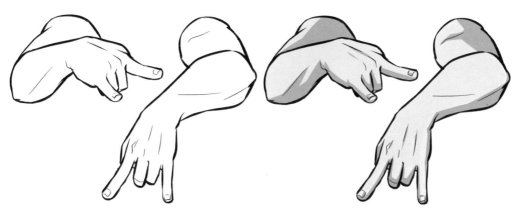

You are now ready to colour your image. Add any finishing details in ink and erase the unwanted pencil lines.

Colour your image. Choose a lifelike skin tone for a flat wash. Use a darker tone in the shaded areas so that your image looks three-dimensional.

LIFTING WEIGHTS

This pose is not dissimilar to the natural pose on pages 124–125. It is reasonably straightforward in that the arms are seen face on and are raised up above the head. The difference here is that the arms are in tension, and not relaxed, so are much more muscular.

Start with a very simple pencil sketch. Draw straight lines as guides for the arms, and the first step for the hands in a fist pose (page 120).

Draw the arms as simple geometric shapes, linked at the joints by circles. Draw the hands in more detail, giving them thumbs.

Use your guide to develop the shape of the arms to make them more realistic. They are very muscular and should be quite broad at the shoulders.

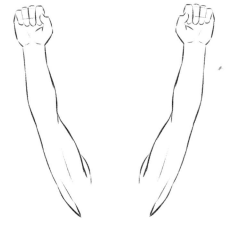

Start to establish the tense muscles, using a few lines to capture them bulging beneath the skin. Give more shape to the hands.

Work more detail into the palms of the hands and to the knuckles. Once happy with your outlines, go over your work using ink.

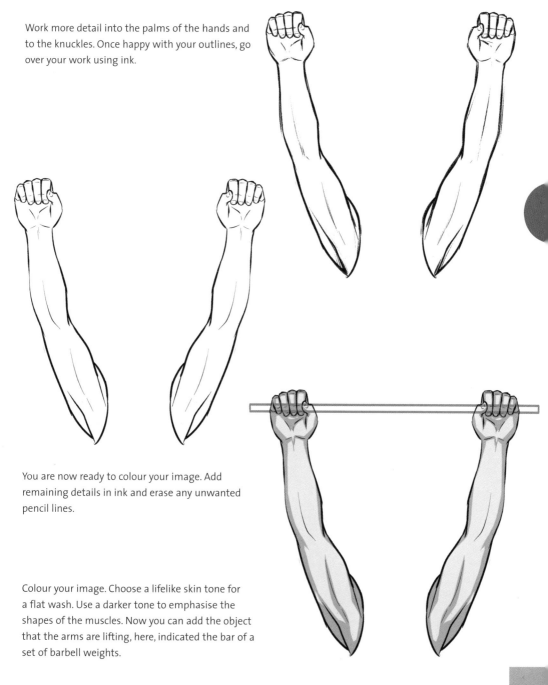

You are now ready to colour your image. Add remaining details in ink and erase any unwanted pencil lines.

Colour your image. Choose a lifelike skin tone for a flat wash. Use a darker tone to emphasise the shapes of the muscles. Now you can add the object that the arms are lifting, here, indicated the bar of a set of barbell weights.

PRAYING

This is a simple pose, with arms bent at the elbows and the hands clasped in prayer. It is worth having a photographic reference for getting the overlapping of the fingers correct, but the rest is pretty straightforward.

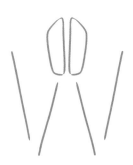

Start with a very simple pencil sketch. Draw straight lines as guides for the arms, and geometric shapes for the hands.

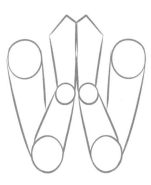

Build up the arms as simple geometric shapes, linked at the joints by circles. Refine the shapes of the hands.

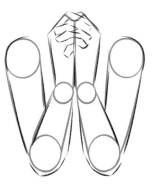

Use your guide to develop the shape of the arms to make them more realistic. Note that this pose is quite symmetrical.

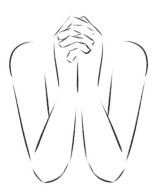

Continue to develop the shape of the arms to make them more realistic. These are the arms of a female character.

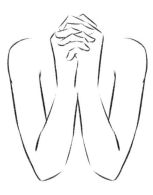

Take your time with the hands. Consider how the hands are clasped – loosely – and give more shape to the fingers.

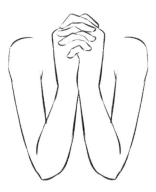

Round off the fingertips, double checking that the fingers are the right length relative to one another. Keep them relaxed.

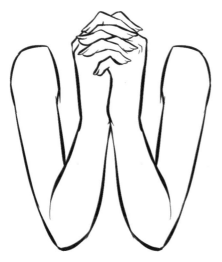

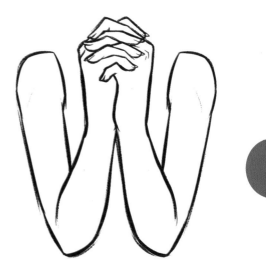

Draw in fingernails to make the hands look three-dimensional. Once happy with your outlines, go over your work using ink.

You are now ready to colour your image. Add any last details in ink and erase unwanted pencil lines.

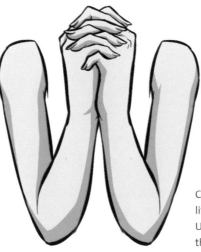

Colour your image. Choose a lifelike skin tone for a flat wash. Use a darker tone for the areas that are in shade.

GALLERY

Armed with the basics outlined in this chapter, you will soon be able to draw realistic hands and arms, keeping them three-dimensional and in perspective. They are never easy to draw, however, so try to find a good number of visual references to help you.

clenched fist

right Here is a view of the fist shown on page 120, but now seen from behind. Only the knuckles of the fingers and thumb are visible.

dancing arm

below The raised arm of a young character. The hand is relaxed and has the suggestion of movement, maybe dancing.

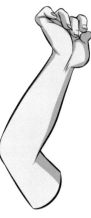

crawling fingers

below A youthful arm and hand, the fingers walking slowly across a surface. There could be something a little sinister about the pose.

relaxed arm

below Although similar to the image to the left, this is more relaxed. It might suit a character going somewhere in a hurry.

reaching for help

above This is a version of the open palm on page 118. There is a slight tension here, however, suggesting that the character is reaching out for help or grasping at something just beyond reach.

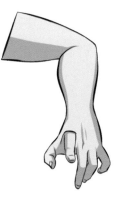

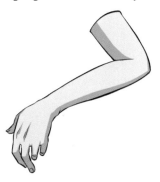

beckoning fingers

below A female hand making a beckoning gesture. The success of this pose lies in the accurate foreshortening of the hand.

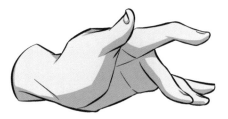

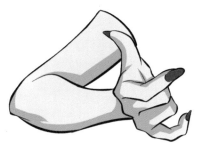

keyboard fingers

above This hand is almost horizontal, with the fingers poised. It is a pose that could suit someone using a computer or playing the piano.

grabbing fingers

right Note the foreshortening of this outstretched hand. The fingers are bent in a grabbing motion and are about to pick something up.

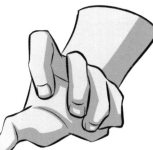

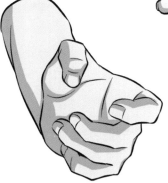

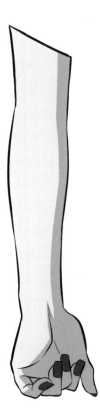

hanging loose

right This is the pose of a very relaxed arm. The limb is hanging straight down and the fingers are curled towards the palm, but not clenched tight.

grasping fingers

above You can just imagine a tennis racket in the hand of this character. The positioning of the fingers suggests that, or something similar.

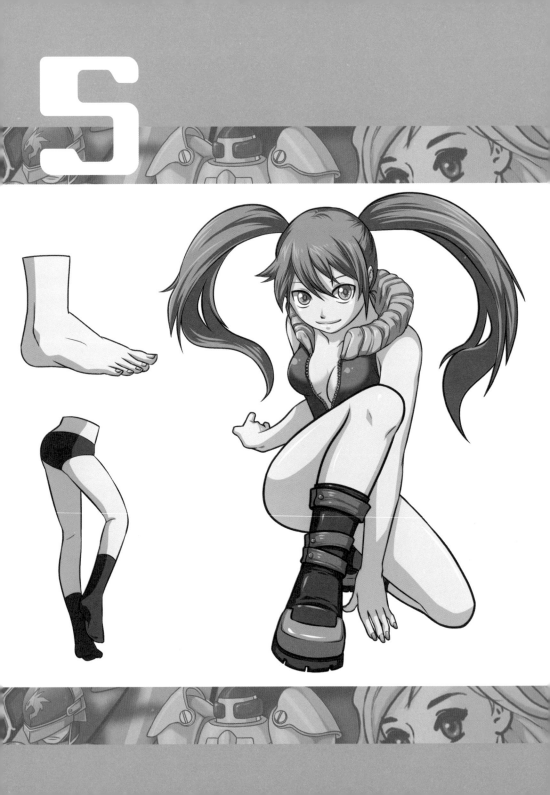

legs and feet

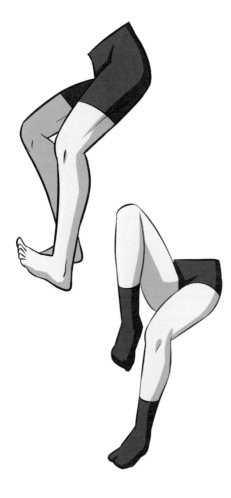

Legs and feet pose similar problems to hands and arms when it comes to drawing them. You need to have a good grip of perspective in order to capture them in a range of different poses. This section of the book offers instruction on drawing legs and feet from different viewpoints and in a range of activities. Having practised these, you'll soon be developing convincing poses of your own making.

LEG ANATOMY

In order to draw legs accurately, it helps to know a little bit about the human body. The success of your image relies on having some knowledge of the skeletal and muscular structure beneath the skin. This is true for all body parts – arms, legs, torso and so on.

left The skeletal make-up of the leg, from hip to toe. You can see the bone structure of the limbs, as well as the correct proportions of thigh to shin – pretty much equal. You can also see the complicated joints at the hip, knee and ankle.

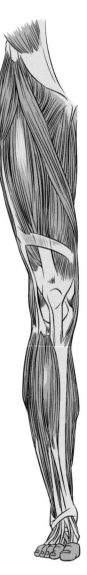

right You can see that the legs are very muscular from top to bottom. In profile, the most prominent muscles are those of the thigh and calf. It is important to remember that the muscular make-up will vary from character to character.

FOOT SIDE VIEW

The foot seen from the side is one of the easiest poses to draw, as long as you can get perspective and proportions right. You need to consider the relative sizes of the toes, but also the fact that they recede into the distance.

Draw an outline using pencil. Use a simple geometric shape for the foot and mark the approximate position of the ankle.

Work on the perspective. Divide the foot shape into sections for the side and top of the foot. Mark out each toe.

Give more shape to the sole of the foot. Round off the heel and sculpt the arch. Define the ankle bone a little more clearly.

Work on the toes, paying attention to their relative sizes. Draw in the toenails. Go over your drawing in ink.

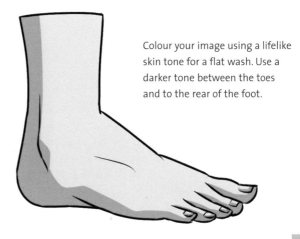

Colour your image using a lifelike skin tone for a flat wash. Use a darker tone between the toes and to the rear of the foot.

FOOT FRONT VIEW

This is quite a difficult viewpoint to master, but a very useful one, as you will need it for any characters seen from the front. You will also need to adapt this version for the various stages of walking – mid-step, for example, where just the ball of the foot makes contact with the ground.

Start with a pencil outline. Draw the foot as a simple geometric form. Try to capture the basic shape the heel and toes make.

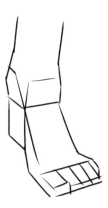

Make your drawing three-dimensional. Draw in the shin and ankle, then work on the heel section and each individual toe.

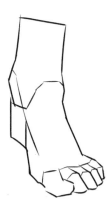

Give more shape to the toes now, curving the tips and marking out the joints. Work on the profile of the foot to define the ankle.

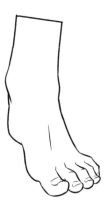

Finish the toes, giving them toenails, before going over your drawing in ink. Erase any unwanted pencil lines.

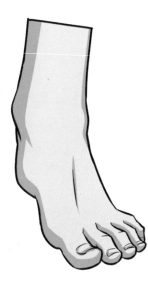

Now you can colour your image. Choose a lifelike skin tone for a flat wash. Use a darker tone in the shaded areas to the rear.

FOOT FROM BELOW

This is a useful viewpoint to master, as it can come in very handy when drawing characters who are mid-air for some reason – say you want to draw someone running or playing a sport, or even locked in combat with an enemy.

Draw an outline using pencil. Use a simple geometric shape for the foot and mark the approximate position of the ankle and toes.

Make your drawing three-dimensional. Draw in the shin and ankle, then work on each individual toe.

Give more shape to the sole of the foot now, rounding the heel and marking the ball of the foot. Round off the toes nicely.

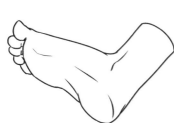

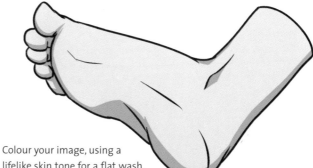

Add any final details – say the ankle bone – before going over your drawing in ink. Erase any unwanted pencil lines.

Colour your image, using a lifelike skin tone for a flat wash. Use a darker tone to define the ankle and the arch of the foot.

RUNNING

For this version of legs and feet, and for many others, the success lies in being able to show the action realistically. You may find it useful to find a drawing or photograph to refer to as you work.

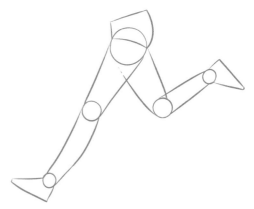

Start with a basic structural sketch using pencil. Draw the legs as straight lines for now, and use geometric shapes for the hips and feet.

Build on your structural sketch, drawing geometric shapes for each of the limbs. Link these at the joints using circles.

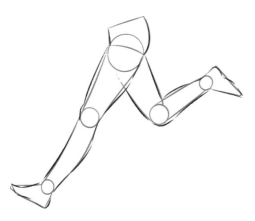

Use your guide to develop the shape of the legs to make them more realistic. They are working hard so their muscular make-up should be evident.

Continue to work on the outline, checking that the perspective is working. The side view means that one leg is partly obscured by the other.

Start to work on some of the finer details. Give more shape to the pelvic area and draw some feint lines to suggest muscles beneath the skin.

Add any final details – mark the ankle bones, for example – then go over your drawing in ink. Erase any unwanted pencil lines.

Use pencil to draw in the runner's shorts. These are tight-fitting and simply drawn using a couple of lines across the mid-thigh area.

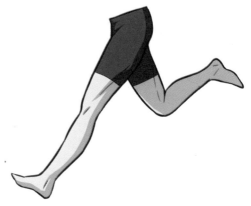

Colour your image. Choose a lifelike skin tone for a flat wash. Note the direction of light when adding darker tones.

JUMPING

With this example, it is important to try to capture the movement of the legs as they keep the jumping character off the ground. There will be tension in the leg muscles and both of the feet should be flexed.

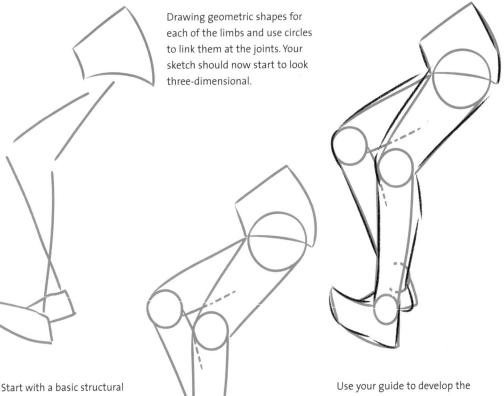

Drawing geometric shapes for each of the limbs and use circles to link them at the joints. Your sketch should now start to look three-dimensional.

Start with a basic structural sketch using pencil. Draw the legs as straight lines for now, and use geometric shapes for the hips and feet.

Use your guide to develop the shape of the legs to make them more realistic. The leg muscles are tense and the feet flexed.

Finish your initial sketch, giving more shape to the feet and defining each of the toes. Go over your drawing in ink. Erase any unwanted pencil lines.

Use pencil to draw in the character's shorts. These are tight-fitting and simply drawn using a couple of lines across the mid-thigh area.

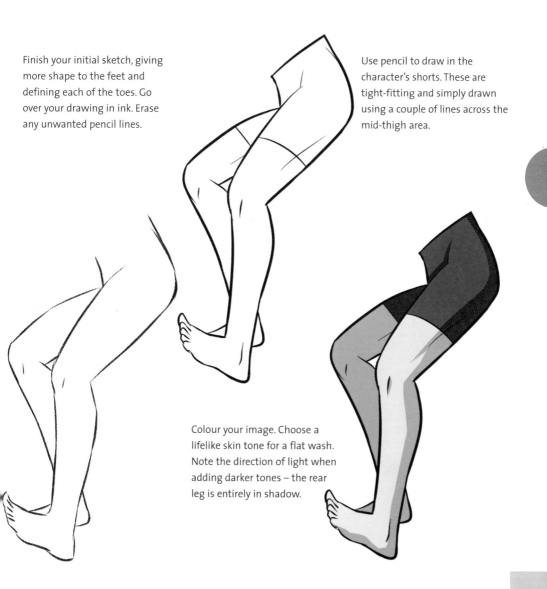

Colour your image. Choose a lifelike skin tone for a flat wash. Note the direction of light when adding darker tones – the rear leg is entirely in shadow.

CROSS-LEGGED ON THE FLOOR

This is a useful pose for adults and children alike. Bear in mind that it is more comfortable for younger characters, however, or those that are physically fitter.

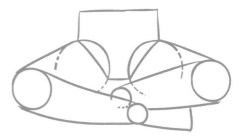

Start with a basic structural sketch using pencil. Draw straight lines as guides for the legs with simple geometric shapes for hips and feet.

Now draw the legs as simple geometric shapes, noting that the thighs are foreshortened here. Use circles for the joints.

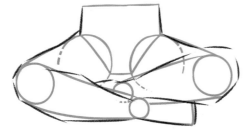

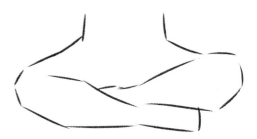

Use your guide to develop the shape of the legs to make them more realistic. These are quite muscular masculine legs.

Double check the proportions of the feet to the limbs and make sure you are happy with the perspective of your sketch.

Continue to work on the legs, adding lines that help suggest the skeletal and muscular make-up beneath the skin. Mark the thigh joints.

Add any final details – toes if they are visible – and go over your artwork using ink. Erase any unwanted pencil lines.

Use pencil to draw in the character's clothes. He is wearing a simple all-in-one. You need only draw an outline, which you can then go over in ink.

Colour your image. Choose a lifelike skin tone for a flat wash. Use a darker tone to emphasise the shapely muscles.

CROSS-LEGGED ON A CHAIR

Suitable for, say, an office or school environment, this cross-legged pose is more readily associated with female characters, although it can be used for any gender. The key to getting it right lies in considering the perspective carefully early on.

Start with a basic structural sketch using pencil. Draw straight lines as guides for the legs with simple geometric shapes for hips and feet.

Draw the legs as simple shapes, using circles for the joints that link them. Note that the crossed leg partially obscures the hips.

Use your guide to develop the shape of the legs to make them more realistic. This character is female, so the legs should be slender and shapely.

Work on your outline, making sure you are happy with the perspective. Pay particular attention to the receding lines of the crossed leg.

Colour your image. Choose a lifelike skin tone for a flat wash. Use a darker tone to emphasise those areas that are in shade.

Add any final details – a few lines to define muscles or toes if they are visible. Go over your artwork in ink and erase any unwanted pencil lines.

DANCING

This pose is not dissimilar to the running pose on pages 144–145. It is reasonably straightforward in that the legs are seen face on and so are easier to draw.

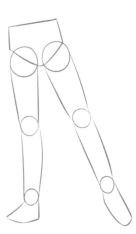

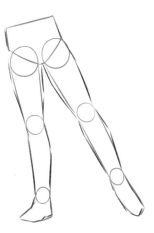

Start with a simple pencil sketch. Draw straight lines as guides for the legs, and geometric shapes for the hips and feet.

Draw the legs as geometric shapes now, linked at the joints by circles. Define the shapes of the feet better.

Use your guide to develop the shapes of the legs to make them more realistic. They are in tension and quite muscular.

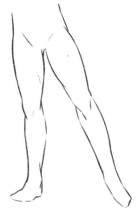

Build up the muscles. First define your outline to show the thigh and calf muscles in profile beneath the skin.

Define the fronts of the legs better. Draw some lines to suggest the knee caps. These will help emphasise the muscles.

Draw in the tops of the thighs where they meet the pelvis. Add a few feint lines mid-thigh to suggest taut muscles.

Add any finishing touches – ankle bones, say – then go over your work using ink. Erase any unwanted pencil lines.

Colour your image. Choose a lifelike skin tone for a flat wash. Use a darker tone in the areas that are in shadow.

Use pencil to draw in the dancer's shorts. They are tight-fitting. You need only draw an outline, which you can then go over using ink.

GALLERY

Here are a number of guides for drawing a range of different poses. The key to success is in getting the right proportions and perspective. As with other body parts, it is always a good idea to source a handful of visual references to help you.

rear view standing

right This is a pose you might use for someone standing leaning against a surface, helping to take the weight of the raised leg.

seated figure

below This character is sitting, perhaps halfway up a flight of stairs, with one foot resting on the step below.

walking

above A character walking, seen from the three-quarter view. You can adapt the foot front view on page 142 for drawing the feet.

skipping for joy

left This is quite a quirky, cheeky pose. Note the legs touching at the thighs and the lower limbs turned in.

crossed ankles

right This is an alternative to the crossed legs on a chair on page 150. Here the character is seen from a side view and the legs are crossed at the ankles.

playful

above Here the character is lying on her back with legs raised and bent at the knees. There is something playful in the pointed toes.

cycling

below This is the pose of a character pedalling a bike. When drawing images like this, you need to take care that the position of the bike works.

standing

below This character is standing with one foot on tiptoe. Seen from the front view, this is relatively easy to draw.

leaping

below This is the elegant pose of a girl leaping – perhaps in a dance studio or on an athletics field. Both feet are raised off the ground momentarily.

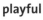

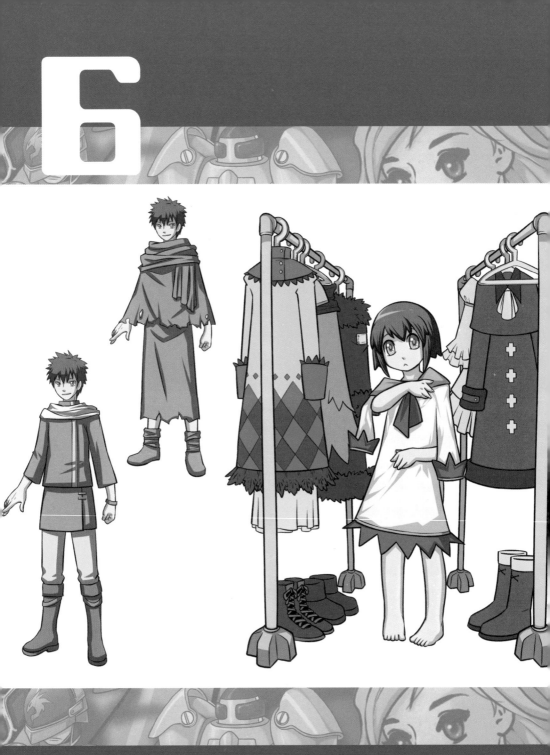

clothing

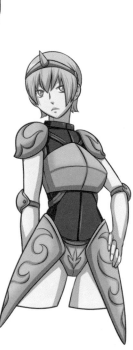

A character's clothing says a great deal about his or her personality. From the menacing mask of a medieval knight to the ditsy striped stockings of your friendly waitress, there are all sorts of ways to make manga characters individual. This section of the book looks at drawing clothing of all styles for both genders and offers advice on how to draw the diverse range of materials from which they are made.

FINDING INSPIRATION

Once you start to develop your stories, you will want to draw manga characters of all kinds. Some will be based on modern-day people, while others might be inspired by times gone by. No doubt you will also have fun exploring your very own vision of the future.

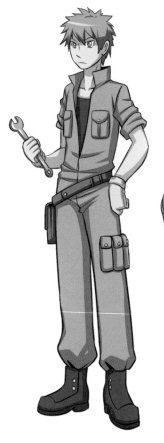

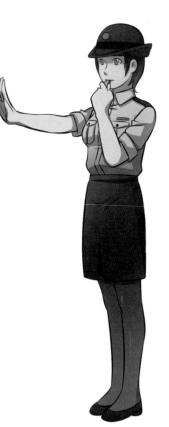

A young female police officer in a blue uniform. It helps to think of accessories that might go with a character's job – the hat and whistle, for example.

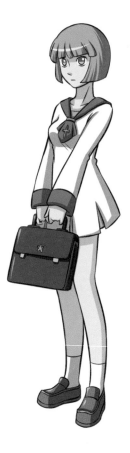

This character is a mechanic of some kind. Note that his protective boiler suit is practical, with handy pockets and is tucked into his boots. It is not a pretty colour – it doesn't need to be.

Always think about the age of the character you are designing clothes for. The short skirt of this Japanese school uniform might not work on an older girl.

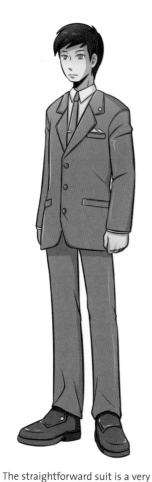

Search through books or the internet for examples of traditional costumes from across the world. Japanese kimonos, Spanish flamenco dresses and Indian saris can all form the basis of a character's outfit.

The straightforward suit is a very versatile outfit and can be adapted for a wide range of characters from professional male to evil schemer.

Think of the many careers that involve the wearing of a uniform from hotel staff, to firefighters and elaborate on them to make your own designs.

SEASONS AND MATERIALS

Before you start to draw an outfit, think carefully about what it is used for and what materials it should be made from. Consider seasonal variations, too, as these will have an impact on the design and weight of fabric.

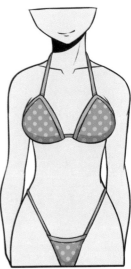

left In the hotter months, shirts and dresses tend to have short sleeves or no sleeves at all. Typical fabrics include light cottons, silks and Lycra.

right The many styles of swimsuit fall into two general groups: bikini and all-in-one. They tend to be made from Lycra and have fun, colourful designs.

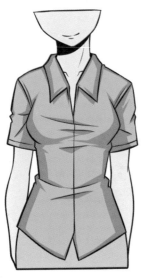

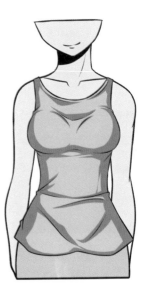

left Summer fabrics often cling to the natural curves of the body. Polyester tends to be stiffer than cotton or Lycra and so has sharp creases. Use thin inking lines to help capture the shape.

right Cotton and Lycra have soft creases that follow the natural shape of the body. You, also need to consider body shape when drawing in any shadows.

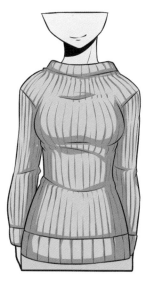

left Clothing for the colder months is usually made from thicker materials, such as wool and fur. They tend to have more interesting textures.

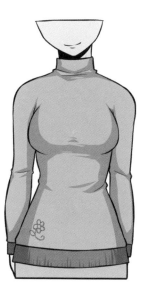

right Woollen garments tend to make the body look slightly fatter. Even though they follow the body shape, the natural curves are less well defined.

left Fur is a particular winter favourite and can be used to give clothing a soft trim around the hem- or neckline. It tends to have a single, massed shape.

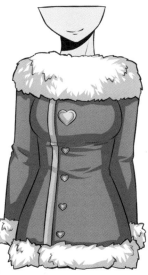

right Owing to their thickness, winter clothes tend to have fewer folds or drapes. Creases, when they do occur, are often soft and deep.

161

LYCRA SWIMSUIT

Lycra is used for the majority of swimwear and sportswear. It is light, quick-drying and has an elasticity that makes it ideal for such clothing. Probably the tightest-fitting fabric used for clothing, Lycra, follows the shape of the body, clinging to every curve.

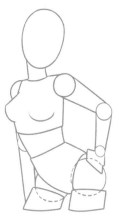

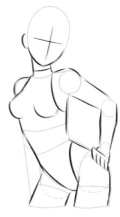

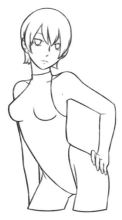

Draw a pencil outline of your figure, using a series of geometric shapes.

Use your pencil outline as a guide for drawing the swimsuit. Follow the shape of the body. Draw guides for facial features.

Draw the hair and facial features. Give shape to the arms, drawing any visible fingers. Add fine lines to suggest bone structure.

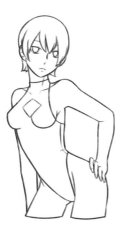

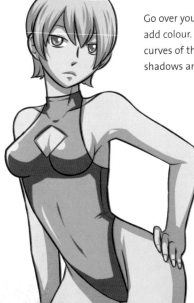

Go over your drawing in ink and add colour. Use the natural curves of the body to place soft shadows and highlights.

Add seams and decorative details to the swimsuit. Remember that Lycra is clingy, so do not lose the shape of the body beneath.

COTTON T-SHIRT

A wardrobe staple, the simple cotton T-shirt can be long and baggy or close-fitting and tight. It is one of the simplest garments to draw and can be adapted in so many ways – with embellishments, logos, trim – and in many colours.

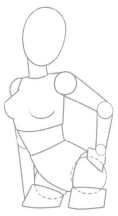

Draw a pencil outline of your figure, using a series of geometric shapes.

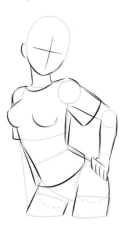

Use your pencil outline as a guide for drawing the T-shirt. Keep it loose at the sleeves and mid-rif. Draw facial guides.

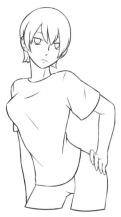

Draw the hair and facial features. Give shape to the arms and legs. Draw feint lines to suggest creases in the cotton fabric.

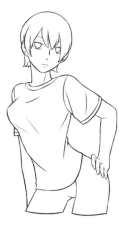

Add trim to the collar and sleeves to finish. Go over your drawing in ink and erase any unwanted pencil lines.

Colour your artwork. Use your crease lines to place shadows, giving shape to the body beneath the T-shirt.

POLYESTER SHIRT

Polyester is a more rigid fabric than Lycra or cotton, and so clothes made from it tend to have a stiffer quality. This makes it ideal for shirts for both men and women.

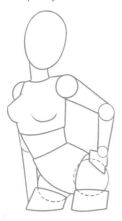

Draw a pencil outline of your figure, using a series of geometric shapes.

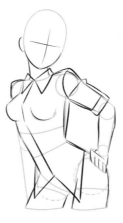

Use your pencil outline as a guide for drawing the shirt. Use short, stiff lines to capture the crisp fabric. Draw facial guides.

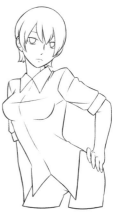

Draw the hair and facial features. Shape the arms and legs. Add lines to suggest creases in the fabric or where it is stretched.

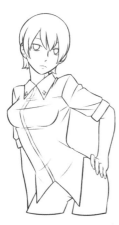

Go over your drawing in ink and erase any unwanted pencil lines. Add finishing touches, such as the front seam and sleeve trim.

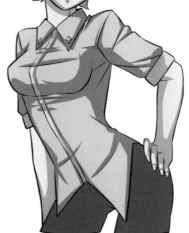

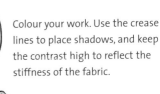

Colour your work. Use the crease lines to place shadows, and keep the contrast high to reflect the stiffness of the fabric.

SILK DRESS

Silk is a very light, smooth and luxuriant fabric. It has an almost fluid appearance as it ripples and sways with the slightest movement of the body.

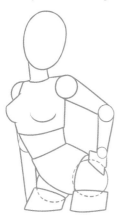

Draw a pencil outline of your figure, using a series of geometric shapes.

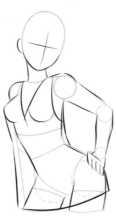

Sketch in the outline of the dress, using the minimum of lines to capture the smooth fabric. Draw in the facial guides.

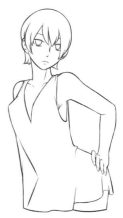

Draw the hair and facial features. Give shape to the arms, drawing any visible fingers. Add fine lines to suggest bone structure.

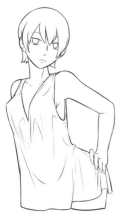

Go over your drawing in ink and erase any unwanted pencil. Add feint lines to suggest the many folds of this very fluid fabric.

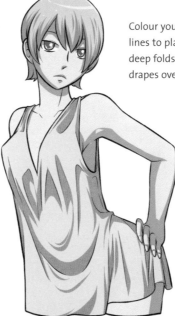

Colour your work. Use the crease lines to place shadows in the deep folds of the fabric as it drapes over the body.

DENIM JEANS

A popular choice for male and female characters of all ages, denim jeans can be long or short, skinny or baggy. You could also use this example for drawing leggings.

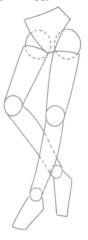

Draw a pencil outline of your figure, using a series of geometric shapes.

Use your pencil outline as a guide for drawing the jeans. These ones are skinny.

Start to add a few details – the zip, waistband and turnups, for example. Give shape to the feet.

Go over your drawing in ink, adding pockets and seams. Draw lines where the denim is creased.

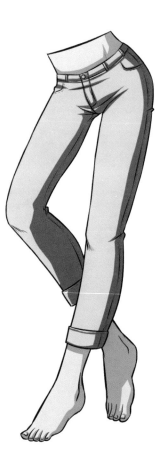

Colour your image. Use flat colour to render the matt quality of the denim. Keep shadows soft.

WOOL SWEATER

Woollen garments are heavier than those made from other fabrics and quite often hug the body. However, natural curves are less apparent on account of the thickness of the yarn.

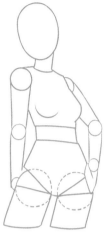

Start with a pencil outline of your figure, drawn using a series of geometric shapes.

Draw the outline of the sweater, keeping it close to your guides. Draw in the facial guides.

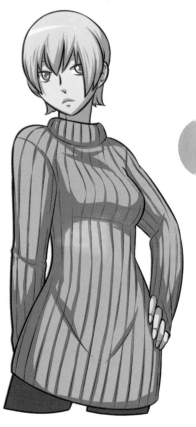

Draw the hair and facial features. Give more shape to the sweater, marking seams and creases.

Go over your drawing in ink, adding feint lines for the vertical ribbing and to define the bust.

Colour your work using soft, muted colours. Keep shadows to a minimum.

WOOL COAT

This project combines the stiff, heavy fabric of the wool coat, with a soft, fluffy fur trim. This version has a cape-like appearance and obscures much of the body beneath.

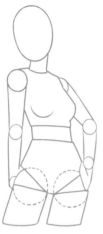

Draw a pencil outline of your figure, using a series of geometric shapes.

Draw the outline of the coat, keeping the shape very loose-fitting. Draw in the facial guides.

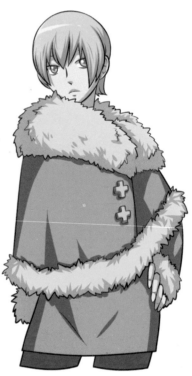

Add hair and facial features. Draw the fur trim, using short jagged lines to create texture.

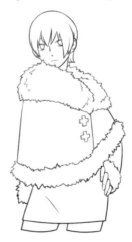

Go over your drawing in ink, adding final details, such as the buttons, and minimal creases.

Colour your work using soft, muted colours. Keep shadows to a minimum.

FUR COAT

Another wool coat with fur trim. The design is such that the coat is well-fitted, so defining the bust and waist. The fabric is stiff, with minimal creasing.

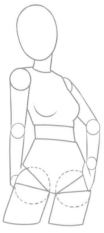

Draw a pencil outline of your figure, using a series of geometric shapes.

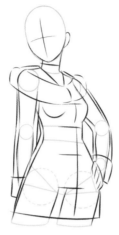

Draw the outline of the coat, keeping it close to your guides. Draw in the facial guides.

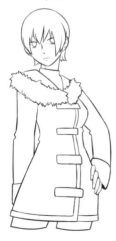

Draw the hair and facial features. Give more shape to the coat, adding decorative details.

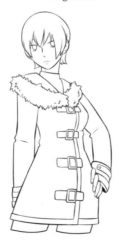

Go over your drawing in ink, adding final details, such as the buckles, and finish the fur.

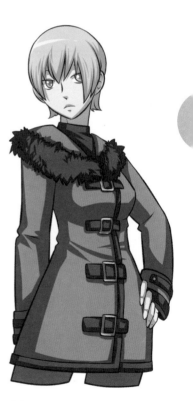

Colour your work using soft, muted colours. Use shadows to give more shape to the body.

METAL ARMOUR

Metal is a favourite for the more outlandish manga characters. Its shiny, rigid surfaces make it useful for all manner of wild designs.

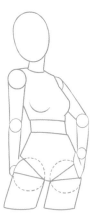

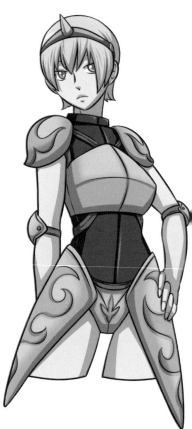

Draw a pencil outline of your figure, using a series of geometric shapes.

Draw the outline of the armour, bearing in mind its rigidity. Draw in the facial guides.

Add hair and facial features. Work on the armour, adding joints for separate metal plates.

Go over your drawing in ink, adding any final decorative details to the design.

Colour your work. The metal has a soft sheen. Use subtle changes of tone to reflect this.

DRAWING CREASES

Almost all clothing will have folds or creases. The only exceptions are Lycra and metal plate and, even then, you may have the odd wrinkle or riveted seam! Folds tend to be more evident, often deeper, in the lighter-weight fabrics, such as cotton and silk.

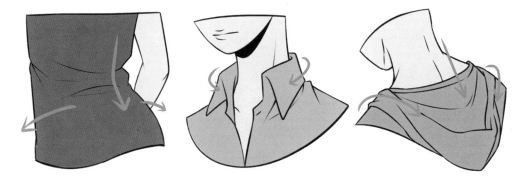

Tops often stretch across the bust and hips, but are looser around the waist. Here the creases form centrally down the back and out towards the sides.

Shirt collars and the tops of jumpers follow the natural curves of the neck and shoulder line. They crease where the straight fabric is forced to bend.

Softer fabrics will always crease in areas that are looser-hanging than others, like this hood. Here the pull is from the shoulders and down the centre of the back.

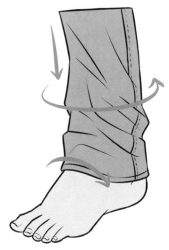

Trousers hang vertically from the knee and are looser around the foot area. Creases form where the material bunches.

Skirts and dresses follow the natural curves of the body, creasing where the fabric is looser.

GALLERY

Being able to draw clothes accurately is key to creating realistic-looking manga characters. It is important to consider the weight and texture of the fabric and the body shape of the wearer. The way in which the fabric has been used or is being worn is also significant.

pleated skirt
below Gathered and pleated fabrics, as used for this skirt, have creases and folds at regular intervals.

windswept jacket
right This character is riding a bike. See how his jacket flaps about, making numerous flowing folds as the fabric is caught by movement.

cotton T-shirt
below Cotton fabrics want to hang in a given direction and will crease when forced to hang differently – around arms and necks, for example.

leggings
below Lycra-based, leggings are naturally skin-tight, creasing only when joints are bent.

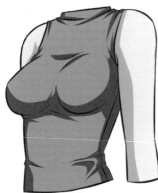

Lycra vest
above All of the body's natural curves are clearly defined owing to the clingy, stretchy nature of this fabric.

rolled sleeves

right All fabrics form loose bands when rolled or pushed up. Generally, the stiffer the fabric, the sharper the creases.

bent joints

above Creases always radiate from the centre of a bent elbow or knee, no matter what fabric.

ruffled skirt

left Complex, multilayered or gathered clothing will have a large number of folds. They may not all go in the same direction.

gathered top

above Grasped areas of fabric have loose folds radiating from a tight pinched centre.

hand in pocket

right A hand in a pocket often makes the pocket area stretch. Creases around the pocket help to emphasise this.

GIRL WEARING KIMONO

The kimono is a traditional form of dress in Japan, worn by both men and women. They are often made from exquisite fabrics with all manner of elaborate patterns.

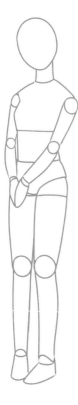

Use your outline as a guide for drawing the kimono. Use simple lines in order to achieve the basic shape of the garment.

Finalise the outline of the kimono and go over your whole artwork using ink.

Draw a pencil outline using a series of geometric shapes. Give the woman a stance in keeping with the style of her clothing.

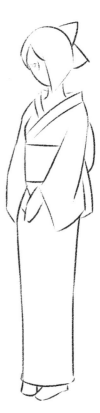

Give the character some hair and draw in the facial features. Begin to add detail to the kimono and draw the feet.

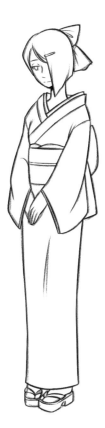

Consider where the lightweight fabric might be folded or creased, such as down the front of the skirt area. Draw a few lines for emphasis here.

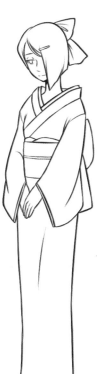

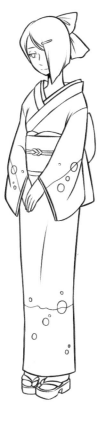

Colour your work. Pay particular attention to areas of light and shade, and use highlights to emphasise the folds.

Start to add detail. Draw in lines to show how the layers build up beneath the outer garment. Give more shape to the sash at the waist and draw in the shoes.

Add any final ink details, such as the pretty decorative elements in the fabric.

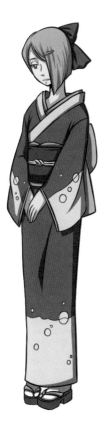

175

NINJA

Ninjas are extremely popular figures in manga art. Their characters are based on ancient Japanese warriors, whose activities were often clandestine. The clothing mysterious, while the pose is very masterful.

Use your outline as a guide for the clothing, keeping your lines simple. Draw in the protective leather shoulder pads.

Begin with a pencil outline using a series of geometric shapes. Give the man a stance in keeping with the nature of his character.

Give the character some hair and draw in the facial features. Begin to work more on the clothing, drawing in the metal plates on the sleeves.

Continue to add detail, bearing in mind the textures and weights of the various materials used. Draw in the long, sweeping scarf. Go over your work in ink.

Colour your work. Pay particular attention to the different materials and really try to capture the texture of the leather and metal elements.

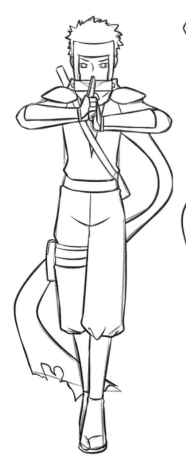

Finish your drawing. There is a lot of detail here. Draw in the shoes and bound legs. Work creases into the lightweight fabric.

COURT DRESS

This character is wearing clothes based on those worn by early 19th-century European royalty or aristocracy. The lines are elegant and feminine, yet maintain a rigid formality. It always helps to source pictures for any period of dress style on which to base your own designs.

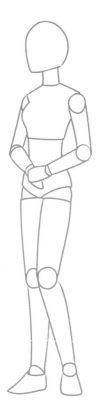

Use your outline as a guide for drawing the dress. Use simple lines to achieve the basic shape. The outfit is fitted above the waist and reaches the floor in terms of length.

Finalise your basic outline of the dress, drawing in the decorative border of the upper section.

Begin by drawing a pencil outline using simple geometric shapes. Give your character an elegant stance, in keeping with the style of her clothes.

Give your character some hair and draw in the facial features. Work a little more on the outline, drawing in the loose-fitting sleeves and shaped hemline.

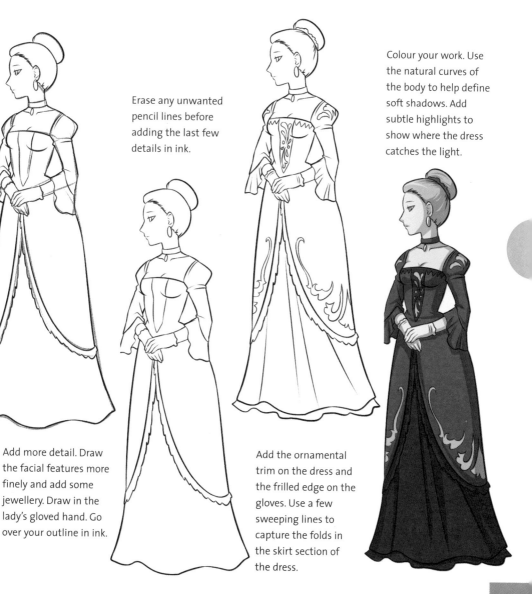

Erase any unwanted pencil lines before adding the last few details in ink.

Colour your work. Use the natural curves of the body to help define soft shadows. Add subtle highlights to show where the dress catches the light.

Add more detail. Draw the facial features more finely and add some jewellery. Draw in the lady's gloved hand. Go over your outline in ink.

Add the ornamental trim on the dress and the frilled edge on the gloves. Use a few sweeping lines to capture the folds in the skirt section of the dress.

COURT SUIT

This is a Western-style outfit, associated with royal courts and the nobility of early 19th-century Europe. The clothes complement those of the female court dress on the previous pages. They are characterised by an elegant formality.

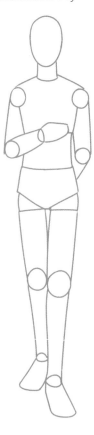

Use your outline as a guide for drawing the clothing. Use simple lines to achieve the basic shape of coat tails and breeches.

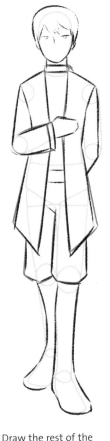

Finish the outline of the clothing and draw in the man's shoes.

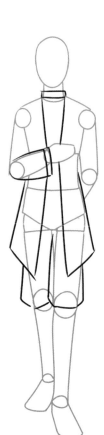

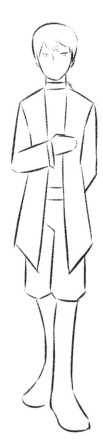

Begin by drawing a pencil outline using simple geometric shapes. Give the man a formal stance in keeping with the style of the clothing.

Draw the rest of the coat and the man's stockinged legs and feet. Give the character some hair and draw in the facial features.

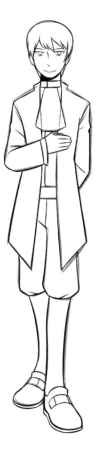

Erase any unwanted pencil lines before adding the last few details in ink.

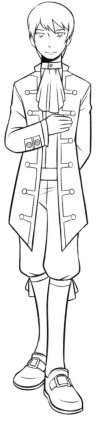

Colour your work, using sombre tones to reflect the formality of the clothing. Use highlights to show where the luxuriant materials catch the light.

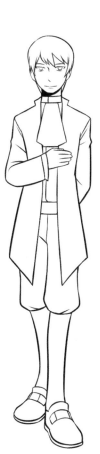

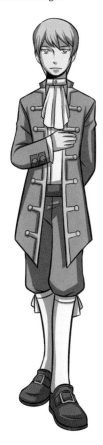

Start to add more detail. Draw in the outline of a cravat at the neck. Draw in some cuffs and buckles on the shoes. Go over your drawing in ink.

Add the decorative elements, such as the buttons on the shirt front and the trim of the jacket. Give more definition to the shoes.

ROMAN STOLA

This is a full-length, tunic-style garment in keeping with the traditional style of ancient Rome. It was the formal dress of wealthy women, the counterpart to the male toga. A hem of a different colour gave the impression of multi-layers.

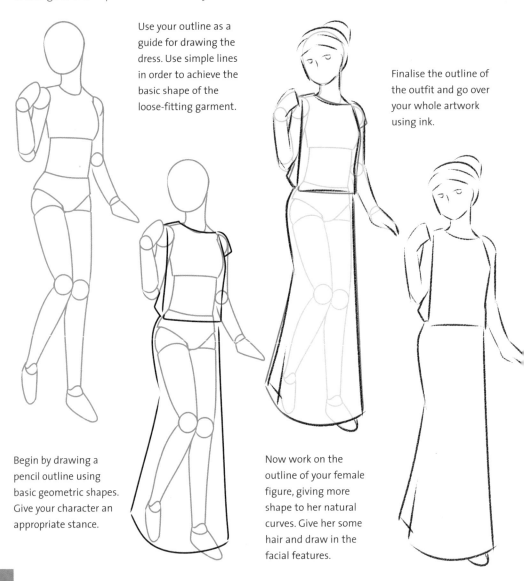

Use your outline as a guide for drawing the dress. Use simple lines in order to achieve the basic shape of the loose-fitting garment.

Finalise the outline of the outfit and go over your whole artwork using ink.

Begin by drawing a pencil outline using basic geometric shapes. Give your character an appropriate stance.

Now work on the outline of your female figure, giving more shape to her natural curves. Give her some hair and draw in the facial features.

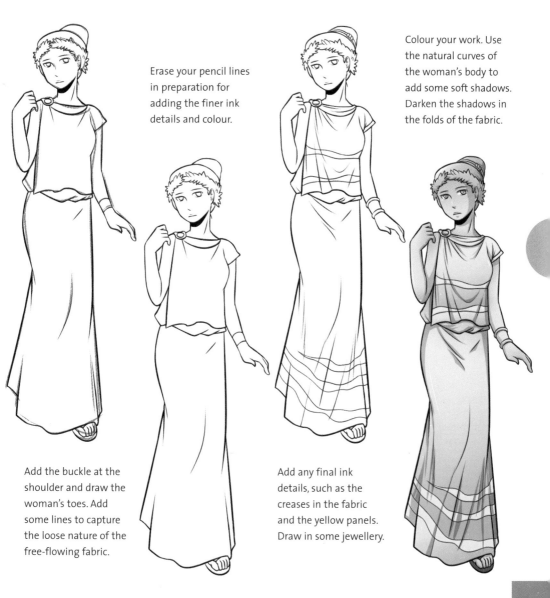

Erase your pencil lines in preparation for adding the finer ink details and colour.

Colour your work. Use the natural curves of the woman's body to add some soft shadows. Darken the shadows in the folds of the fabric.

Add the buckle at the shoulder and draw the woman's toes. Add some lines to capture the loose nature of the free-flowing fabric.

Add any final ink details, such as the creases in the fabric and the yellow panels. Draw in some jewellery.

JAPANESE SCHOOLGIRL

The traditional Japanese school uniform for girls is based on a sailor-suit design. There are many variations, but most of them feature a blue-and-white colour scheme. Japanese boys wear suits inspired by a Prussian military uniform.

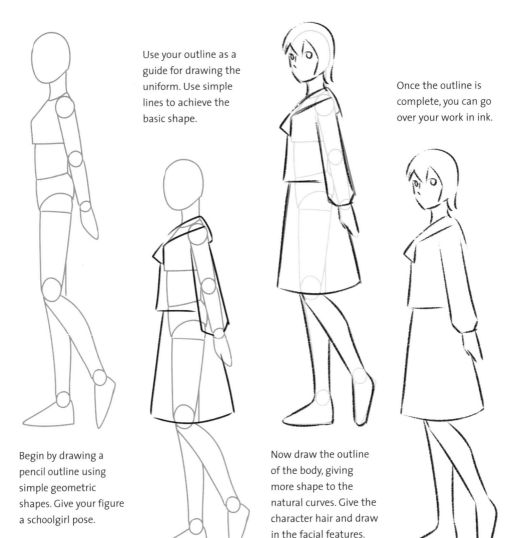

Use your outline as a guide for drawing the uniform. Use simple lines to achieve the basic shape.

Once the outline is complete, you can go over your work in ink.

Begin by drawing a pencil outline using simple geometric shapes. Give your figure a schoolgirl pose.

Now draw the outline of the body, giving more shape to the natural curves. Give the character hair and draw in the facial features.

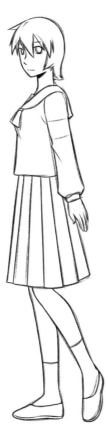

Erase your pencil lines in preparation for adding the finer ink details and colour.

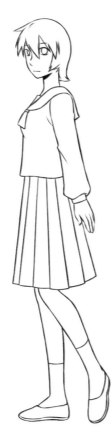

Colour your work. Add very soft shadows in the folds of the shirt, and stronger ones in the pleats of the skirt. Add subtle highlights.

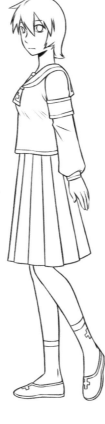

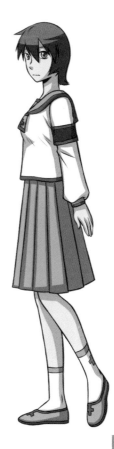

Draw in a crease to emphasise the loose, flowing nature of the sleeve. Give the skirt pleats. Add a sock line and draw the shoes.

Add final ink details, such as the short lines defining the bust area, extra creases in the sleeve and the stripe in the blue trim. Finish the shoes and socks.

ROCK MAN

This look is mostly associated with teenagers, and can be adapted for both boys and girls. You can have great fun with different hairstyles and colours (see pages 48–81). This young man has a dishevelled, punk-type haircut.

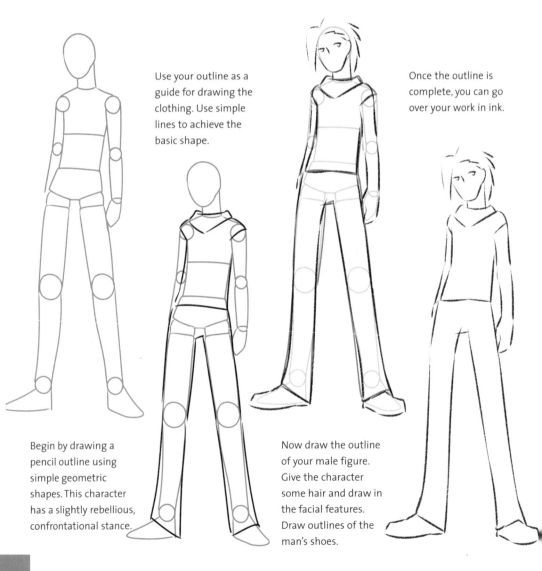

Use your outline as a guide for drawing the clothing. Use simple lines to achieve the basic shape.

Once the outline is complete, you can go over your work in ink.

Begin by drawing a pencil outline using simple geometric shapes. This character has a slightly rebellious, confrontational stance.

Now draw the outline of your male figure. Give the character some hair and draw in the facial features. Draw outlines of the man's shoes.

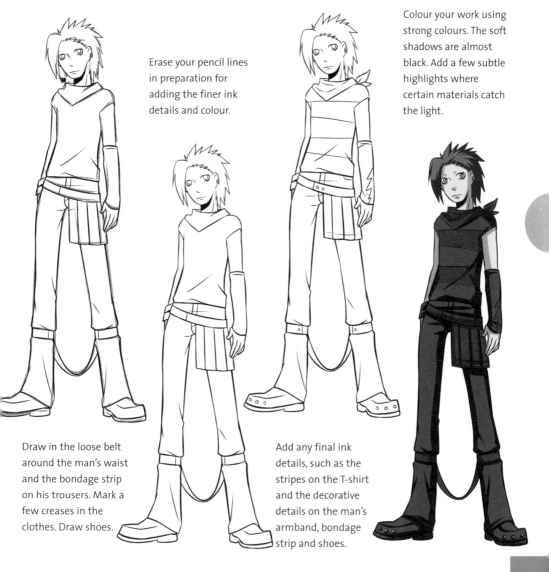

Erase your pencil lines in preparation for adding the finer ink details and colour.

Colour your work using strong colours. The soft shadows are almost black. Add a few subtle highlights where certain materials catch the light.

Draw in the loose belt around the man's waist and the bondage strip on his trousers. Mark a few creases in the clothes. Draw shoes.

Add any final ink details, such as the stripes on the T-shirt and the decorative details on the man's armband, bondage strip and shoes.

BUSINESS WOMAN

Clothing for the office environment tends to be more formal than everyday or weekend wear. This outfit has a matching skirt and blouse in muted colours. The clothes are fitted, so giving the character a smarter appearance.

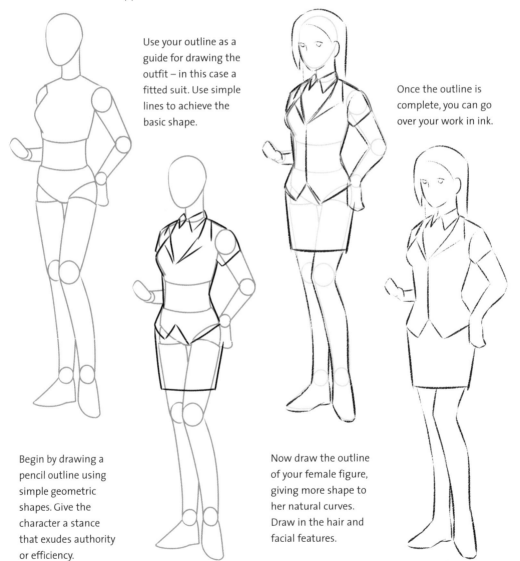

Use your outline as a guide for drawing the outfit – in this case a fitted suit. Use simple lines to achieve the basic shape.

Once the outline is complete, you can go over your work in ink.

Begin by drawing a pencil outline using simple geometric shapes. Give the character a stance that exudes authority or efficiency.

Now draw the outline of your female figure, giving more shape to her natural curves. Draw in the hair and facial features.

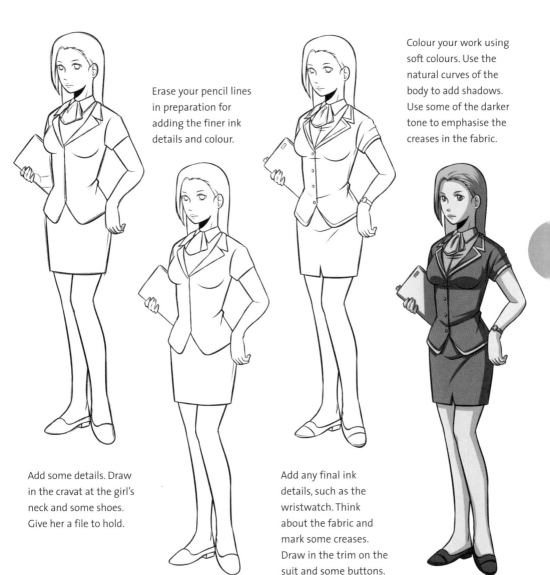

Erase your pencil lines in preparation for adding the finer ink details and colour.

Colour your work using soft colours. Use the natural curves of the body to add shadows. Use some of the darker tone to emphasise the creases in the fabric.

Add some details. Draw in the cravat at the girl's neck and some shoes. Give her a file to hold.

Add any final ink details, such as the wristwatch. Think about the fabric and mark some creases. Draw in the trim on the suit and some buttons.

CUTE GIRL

This character has a cute baby-doll look. She is clearly a teenager, but wears clothes and accessories associated with children. It is a popular look in manga art, but is only ever used for young female characters.

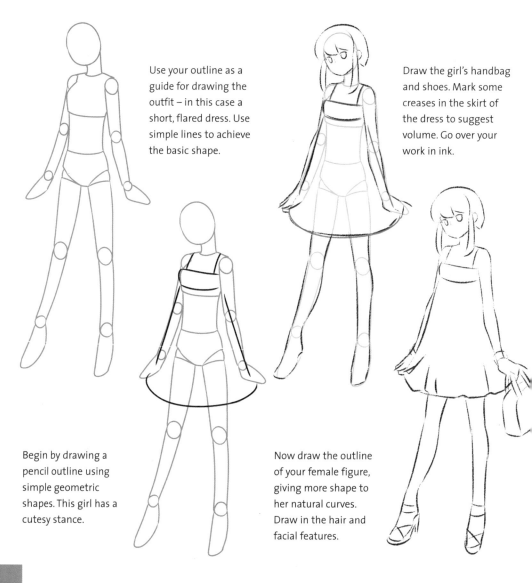

Use your outline as a guide for drawing the outfit – in this case a short, flared dress. Use simple lines to achieve the basic shape.

Draw the girl's handbag and shoes. Mark some creases in the skirt of the dress to suggest volume. Go over your work in ink.

Begin by drawing a pencil outline using simple geometric shapes. This girl has a cutesy stance.

Now draw the outline of your female figure, giving more shape to her natural curves. Draw in the hair and facial features.

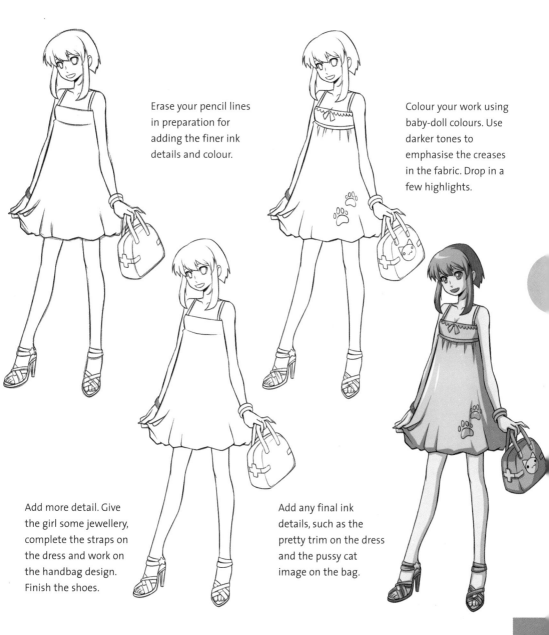

Erase your pencil lines in preparation for adding the finer ink details and colour.

Colour your work using baby-doll colours. Use darker tones to emphasise the creases in the fabric. Drop in a few highlights.

Add more detail. Give the girl some jewellery, complete the straps on the dress and work on the handbag design. Finish the shoes.

Add any final ink details, such as the pretty trim on the dress and the pussy cat image on the bag.

191

HIP-HOP BOY

This is a great look for the streetwise teenager – the slouchy hoodie and flared jeans of the hip-hop generation. You can easily adapt the clothes for a female character, but the look is best used for young adults and not older ones.

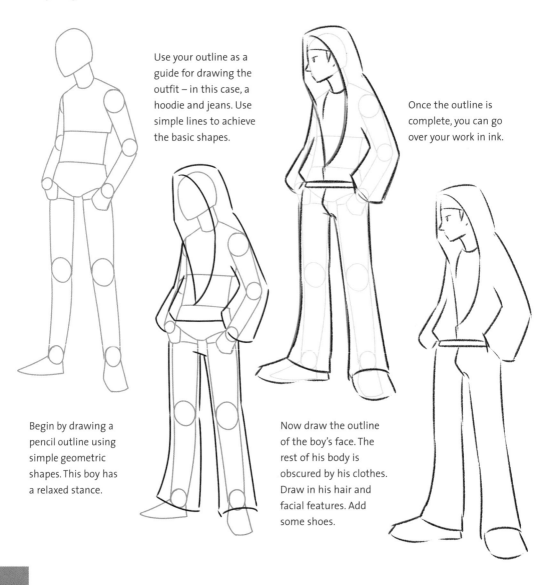

Use your outline as a guide for drawing the outfit – in this case, a hoodie and jeans. Use simple lines to achieve the basic shapes.

Once the outline is complete, you can go over your work in ink.

Begin by drawing a pencil outline using simple geometric shapes. This boy has a relaxed stance.

Now draw the outline of the boy's face. The rest of his body is obscured by his clothes. Draw in his hair and facial features. Add some shoes.

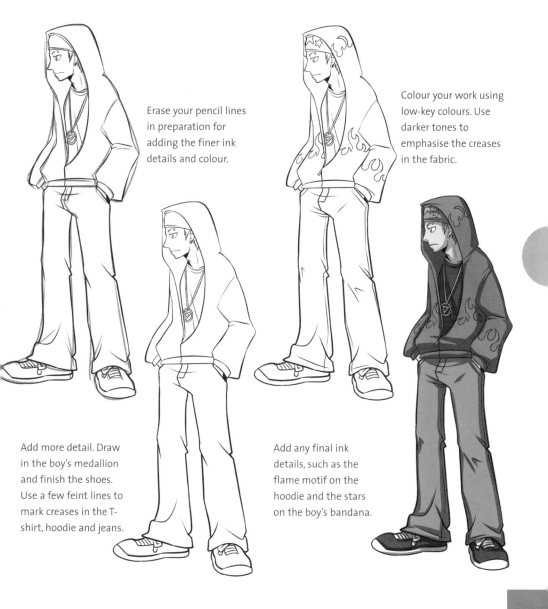

Erase your pencil lines in preparation for adding the finer ink details and colour.

Colour your work using low-key colours. Use darker tones to emphasise the creases in the fabric.

Add more detail. Draw in the boy's medallion and finish the shoes. Use a few feint lines to mark creases in the T-shirt, hoodie and jeans.

Add any final ink details, such as the flame motif on the hoodie and the stars on the boy's bandana.

WAITRESS

This American-diner-style waitress has a surreal quality to her character, with her impossibly short skirt, laced bodice and long, stockinged legs. She is a perfect example of how manga art allows you to blur the lines between reality and fantasy.

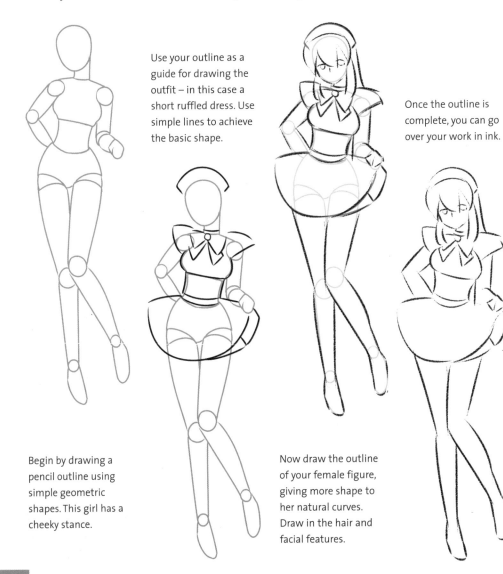

Use your outline as a guide for drawing the outfit – in this case a short ruffled dress. Use simple lines to achieve the basic shape.

Once the outline is complete, you can go over your work in ink.

Begin by drawing a pencil outline using simple geometric shapes. This girl has a cheeky stance.

Now draw the outline of your female figure, giving more shape to her natural curves. Draw in the hair and facial features.

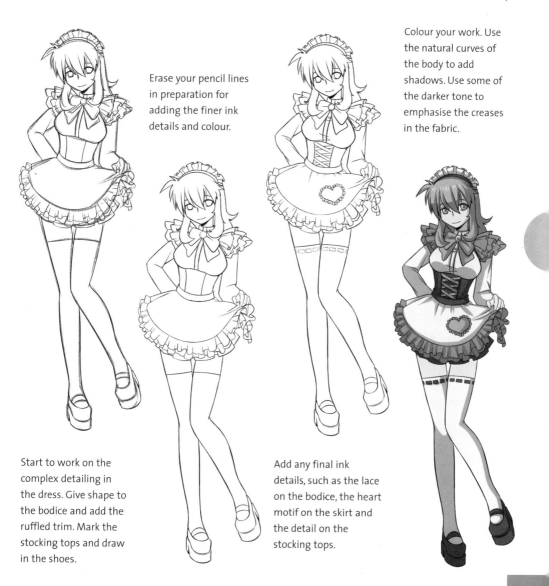

Erase your pencil lines in preparation for adding the finer ink details and colour.

Colour your work. Use the natural curves of the body to add shadows. Use some of the darker tone to emphasise the creases in the fabric.

Start to work on the complex detailing in the dress. Give shape to the bodice and add the ruffled trim. Mark the stocking tops and draw in the shoes.

Add any final ink details, such as the lace on the bodice, the heart motif on the skirt and the detail on the stocking tops.

PIRATE

This character has a great other-worldly quality. Dressed as a pirate, complete with cutlass, this is a genuine tom-boy and not just a case of dressing up. You could adapt the look for a Robin Hood type character with a bow and arrow.

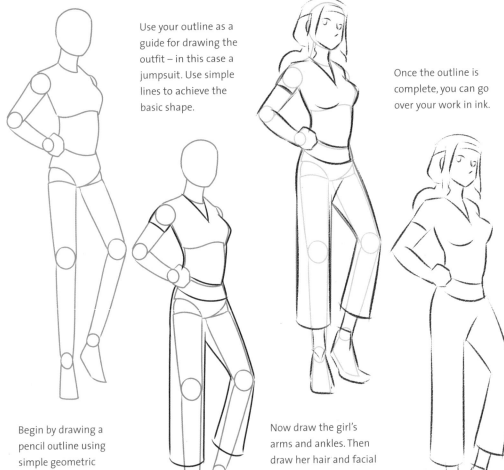

Use your outline as a guide for drawing the outfit – in this case a jumpsuit. Use simple lines to achieve the basic shape.

Once the outline is complete, you can go over your work in ink.

Begin by drawing a pencil outline using simple geometric shapes. This girl has a defiant stance.

Now draw the girl's arms and ankles. Then draw her hair and facial features. Add outlines for the leather boots.

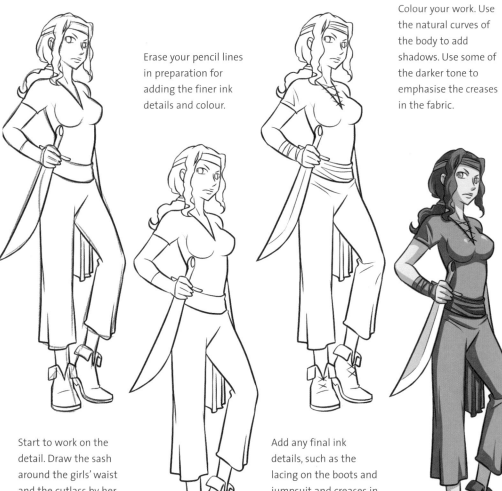

Erase your pencil lines in preparation for adding the finer ink details and colour.

Colour your work. Use the natural curves of the body to add shadows. Use some of the darker tone to emphasise the creases in the fabric.

Start to work on the detail. Draw the sash around the girls' waist and the cutlass by her side. Give more shape to the boots.

Add any final ink details, such as the lacing on the boots and jumpsuit and creases in the lightweight jumpsuit fabric. Finish the sash and headband.

POLICEMAN

Police uniforms differ from country to country, so there are plenty of examples to base your designs on. You can also adapt this outfit to suit a wider range of uniforms, for example, for a military character, a park keeper or a hotel valet.

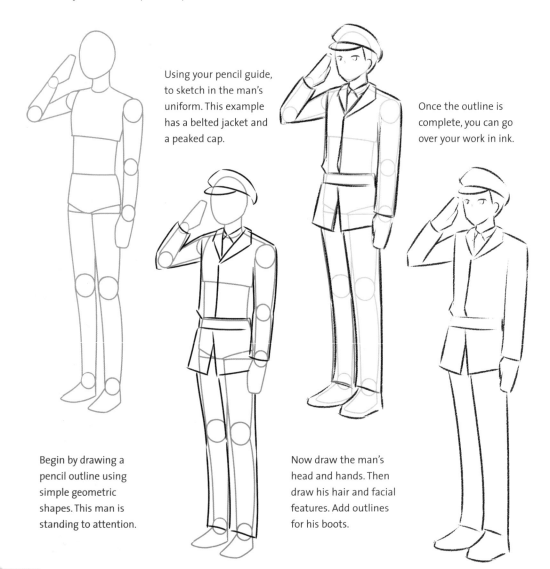

Using your pencil guide, to sketch in the man's uniform. This example has a belted jacket and a peaked cap.

Once the outline is complete, you can go over your work in ink.

Begin by drawing a pencil outline using simple geometric shapes. This man is standing to attention.

Now draw the man's head and hands. Then draw his hair and facial features. Add outlines for his boots.

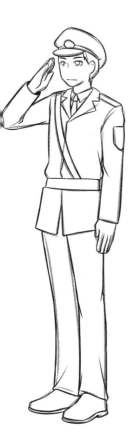

Erase your pencil lines in preparation for adding the finer ink details and colour.

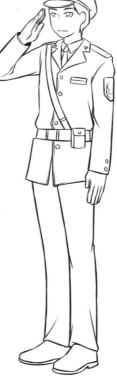

Colour your work, using a flat, dark colour. The shadows in the creases will be black. Use highlights to show where the uniform catches the light.

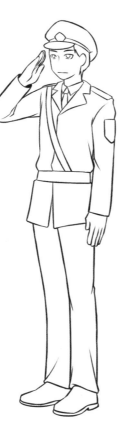

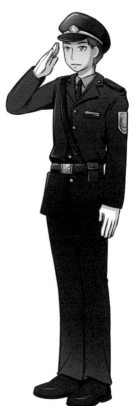

Work on the finer details now – the creases in the man's jacket and trousers, the badge on his arm and the belt across his chest Finish the boots.

Add any final ink details, such as the buttons on his jacket, seams on his gloves and pouch on his belt.

NURSE

Like the police uniform on page 198–199, nurse uniforms differ from country to country, so do a little research to find a design you like. Adapt this example to design uniforms for other characters, for example, a woman from a religious order or a schoolgirl.

Using your pencil guide, to sketch in the uniform. This example has a simple knee-length coat and hat.

Once the outline is complete, you can go over your work in ink.

Begin by drawing a pencil outline using simple geometric shapes. This woman has a benign stance.

Now draw the outline of your female figure, giving more shape to her natural curves. Draw in the hair and facial features.

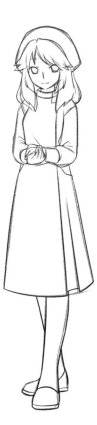

Erase your pencil lines in preparation for adding the finer ink details and colour.

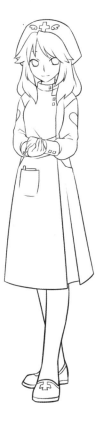

Colour your work using soft colours. Use the natural curves of the body to add shadows. Use some of the darker tone to emphasise the creases in the fabric.

Work on the finer details now – the front seam of the coat and pleated detail. Give more shape to the sleeves and add shoes.

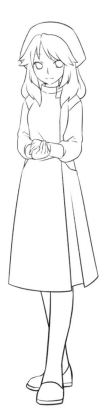

Add any final ink details, such as the decorative elements on the hat and shoes and the pocket on the coat.

FANTASY SOLDIER

There is no end of fun you can have in creating fantasy figures like this and the sci-fi bounty hunter on the following pages. This outfit combines fabrics with metal finishes. Take care in making each material look realistic.

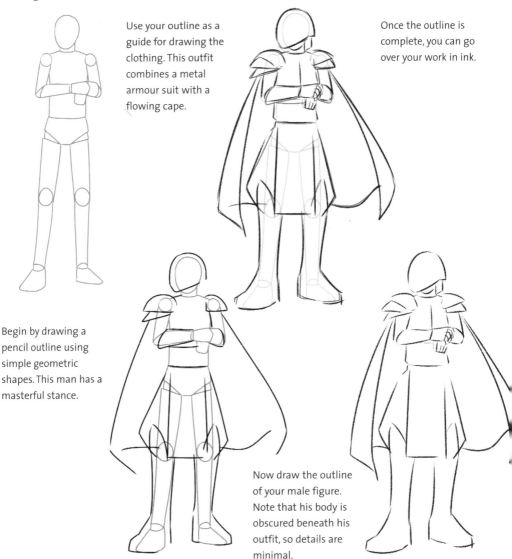

Use your outline as a guide for drawing the clothing. This outfit combines a metal armour suit with a flowing cape.

Once the outline is complete, you can go over your work in ink.

Begin by drawing a pencil outline using simple geometric shapes. This man has a masterful stance.

Now draw the outline of your male figure. Note that his body is obscured beneath his outfit, so details are minimal.

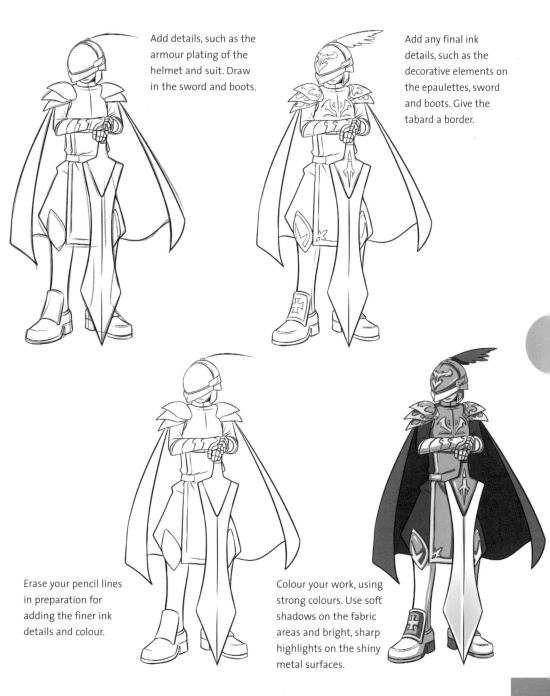

Add details, such as the armour plating of the helmet and suit. Draw in the sword and boots.

Add any final ink details, such as the decorative elements on the epaulettes, sword and boots. Give the tabard a border.

Erase your pencil lines in preparation for adding the finer ink details and colour.

Colour your work, using strong colours. Use soft shadows on the fabric areas and bright, sharp highlights on the shiny metal surfaces.

SCI-FI BOUNTY HUNTER

This character epitomises the departure from reality to fantasy. With no visible facial features and a curious breathing apparatus he has a menacing air about him. The toughness of his character is reflected in the hard materials used for his protective suit.

Use your outline as a guide for drawing the clothing. This protective suit combines metal plate with durable and flexible rubber.

Once the outline is complete, you can go over your work in ink.

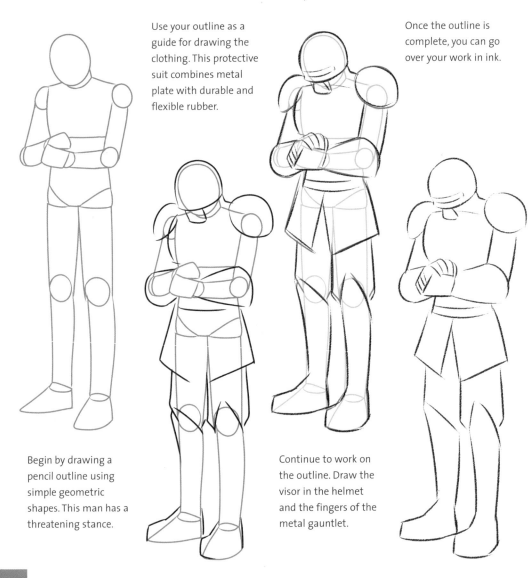

Begin by drawing a pencil outline using simple geometric shapes. This man has a threatening stance.

Continue to work on the outline. Draw the visor in the helmet and the fingers of the metal gauntlet.

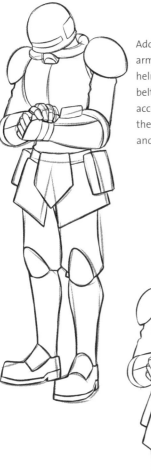

Add details, such as the armour plating of the helmet suit and the belt with all of its accessories. Draw in the tube for breathing and the boots.

Add any final ink details, such as the shading on the metal, the insignia on the armour and stiff creases in the rubber sleeves.

Erase your pencil lines in preparation for adding the finer ink details and colour.

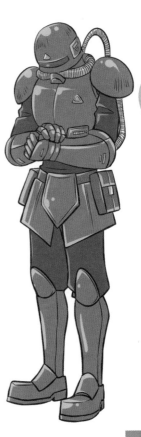

Colour your work, using sinister colours. Use bright, sharp highlights to show how the metal surfaces catch the light.

FAIRY GIRL

This wonderful fantasy character combines a short, fitted dress and long, stockinged legs with a full-flowing, jewel-encrusted cape. The look is light and airy, in keeping with her kindly nature. You could easily adapt the colours and hairstyle to create a malevolent version.

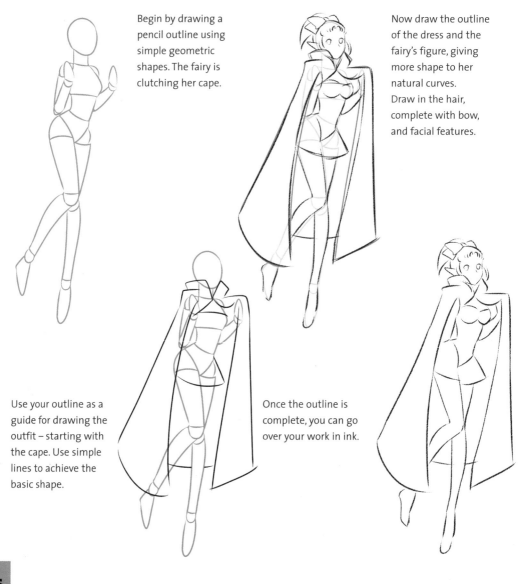

Begin by drawing a pencil outline using simple geometric shapes. The fairy is clutching her cape.

Now draw the outline of the dress and the fairy's figure, giving more shape to her natural curves. Draw in the hair, complete with bow, and facial features.

Use your outline as a guide for drawing the outfit – starting with the cape. Use simple lines to achieve the basic shape.

Once the outline is complete, you can go over your work in ink.

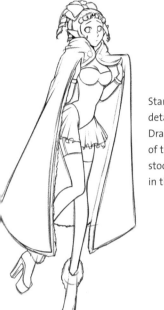

Start to work more detail into the hair. Draw the ruffled skirt of the dress. Mark the stocking tops and draw in the shoes.

Add any final ink details, such as the stitching on the bodice of the dress, and finish the jewels.

Work on the cape, adding outlines of the jewels. Finish the shoes Erase your pencil lines in preparation for adding the finer ink details and colour.

Colour your work. Use the natural curves of the body to add shadows. Work at getting the texture of the cloak's fur lining and fluffy boot trim.

GALLERY

When it comes to designing clothing, you can really use your imagination to draw a huge range of outfits. And there is no lack of source material. Just take a look at native costumes from around the world or the latest fashions and you will be inspired.

woodland boy

right The basic cut of the clothes and their earthy colours are fitting for a simple life in a small woodland or rural community.

streetwise

below The urban fashionista. Note the high collar and deep cuffs of the shirt with the double belt worn over the top.

futuristic

right The practical yet other-worldly uniform of a spaceship crew member, complete with cape and elbow-length armbands.

medieval

right The outfit of a workhand at a medieval castle. It has simple lines and is worn with bound legs and handmade boots.

young pup

right A playful looking outfit. The T-shirt worn over the shirt and the massive boots worn with knee-length shorts give a certain mismatched look.

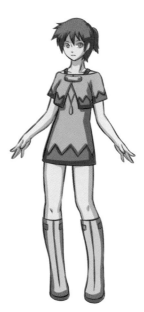

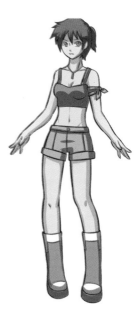

schoolgirl

below This is an alternative version of the school uniform seen on pages 184–185. This is a slightly less formal example.

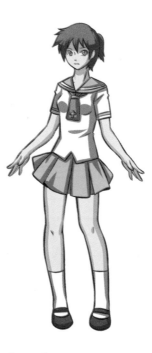

native American

above This outfit has a zigzag pattern inspired by native American costume.

crop top and shorts

above The streetwise look of a girl who knows her style. She wears a fitted crop top and shorts with chunky boots.

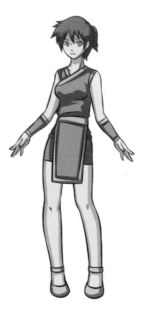

sloppy jumper

right The ditsy look of this sloppy jumper is echoed in the one up, one down stripy tights.

ancient world

left The simple lines and apron front of this outfit were inspired by clothing once worn in ancient Rome and Greece.

GALLERY

You can have tremendous fun working on clothing ideas for your characters. Think about suitable textures and colours, as these often determine whether or not an outfit is successful. Put some thought into appropriate accessories, too.

countryman

right The smart outfit of a member of a medieval land-owning family. The clothing is made from soft fabrics in natural colours.

operator

below The protective overall and gloves of a workshop employee. This outfit has a certain fantasy element to it.

smart suit

right A snappy single-breasted suit. The good quality of the matt black material lends the suit an elegance.

mechanic

right The protective jumpsuit of a car mechanic or factory operator. Highly practical, the zip-up outfit tucks into heavy, head-wearing boots.

waif

right A young man who has fallen on hard times in an outfit that he has fashioned from sacking. It is tattered and torn.

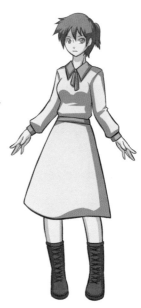

fancy dress

below A great-fun outfit for Halloween, this costume combines a host of motifs from the devil's horns and tail to batwings and a pumpkin.

theatrical cat

above An outfit for a school play or a fancy-dress party, this girl is dressed in a huge cat costume. Note the texture of the fur.

country girl

above The simple dress of a little country girl, married with durable leather boots.

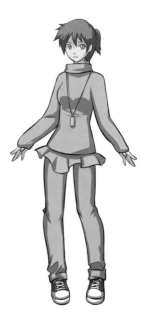

girl next door

right This outfit has a thrown-together look to it, reminiscent of teenagers at the weekend.

disco diva

left This sassy character is dressed to party with thigh-length stockings, crop top and skimpy shorts.

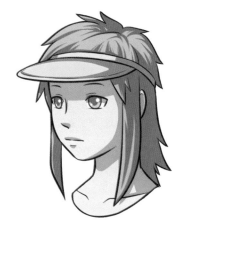

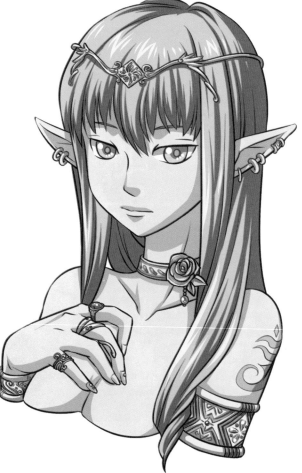

accessories

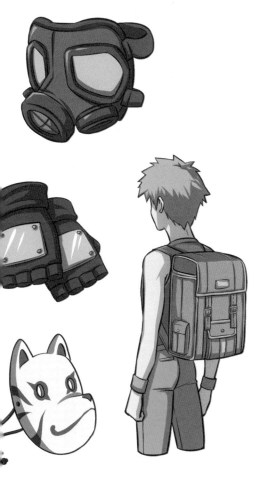

Quite often, a character will be made by his or her accessories – a disco diva and her plugged in headphones, the policeman and his whistle, the skateboarder and his bandanna. This section of the book offers a small selection of accessories, including hats, bags and scarves. There are step instructions for drawing a few of them, as well as advice on how to adapt almost any kind of accessory to suit the characters you want to create.

SUN VISOR

This is a very simple design – simply the peak of a baseball cap on a strap. You can adapt it to suit a wide range of characters from sun-seeker to dubious dude.

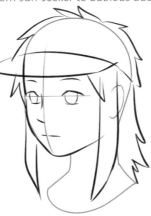

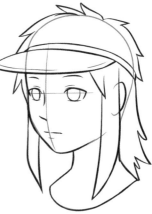

Use pencil to draw your basic oval shape, with three-quarter view guidelines. Draw in your character's facial features.

Sketch in an outline of the hair – in this case long and shaggy. Draw in the visor, making sure you get the perspective right.

Now draw in the headband. Note how it disappears beneath the hair towards the rear. Draw in the girl's neck and ear.

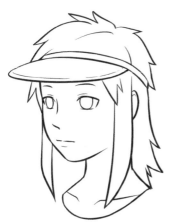

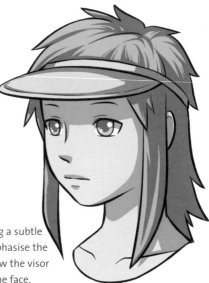

Add any final details – a few lines to define the crown of the head and shaping to the girl's neck. Go over your artwork in ink.

Colour your work using a subtle change in tone to emphasise the shaded areas. Note how the visor casts a shadow over the face.

BASEBALL CAP

The baseball cap is a wardrobe staple for boys and young men, although it may also be worn by girls. You can adapt the steps to draw the hat worn back to front.

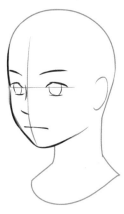

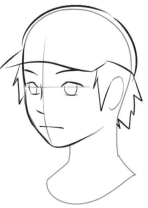

Use pencil to draw your basic oval shape, with three-quarter view guidelines. Draw in your character's facial features.

Sketch in an outline of the cap and hair. Note how the cap follows the oval guide closely and extends out over the eyes.

Draw in the stitching lines on the cap. This will help to make the image look three-dimensional. Draw in the neck and ear.

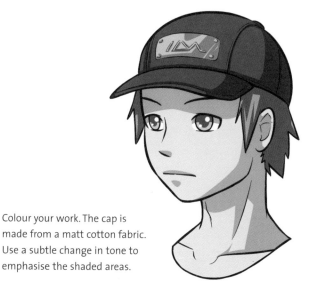

Add any final details, such as the badge on the cap and the shaping to the boy's neck. Go over your artwork in ink.

Colour your work. The cap is made from a matt cotton fabric. Use a subtle change in tone to emphasise the shaded areas.

BACKPACK

The trusty backpack is a manga favourite, used by young and old alike. Although this version is practical and compact, you can use the steps to design any backpack you like, from a fun and fluffy animal-shaped one for kids to the heavy-duty sort used by the military.

Start by drawing a pencil outline of your figure using basic geometric shapes. This man is viewed from the rear. Build on your outline to sketch the man and backpack more fully.

Add any final details – a little more texture in the hair, fine stitching on the backpack, creases in the clothing – before going over your artwork in ink.

Consider the size of the backpack and make sure it fits your characters proportions. Work on the details, drawing in the many pockets and straps.

Colour your work using appropriate shades. Use subtle tones to capture the changes from light to dark.

WOOLLY SCARF

The scarf is a popular winter accessory and is usually made from a soft knit. There are various ways to wear them – tied loosely at the neck, wrapped around once or twice or simply draped around the shoulders.

Start by drawing a pencil outline of your figure using basic geometric shapes. Build on your outline to sketch the girl in more detail, adding hair and facial features.

Give more shape to the scarf, marking crease lines where it folds and drawing the individual tassels at the ends. Go over your work in ink.

Draw in the girl's clothes, adding an outline of the scarf. In this case it is wrapped around the neck with the ends hanging loose.

Colour your work. This scarf is a mid-blue. Use the creases as guides for adding some soft shadows in the folds.

GALLERY

Accessories can be invaluable when it comes to giving a character personality, particularly once you start to develop stories around your creations. By giving your characters accessories, you make them stand out more from one another.

centurion's helmet
below Modelled on those of ancient Greece and Rome, this is a fantastic helmet with wing motif and visor.

gas mask
below Gas masks always have a sinister air to them. This could be adapted to create many other mask designs.

knight's helmet
above Based on medieval versions of the knight's helmet, this is a simple design with useful visor.

dandy's hat
below A stylish and shapely felt hat with jewel and fur decoration. This could be worn by a male or female character and coloured accordingly.

goggles
below Goggles offer a good accessory for a number of sports such as swimming, flying, skiing and motorcycling.

cat's ears
above A headband fashioned as a cat's ears, this is a great design for fancy-dress and can be adapted to suit any occasion.

little bag

above This handbag might be suitable for ladies' eveningwear. It is small, compact and very easy to carry.

witch's hat

above All tattered and torn, this is the ultimate accessory for a gnarled old witch.

glasses

above Glasses are a surprisingly useful accessory. This model could be adapted endlessly.

backpack

above This design is in keeping with the sort seen used by European schoolchildren. It is both robust and practical.

day bag

above This is a design that could be drawn in any colour and with any motif. Its a great bag for everyday use.

beanie hat

above This style of hat can be worn by girls and boys. You could also adapt it to serve as part of a uniform.

summer shade

above A girl's simple summer bonnet, with a bright ribbon and a pretty bow. It could form part of a school uniform.

bowler

right A jolly bowler in a custard colour and with a feather tucked into the hatband.

GALLERY

Almost all of the accessories in this section of the book can be adapted to suit a wide range of characters. That is what makes them so versatile. Imagine changing the colour or pattern of a piece to suit a character you have in mind.

buckle bracelet

right A cool strap-like bracelet with a buckle fastening. This design, with its dark muted colours, might appeal to a punk character.

leather cap

below Though modelled on the baseball cap, this leather cap has more style.

drawstring bag

below A lightweight fabric tote bag with decorative patches and a drawstring. This is a very versatile design.

head phone set

above This is the sort of accessory you might see on an inline skater waitress or a DJ in a busy nightclub.

cat bracelet

below An elasticated bracelet threaded with cutesy little cat beads. Ideal for a schoolgirl character or chibi.

cat necklace

left A pretty necklace with cutesy cat bead threaded on a leather thong.

cat earrings

right Simple little dangly earrings threaded with cat beads to match the necklace and bracelet.

cross earring

below A simple enamelled cross attached to a hoop earring. This is the sort that might be worn singly by a teenage boy or girl.

neckerchief

above This is a design that can be worn by virtually any character and can be drawn to suit any style from hip-hop to punk to Wild West.

cat mask

above Masks are great accessories for manga characters, helping to conjure up an air of mystique. They can be benign or intimidating.

woolly scarf

above Easy to draw, the woolly scarf can be patterned or plain and may be worn by any kind of manga character.

workmen's gloves

above Gloves are useful for characters in winter outfits, but also suit a wide range of professions – firefighters, manual labourers, doctors.

plastic bangles

right Simple round bangles can be drawn in all colours and patterns. They can be studded with jewels and beads.

shell necklace

above A simple necklace with pretty shells threaded on a leather thong.

animals

Manga art is bursting with wonderful creatures of all shapes and sizes. Some of them are realistic, and capture the true likeness of creatures we see in this world. Others are weird and wild creations of a vivid imagination, often loaded with symbolism. In this section of the book are some great examples of manga animals, from scaly serpents to timid bunnies with instructions on how to draw them.

ANIMAL COMPARISON

Animals feature widely in manga art. Sometimes they are imbued with symbolism or have secret powers. Just as with manga people, they can be realistic or fantasy forms.

below This is quite a realistic interpretation of a kitten. It is small and cute-looking with lots of thick, soft fur. Typically the eyes are big and round, like those of manga children.

above A made-up chibi creature, resembling something between a hamster and a fat cat. The small eyes and limbs give this creature a benign appearance.

left A fluffy ambiguous creature. Somewhere between reality and fantasy, this is still quite cat-like. It has a tiny body, but huge head with big black eyes and perky pointed ears.

left A realistic representation of a sabre-toothed tiger. Mythical and extinct animals like this are a great source of inspiration for manga art, adding an element of other-worldiness and mystery.

right This creature is pure fantasy. Based on the wildcat form it has oversized rear limbs, spiked horns and vicious-looking teeth and claws. This is a beast set to intimidate even the hardiest of opponents.

CUTE DOG

This is a friendly, cuddly puppy. He looks cute, because his proportions are slightly exaggerated. His head and body are large compared with his legs and his tail has a comical curl to it. Facially, the dog appears to be smiling, tongue out and ready to please.

Start with a rough structure for your dog, using pencil. Draw the body as a series of geometric shapes. Add guides for positioning the facial features.

Use your structural guide to draw the dog's outline. Keep the legs and ears short and the head large. Make sure the perspective looks right.

Develop your outline. Give shape to the tail, curling it up and over the dog's back. Draw the legs, paying attention to their relative shapes and perspective.

 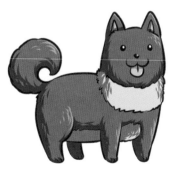

Draw the dog's facial features and finish the tail. Go over your artwork in ink and erase any unwanted pencil lines.

Mark out the areas of different coloured fur, and fluff up the tail. Define the dog's paws and finish off his ears. Finally, draw in that sticking-out tongue.

Add colour. Use flat colour to emphasise the fullness of the dog's body. Pick out just a few areas of shade, plus highlights on the legs, tail and head.

REALISTIC DOG

There are a number of differences between this dog and the cute version opposite. Primarily, this dog is well-proportioned and lean. His strong muscular legs give the impression that he might be a working dog. The structure of his head and face is more accurate.

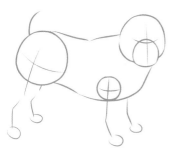

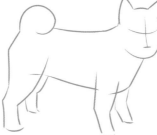

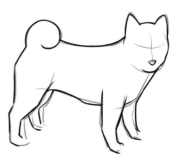

Use pencil to draw a rough structure for your dog. Draw the body as a series of geometric shapes with circles for joints. Add guides for the facial features.

Use your structural guide to draw the dog's outline more accurately. The legs are strong and the tail small. Make sure the perspective looks right.

Develop your outline. Keep the tail small, curling it up tight so that it rests on the dog's back. Give shape to the head, noting its slightly angular form.

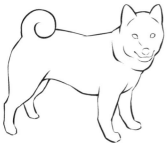

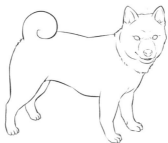

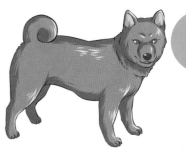

Draw the dog's facial features and finish the tail. Mark the loose fold of skin at the neck. Go over your artwork in ink and erase any unwanted pencil lines.

Work on the facial features, drawing the ears and snout in more detail. Define the dog's paws and give the ink outline a fur-like edge in places.

Add colour, using flat colour to start with. Use light and dark shades to pick out highlights and shadows. Graduate them a little to make them look like fur.

CUTE CAT

This pretty little kitty is looking up with large doleful eyes. Like the cute dog on page 226, her head is large compared to the rest of her body. She is covered in irresistibly soft fur.

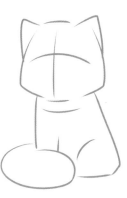

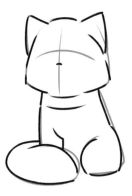

Start with a rough structure for your cat, using pencil. Draw the body as a series of geometric shapes. Add guides for positioning the facial features.

Use your structural guide to draw the cat's outline. Her head is huge, as is the fluffy tail sweeping around her body. Make sure the perspective looks right.

Refine your outline, paying particular attention to the shapes made by the legs. Don't forget that front and hind legs should be partly visible here.

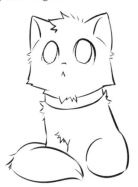

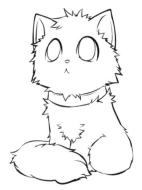

Draw the cat's facial features – really concentrate on those huge eyes. Draw in the ears and add some fluffy details before going over your artwork in ink.

Draw in the cat's nose and her inner ears. Work more on the fur, adding details here and there and fluffing up the tail.

Colour your work using soft, light colours. Use darker tones in the areas of shade and to emphasise the texture of the fur. Drop bright highlights into the eyes.

REALISTIC CAT

Like the dog on page 227, this is a truer representation of a cat than the version opposite. Her body is well-proportioned and she looks lithe.

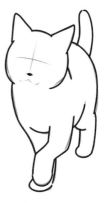

Use pencil to draw a rough structure. The cat is seen from the front view, so you have to think carefully about perspective. Add guides for facial features.

Use your structural guide to draw the cat's outline more accurately. Note how the front leg is raised as the cat steps forward. Draw her mouth.

Refine your outline. Make sure you are happy with the perspective and note the foreshortening of the body as it recedes to the rear.

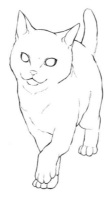

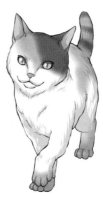

Go over your artwork in ink and erase any unwanted pencil lines. Draw the cat's facial features and define the paws.

Work on the texture of the fur, drawing little lines here and there. Keep them very light. Finish the eyes and ears.

This cat has tortoiseshell colouring. Use the darker colours to create the texture of the fur, blending them into the areas of white with care.

CUTE BUNNY

This version of a bunny is about as far as you can get from the real thing. It almost looks more like a soft toy than a living creature, and that is part of its appeal.

Start with a rough structure for your bunny, using pencil. In this example, the head and body are all one shape. Add guides for positioning the facial features.

Use your structural guide to draw the bunny's outline. See how small the paws are in relation to the body. Draw in the ears and a tail.

Refine your outline, making sure the hind paws are neatly tucked beneath the bunny's body. Draw in a guideline for the nose.

Draw the bunny's facial features, keeping them simple. Give the bunny some patches before going over your artwork in ink.

Note how the patches have stitches, blurring the line between fantasy and reality. Define the ears and paws and give the tail a fluffy texture.

Colour your work, using typical soft-toy colours. Note that there is little in the way of texture or shading here. Drop a couple of bright highlights into the eyes.

REALISTIC BUNNY

This realistic version of a bunny is true to life. The body is well-proportioned and the creature has plenty of short-cropped fur.

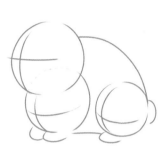

Use pencil to draw a rough structure. Seen side on, this bunny is made up of a series of overlapping ovals and circles. Add guides for facial features.

Use your structural guide to draw the bunny's outline more accurately. Shape the face and hind leg a bit more. Draw in the nose and ears.

Refine your outline, making sure you are happy with the perspective. Keep the body looking tight and hunched up.

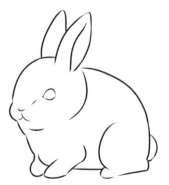

Go over your artwork in ink and erase any unwanted pencil lines. Draw the bunny's facial features.

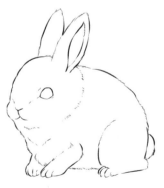

Work on the texture of the fur, drawing little lines here and there. Keep them very light. Finish the paws and ears.

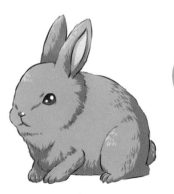

This bunny is a soft grey colour. Use a darker tone to create the texture of the fur, and to emphasise the areas of shade.

CUTE HORSE

This is a truly fantastical version of a horse, with its outlandish colouring and huge eye. It looks more like a little girl's toy pony.

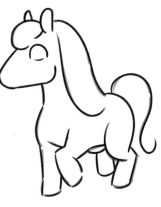

Start with a rough structure for your horse, using pencil. Draw her as a series of geometric shapes. Use single lines for the legs and tail.

Use your structural guide to draw the horse's outline. Try to capture movement in the legs. Draw the head in more detail, adding the ears and mane.

Refine your outline, keeping the general appearance smooth and rounded. Give the horse's tail a sweeping curve. Draw in the massive eye.

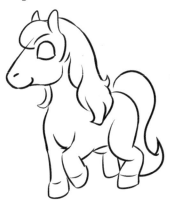

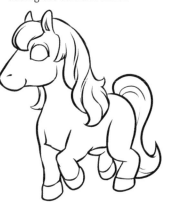

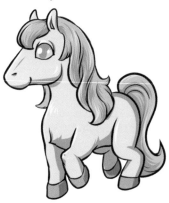

Work on the mane and tail, exaggerating their volume. Mark out the horse's hooves before going over your artwork in ink.

Draw lines to emphasise the luxuriant curls in the horse's mane and tail. Finish off the ear and give the eye a lid.

Colour your work, using unusual shades. Use the curls in the tail and mane as guides for lighter tones. Add a sparkle to the eye.

REALISTIC HORSE

The horse is one of the more difficult animals to draw realistically, since it has quite unusual proportions. The large body is supported on relatively slender legs.

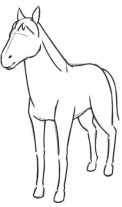

Use pencil to draw a rough structure. This is a three-quarter view, so think carefully about perspective as you draw a series of geometric shapes.

Use your structural guide to draw the horse's outline more accurately. Focus on getting the shapes of the head and legs right where they join the body.

Refine your outline, making sure you are happy with the perspective. Start to draw in the facial features and the mane.

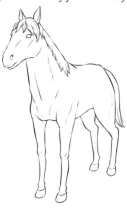

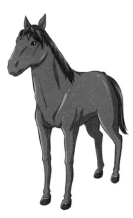

Finish the horse's facial features and give the mane a ragged edge. Try to capture the skeletal make-up of the legs and define the hooves.

Work on the texture of the mane, drawing little lines here and there. Mark some folds in the skin to emphasise the horse's muscular make-up.

Colour your artwork, using a flat mid-brown colour. Use darker tones for the shadows. Drop in fine highlights to show the gloss of the horse's coat.

CUTE BEAR

Like the cute bunny on page 230, this cuddly bear is more like a child's toy than a living creature. This gives the bear a curiously other-worldly feel.

Start with a rough structure for your bear, using pencil. This example really does have the shape of a toy. Add guides for positioning the facial features.

Use your structural guide to draw the bear's outline. See how rounded his features are – from his paws to his ears. Draw a guide for his snout.

Refine your outline, making sure you capture a pose that suits his personality. Here he has a paw raised to his face, as if confused or worried.

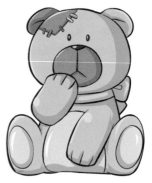

Draw the bear's facial features, keeping them simple. Mark out his little pink tummy before going over your artwork in ink.

Give the bear a patch, complete with stitches, and draw a satin bow around his neck. Define his ears and paws and mark the pads on his feet.

Colour your work, using typical soft-toy colours. Note that there is little in the way of texture or shading here. Drop a couple bright highlights into the eyes.

REALISTIC BEAR

This is a proper, real-life brown bear that has no resemblance to the cute bear on the opposite page. He is a big, solid mass of fur.

Use pencil to draw a rough structure. The bear is sitting face on, so think carefully about perspective as you draw a series of geometric shapes.

Use your structural guide to draw the bear's outline more accurately. Note the size of his heavy limbs and the shape of huge head.

Refine your outline, making sure you are happy with the perspective. Pay careful attention to the shapes made by the bear's hind legs.

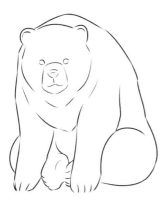

Draw in the bear's facial features and the folds of skin around his neck. Start to define his paws. Go over your artwork in ink and erase unwanted pencil lines.

Work on the texture of the fur, drawing little lines radiating out around the neck. Finish the facial features and give those powerful paws some claws.

Colour your artwork, using rich browns to emphasise the luxuriance of the fur. Use darker tones for the shadows. Drop highlights into the eyes.

FANTASY CREATURES

Once you have had a go at drawing the animals that you are familiar with, why not try your hand at one of the more outlandish beasts. One way to go about this is to invent a creature that borrows features from a number of real animals.

right This mythical beast most closely resembles a wild goat with its hoofed hind legs and horns. The fierce claws and a swishing fish's tail bring an entirely new, surreal dimension.

above This curious creature is a puffball of lilac fur with cat's ears and paws and a bat's wings. It even has a little tufty tail.

right A realistic-looking pussy cat takes on a sinister air with this pair of dove's wings. It is not just the appearance that is unsettling, but the idea that the cat can fly.

left A walking, talking fish. Again there is something unnerving about the idea that the fish can leaves its natural habitat on its springy frog's legs.

PET HAMSTER

This little character is a manga-style hamster. Standing on his hind legs, he has been given a chunky tail for balance. His small features and warm colouring give him a benign look.

 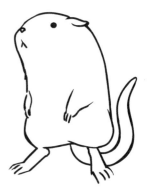

Draw a rough structure in pencil. This is a face-on view so is quite straightforward. Use geometric forms to capture the shape a hamster makes when raised up.

Use your structural guide to draw the hamster's outline more accurately. Note how small the tiny limbs and ears are.

Refine your outline, making sure you capture the slightly bulging form. Give shape to the feet and draw in the facial features.

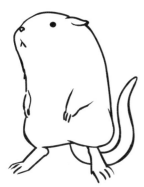

Give the hamster little claws. Work on the texture of the fur, drawing little lines radiating out around the neck. Go over your outline in ink.

Colour your artwork, using warm, golden yellows for the fur. Use darker tones for the shaded areas and pick out a few highlights in white.

PRETTY FOX CUB

This cuddly miniature has foxlike features and yet looks totally harmless. She has the innocence of a fox cub and plenty of thick orange fur.

Draw a rough structure in pencil. This is a side on view so think about perspective. Use geometric shapes to capture a basic outline.

Use your structural guide to draw the cub's outline more accurately. She has short legs compared to the size of her body.

Refine your outline, giving the cub a lovely bushy tail. Draw in her facial features and her inner ear. Go over your work in ink.

Add any final details, such as the decorative collar, before colouring your image. Use natural colours with soft highlights in the fur.

BASHFUL BUNNY

This is a great character – an oversized amorphous bunny with miniature features. His eyes are lost in the folds of fur and his little ears hang down in shame.

Draw a rough structure in pencil. This bunny is simply a shapeless blob. Draw guides for positioning his minimal facial features.

Draw in the bunny's floppy ears and his tiny front paws. Use your guides to draw in a small nose.

Refine your outline. Finish the nose and mouth. Add two lines to mark the folds of fur that obscure the bunny's eyes.

Add any final details, before colouring your image. Use natural colours with a subtle change of tone in shaded areas.

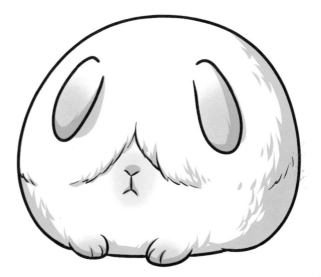

VENOMOUS SPIDER

You can have a great deal of fun inventing scary creatures – just let your imagination run wild. This hairy spider has way too many legs and sharp-looking fangs.

Draw a rough structure in pencil. Use a circle each for the body and head, and draw lines to position the legs.

Think about the perspective as you draw each of the spider's legs. Draw the larger pair of fangs at the front.

Refine your outline, giving the legs joints and claws. Finish the fangs and give your spider additional facial features.

Add any final details, before colouring your image. Use vivid colours – this purple gives the spider a venomous quality.

SCALY SERPENT

Serpents are a manga favourite and can be loaded with symbolism. This fierce creature is malignant, but they can also be benign.

Draw a rough structure in pencil. This is a wonderful mass of spiralling coils. Think carefully about the perspective.

Give shape to the serpent's head and tail. This will help to make it look three-dimensional. Draw in the beady eye.

Refine your outline. Develop the head further, drawing the fins and fangs. Mark out the shape of the inside of the mouth.

 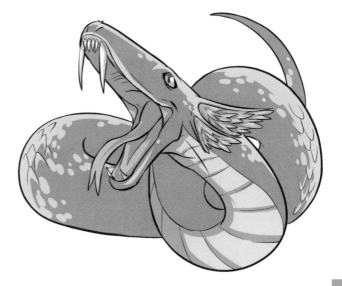

Add any final details, such as the long forked tongue, bulging eye and scales, before colouring your serpent in a vibrant hue.

ICE WOLF

Taking inspiration from a realistic wolf, which is scary in itself, this beast has spiky protrusions for attacking his enemies. He is hunched, ready to attack.

Draw a rough structure in pencil. Seen face on, this wolf is quite complex. Draw guides for positioning his facial features.

Build on your outline. Give shape to the head and draw the snarling face, complete with horn. Define the legs better.

Add some fur around the ruff of the neck and draw the wolf's toes. Develop the snarling mouth and glinting eye.

Add any final details, such as bevelled edges of his spikes, before colouring your image. Use natural colours for the fur.

WINGED SALAMANDER

A smooth-skinned salamander is given a spiky crest and wings to make him look more threatening. He is a great character for a futuristic desert landscape.

Draw a rough structure in pencil. Seen from above, the salamander has a characteristic kink as he slinks towards his prey.

Think about foreshortening as you draw in the legs. Make the eyes bulge for a three-dimensional appearance.

Refine your outline. Add the sharp spiked crest that runs down the salamander's back. Draw outlines of the wings.

 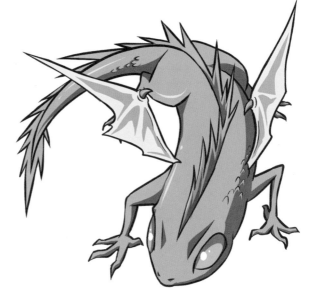

Add any final details, such as the scaly skin, before colouring your image. Use sinister, unnatural colours with bright highlights.

GALLERY

With a vivid imagination, there are no boundaries when it comes to drawing manga animals. You can be inventive with features borrowed from other creatures and can use colour to emphasise a character's personality.

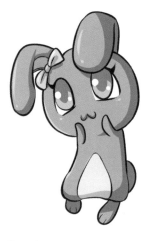

penguin pal

right A fun penguin, who is not that unrealistic in terms of design and colour. He has a friendly look to him.

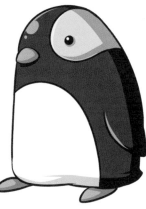

giggly beaver

below This creature borrows elements from several animals – cat's ears, bunny paws and a beaver-like tail.

ditzy bunny

above This bunny has human characteristics, in that she can walk on two legs. Her massive head and eyes give her a disarming quality.

injured wolf

below This realistic wolf has been injured. Instead of being harmful, he has a defeated look about him.

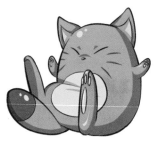

comedy lizard

left This character is humourous on account of his out-sized head. His little feet make him look as if he can scamper at speed.

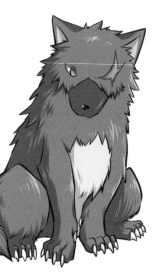

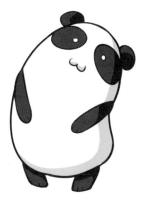

snorting hog

right Somewhere between a pig and a bull, this wonderful snorting creature looks ready to stampede the nearest crowd.

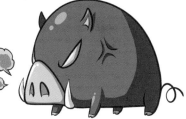

baby panda

above This amorphous creature has panda colouring. Small and round, and standing on tiptoe she is irresistibly cute.

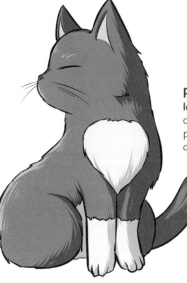

perfect pussy

left This pretty kitty has an air of conceit. Her heart-shaped patch is something to be proud of and she knows it.

fox bandit

below The great colouring of this foxlike creature gives him the appearance of a robber on the run from someone.

cutesy hedgehog

above A realistic-looking hedgehog, this spiky little ball looks fun to play with.

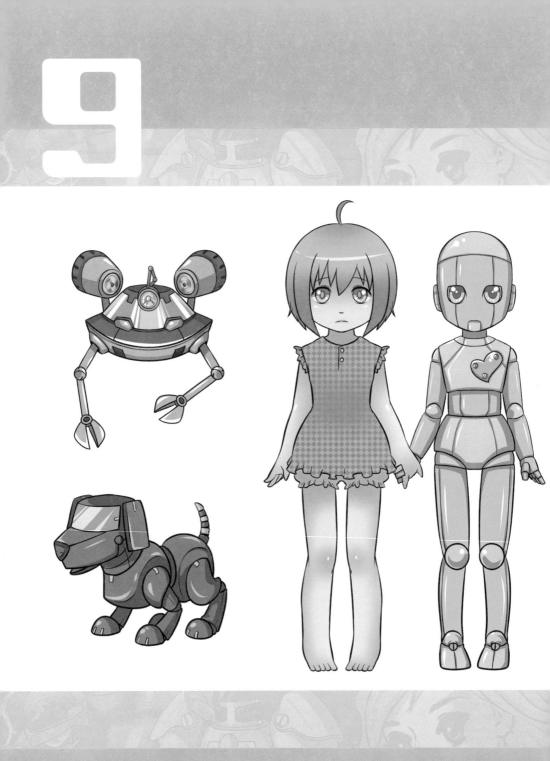

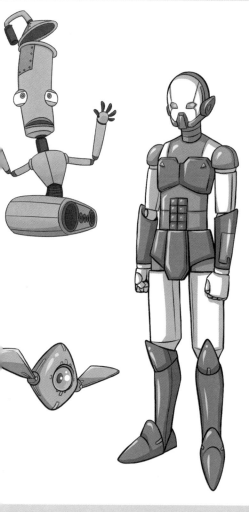

Many manga stories team mechas with the more human-looking characters. Whether based on animal or human forms, many of these creations are designed specifically for serving, fighting or performing some sort of routine, and this adds an other-worldly element to the stories. This section of the book shows you how to develop a range of mechas and offers inspiration on creating characters of your own.

TYPES OF MECHA

Many characters are based on the human form. This means that their bodies share the same proportions. This does not mean that mechas have to have human features, however.

Starting with the basic human form, it is possible to see how you can develop your manga characters into different types of mecha. Working from left to right, these examples become less recognisably human. The beauty of designing mecha characters is that there are no limits to what you can do. Many mechas are designed for specific tasks and you can have fun giving them extra limbs or other additional features that are contrived to help with that task.

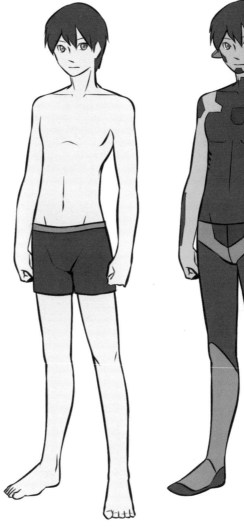

A human-looking young man, well-proportioned and with recognizable features.

Though resembling the human form closely, this character is partially made from metal.

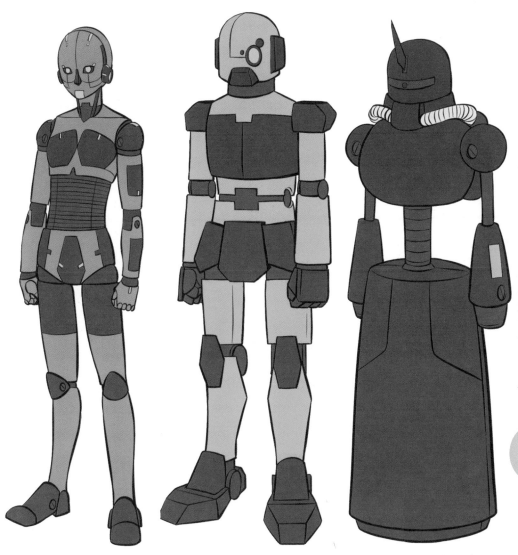

Now completely metal, the character has hinged joints and armour plate bodywork.

This character is large in scale and has a more robotic appearance with seemingly limited function.

This is a working mecha with one specific job. The features are no longer recognisably human.

DESIGN AND COMPONENTS

Mechas include anything from docile servants to big, bad fighting machines to super-strength creatures. The key to their success is being able to develop them in such a way that whatever function they have is instantly recognisable.

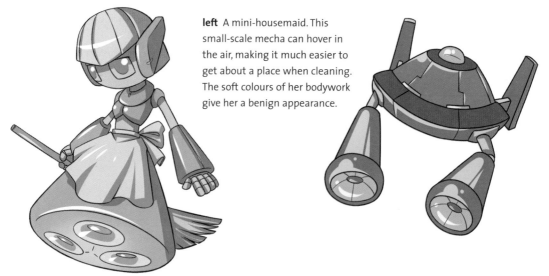

left A mini-housemaid. This small-scale mecha can hover in the air, making it much easier to get about a place when cleaning. The soft colours of her bodywork give her a benign appearance.

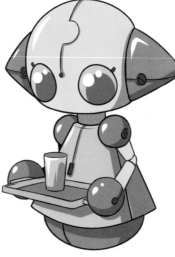

right This simple-looking mecha, has one function. With an in-built tray, she is used to fetch and carry. She moves around smoothly on casters and has basic swivel-functioning arms.

above Used for spotlighting areas, or searching out in the dark, this mecha's primary limbs have powerful in-built lights.

left This dizzy-looking character. is panicking about the latest disaster. His caterpillar-track base and flexible upper body suggest he plays a role in some sort of factory or machine works.

right A working mecha, this character has tools instead of hands at the end of his flexible arms. He is mounted on wheels for ease of mobility.

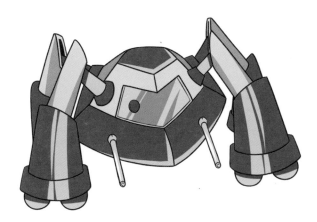

left With huge, crab-like legs, this manga scuttles about in low-level places, which suggests that his job involves some form of detection.

HUMANOID MECHA

This is one of the simplest forms of mecha, and is based on the male human body. With very similar proportions to a human, this character also shares a number of characteristics.

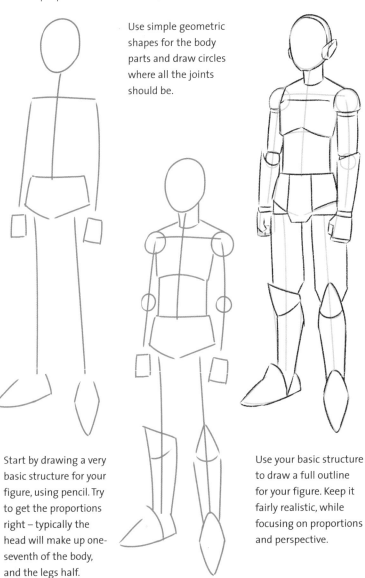

Use simple geometric shapes for the body parts and draw circles where all the joints should be.

With that done, you can begin to consider the mechanical aspect of your figure. Divide the body into separate moving parts, and give the shapes a more manufactured look.

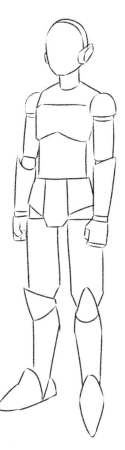

Start by drawing a very basic structure for your figure, using pencil. Try to get the proportions right – typically the head will make up one-seventh of the body, and the legs half.

Use your basic structure to draw a full outline for your figure. Keep it fairly realistic, while focusing on proportions and perspective.

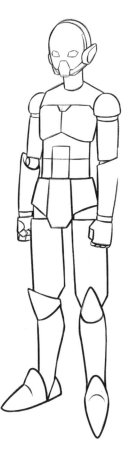

Erase any unwanted pencil lines before adding the last few details in ink.

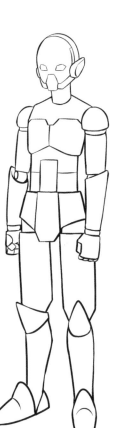

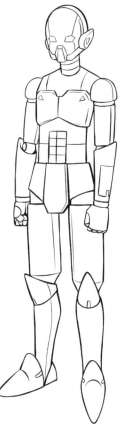

Colour up your image. Apply flat colour to start with. Consider where the light is coming from and add highlights to show where it is reflected by the mecha's armour.

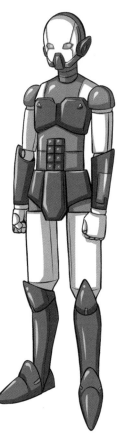

Build on the detail, drawing metal plates and hinged joints. Add facial features, using them to add some character. Go over your drawing in ink.

Think about the metal element of this character and add lines to suggest seams in the armour. Add some bolts where there are joints.

MILITARY MECHA

Here is a mecha with a single purpose – to make war. Taking the humanoid mecha on pages 252–253 one step further, this military mecha has in-built weaponry. The body shape is generally more bulky with the extra, protective armour.

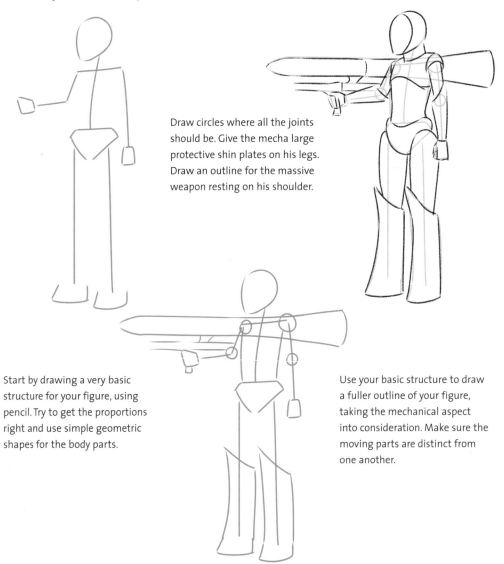

Draw circles where all the joints should be. Give the mecha large protective shin plates on his legs. Draw an outline for the massive weapon resting on his shoulder.

Start by drawing a very basic structure for your figure, using pencil. Try to get the proportions right and use simple geometric shapes for the body parts.

Use your basic structure to draw a fuller outline of your figure, taking the mechanical aspect into consideration. Make sure the moving parts are distinct from one another.

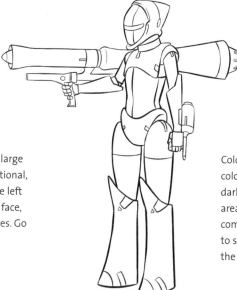

Develop the design of the large weapon and draw an additional, smaller piece as part of the left arm. Work on the mecha's face, giving him minimal features. Go over your work in ink.

Colour up your image. Apply flat colour to start with, adding darker tones to suggest shaded areas. Consider where the light is coming from and add highlights to show where it is reflected by the mecha's armour.

Erase any unwanted pencil lines before adding the last few details in ink. Consider how this mecha has been assembled and draw in hinges to show how his various parts move.

INDUSTRIAL MECHA

This mecha has been designed for a specific task in an industrial environment. It has bright lights for eyes and arms with pincer-like tools for hands, but no need for legs.

 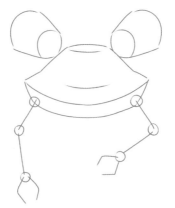 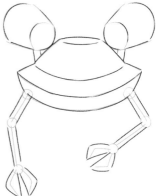

Start by drawing a very basic structure for your figure. This is a small, single, compact unit with two arms.

Add two geometric shapes for the light-beam 'eyes'. Draw in some small circles at the joints in the arms.

Use your basic structure to draw a fuller outline for your figure to make it look three-dimensional.

 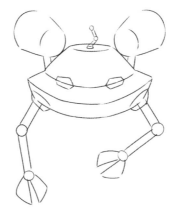 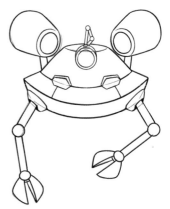

Make sure you are happy with the outline so far. Check perspective carefully and make any necessary adjustments.

Build on the detail, drawing hinges, sockets and joints. Start to draw the telescopic light attached to the mecha's top.

Go over your artwork in ink, refining your shapes. Draw in the telescopic light.

Erase any unwanted pencil lines before adding the finishing touches in ink.

Finish the lights, adding a few lines to suggest the glass surfaces. Draw any seams in the metal and finish the joints.

Apply flat colour, using brass or steel shades for the working elements. Drop in some bright highlights where the harsh materials catch the light.

MEDICAL MECHA

The epitome of practicality, this mecha is small and airborne, which means she can get to the scene of an emergency in no time. She has a friendly face and colouring.

Start by drawing a very basic structure for your figure. This is a large, single unit with short arms and legs.

Shape the body a little and add geometric shapes for the hands and feet. Draw in the wing on the near side.

Work on the hands and feet. They are attached to tube-like flexible arms and legs. The hands have gloved fingers.

Make sure you are happy with the outline so far. Check perspective carefully and make any necessary adjustments.

Build on the detail, arm sockets and facial features. Work on the wing and draw in the backpack.

Go over your artwork in ink. Refine the shape of the near wing and add details to the shoes and backpack.

Erase any unwanted pencil lines before adding the finishing touches in ink.

Add the elements that make the mecha look factory-made: seams in the metal, screws in the feet, hinges. Add the first-aid symbols.

Apply flat colour, using a benign scheme. Drop in some highlights where the glossy metal finish catches the light.

GALLERY

You can develop every mecha imaginable, from evil-looking warriors to friendly automated pets. Think about colour choice and symbolism, both of which can be used to exaggerate a mecha's character or give it more purpose.

industrial mecha

below This mecha operates machinery. It has a single-unit body and rides on caterpillar tracks. It has strong, claw-like hands on arms that can rotate full circle.

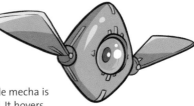

flying eye

right This sinister little mecha is all about observation. It hovers in the air, recording all that goes on around it.

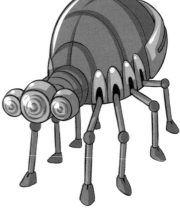

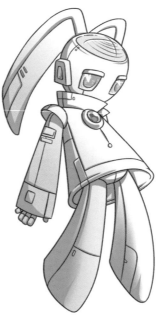

floppy bunny

right The inspiration for this mecha is part human part bunny. Despite being made of metal, she has a floppiness that makes her look harmless.

scary spider

above The outsize body of this spider is supported on eight double-jointed legs. The extended head makes the mecha look intimidating.

dummy

below This mecha has a comical body and a dopey look on his face. This gives him dumb personality and makes him a truly credible character.

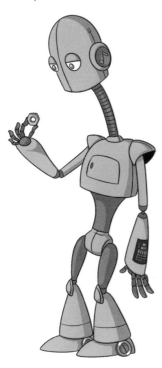

mecha detector

right This mecha is rocket powered and needs no arms or legs. Its only device is a flexible tube with its weird detector.

security guard

right A solid looking mecha, with sturdy legs, thick head protection and huge, sweeping, bladelike arms.

personal tv

left This handy little television mecha can follow you around to provide 24-hour entertainment. He can even change the channel by himself.

GALLERY

When developing mecha characters of your own, think very carefully about their functions and how they can influence appearance. Think about those features that might be more human-looking as well as those that are no longer necessary.

observation mecha

right This mecha has long, articulated legs that allow it to move freely above all else. It's function is purely to observe, so it has no need for arms.

all-seeing eye

left This mecha is, quite literally, an eye popped on top of a body. There is a comical aspect here, when you compare head size with skinny limb size.

domestic

left Scuttling around the house on the lookout for the occasional spill, this servile mecha keeps a dustpan and brush in his tummy-cupboard.

mecha dog

below This is a friendly companion that comes complete with happily wagging tail. It has a realistic form and proportions.

hovering mechanic

right This little mecha operates a machine in mid-air. He is small and compact and has no need for a more complex form.

superhero

above This is an alternative version of the medical mecha on pages 258–259.

scanning mecha

left Used as a scanning machine, this tiny desk-top mecha has sturdy legs for support, but no arms.

rocket giant

right This huge, solid mecha has strong articulated legs to support the weight and power of its rocket-launcher arms.

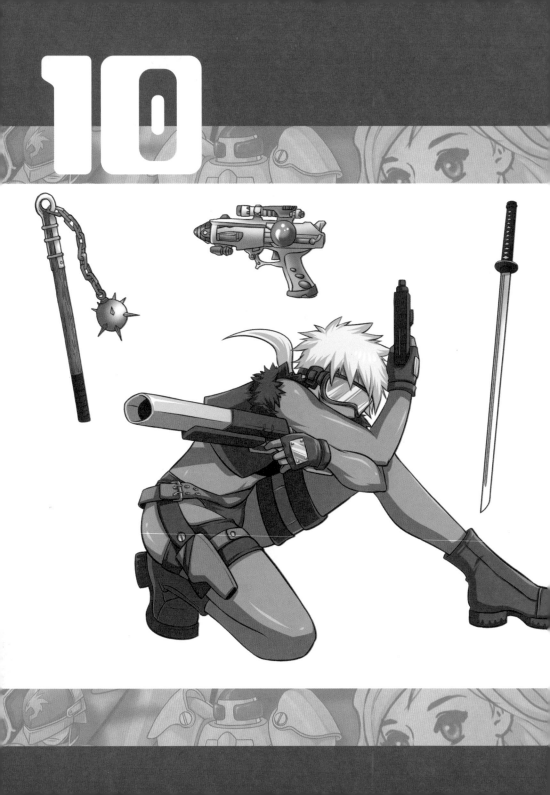

Weapons

Many worlds exist in manga art, from the medieval forest, to intergalactic outpost. These places are populated by all manner of weird and wonderful characters. In this section of the book, you can discover the wide range of weapons that such characters might use, from a realistic revolver to a sci-fi-type laser gun. There are instructions for drawing a number of them, plus examples of pieces you might use for inspiration.

SWORD

This sword is based on the ancient Chinese dao, a weapon used for cutting and thrusting. It has a gentle curve from sword tip to hilt and a broad blade.

VARIATIONS

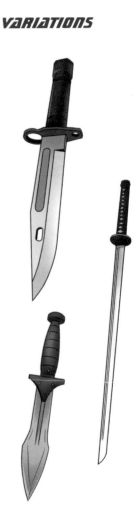

Draw a pencil sketch of the dao. Note how the hilt of the sword curves in the opposite direction to that of the broad blade.

Fine-tune your sketch, drawing the hilt in greater detail. This will help to make it look more three-dimensional.

Go over your drawing using ink, adding the slight bevel on the blade and wrinkles in the cloth. Erase unwanted pencil lines.

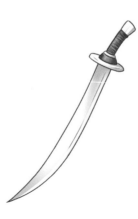

The sword is made from steel . Use high-contrast shading to capture its sheen. Use strong colours for the cloth on the hilt.

Look at pictures for inspiration. These are based on the Bowie knife, a short-handled dagger and samurai sword.

BOW AND ARROW

The simple bow and arrow was a popular choice of weapon in Europe and Asia during the Middle Ages. It is great for medieval, Robin Hood type stories.

VARIATIONS

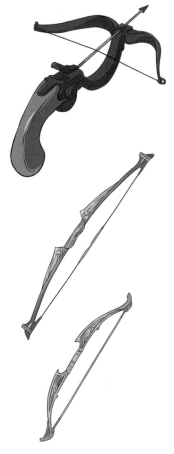

Begin by drawing a pencil sketch of the bow and arrow. Note the slender curves of the bow and the narrowness of the arrow.

Draw the bow grip in greater detail to make it look more three-dimensional.

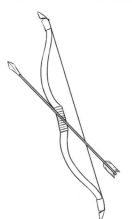

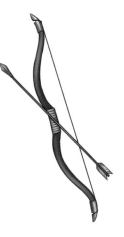

Add detail. Draw in the cord grip on the bow and give the arrow shaft a tip and feathers. Go over your drawing in ink and erase any unwanted pencil lines.

Colour your work. The bow and the arrow shaft are made from wood. Use soft, warm browns. Emphasise the metal of the arrow with a couple of highlights.

Alter your drawings to suit a storyline. You might want a crossbow instead, for example. Or use colour to tailor a design to a specific character.

GALLERY

Ancient worlds can be a fantastic source of inspiration when it comes to choosing weaponry for your manga characters. Whether defending their cities or on the attack, the ancients were incredibly resourceful makers of weapons.

dagger

below An effective stabbing weapon, this knife has a double-edged, tapered blade like those seen on similar weapons from ancient Rome.

brass knuckles

below Worn on the hand, brass knuckles have origins in pieces like the tekko, worn by the ancient Japanese.

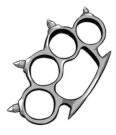

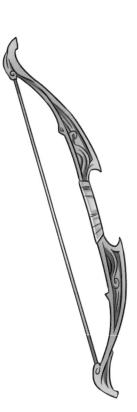

side-handle baton

below These modern-day batons have origins in ancient Chinese nunchaku – two batons linked by a chain.

bo shuriken

below The ancient Japanese used lethal throwing blades, like these. They favoured them because they were easy to conceal for a surprise attack.

bow

above The bow and arrow is one of the most recognizable of all traditional weapons, and has an ancient history dating back as far as 8000BC.

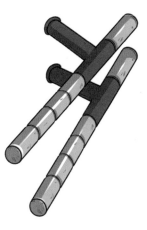

bow and arrow

right With examples existing from Mongolia to medieval Britain and native America, there are countless bow types on which to base your own designs.

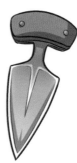

lethal blade

above Weapons like this were used in ancient Japan. They could be easily concealed in the palm before making an attack.

hira-shuriken

above This is a hand-held blade originating from medieval Japan. Pieces like this were used for throwing and stabbing.

yatagan sword

right This unusually shaped medieval Turkish sword has a long single-edge, forward curving blade.

Dao-type blade

below Based on ancient Chinese forms, this sword has a curved blade used for making sweeping attacks on an opponent.

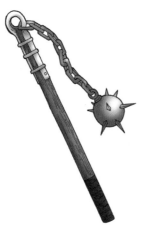

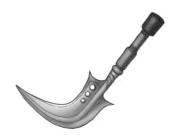

medieval flail

above Swung above the head in a large circular movement, this nasty weapon has roots in the middle ages.

AUTOMATIC PISTOL

Handguns are great weapon choices for modern-day manga stories. Whether in the hands of a scheming criminal, a sinister spy or a professional law-enforcer, they are neat and easy to conceal. There is a brutal efficiency in their design.

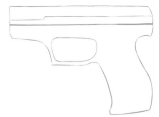 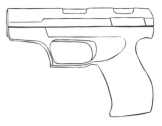 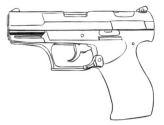

Begin by drawing a pencil sketch of the pistol. Draw the weapon as a series of rectangles that you then give more shape to.

Make a more detailed sketch now. Refine the shape of the pistol. Draw in the trigger guard and surface details.

Go over your drawing using ink and erase any unwanted pencil lines. Draw any final details, such as the trigger and rivets.

VARIATIONS

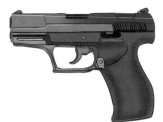 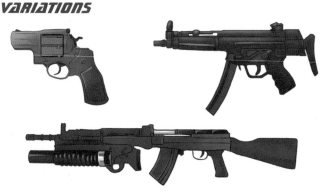

Colour your weapon, paying close attention to materials. The dark steel of the gun should have sharp highlights where it catches the light.

Seek out references for other handheld weapons – revolvers machine guns and rifles are all great examples.

CANNON

When it comes to all-out war, why not opt for a heavy-duty artillery piece like this cannon. This is an early type, based on examples that might have been used during the Napoleonic Wars in Europe, or the American Civil War, both during the 19th century.

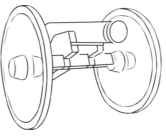

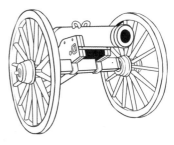

Begin by drawing a pencil sketch of the cannon. Draw the weapon as a series of geometric shapes. Think about perspective.

Make a more detailed sketch now. Refine the shape of the cannon. Draw the wheels and axle in greater detail.

Give the wheels spokes and develop the gun. Go over your drawing using ink and erase any unwanted pencil lines.

VARIATIONS

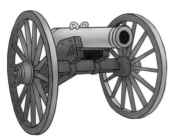

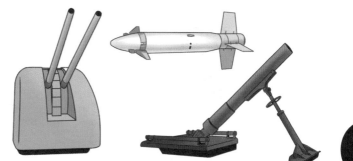

Colour your cannon, using dull, military colours. Use darker tones for the shaded areas and use highlights sparingly.

Look around for other weapons with which to illustrate your stories – from futuristic rockets to realistic military pieces.

GALLERY

Many manga stories see one group of characters pitched in battle against another. They may be from different worlds and the weapons they use can be as diverse as a medieval bow and arrow to an alien laser and everything in between.

revolver

right The staple of film noir, the ladies' revolver. Small and compact, this weapons is easy to conceal before dealing that lethal shot.

alien phaser

below A handheld weapon that stuns the enemy using a light beam. Sometimes the victim completely disintegrates.

automatic pistol

left This efficient-looking weapon is a variation of the pistol shown on pages 270–271.

grenades

below Realistic-looking grenades in camouflage colours. These are quite often used for launching a surprise attack.

automatic weapon

right This sinister-looking weapon is the real tough guy's choice. The dark metal finish gives it a brutal appearance.

assault rifle

below This futuristic-looking weapon borrows elements from various guns, including the Russian AK47.

light sabre

above The mainstay of intergalactic battles, the trusty light sabre has a metre-long blade that can cut through almost any substance.

rocket missile

right This rocket is based on the French exocet, which was developed in the 1980s and designed for attacking warships.

futuristic cannon

below This is a simple design, in keeping with the streamlined, paired back look that sums up our vision of the future.

torpedo

below A torpedo-shaped weapon, tapering towards the tail end. Fins at the mid-section and tail keep it stable in flight.

rocket launcher

below A powerful weapon with long-distance range, this rocket launcher is a staple of modern-day warfare scenes.

grenades

above Hand grenades based on the German WWII type, the long wooden handles enable the attacker to throw them considerable distances.

vehicles

You can have great fun imagining scenarios in which vehicles might play a role – from a speedy getaway on a motorbike to a long-haul flight on a passenger jet. This section of the book looks at the various different types of vehicle that you might use to illustrate your manga stories and offers instruction on how to draw a handful of them. You'll also find suggestions for developing vehicle designs of your own.

BICYCLE

Although bicycles are notoriously difficult to draw, this version is seen side on – by far the easiest angle. The key lies in achieving the right proportions.

Using a pencil, draw a basic outline of the bicycle. Think about the proportions of wheels to frame.

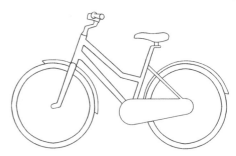

Work on your outline to complete the frame of the bicycle and the wheels.

Use ink to blacken the tyres. This will help to make the bicycle look three-dimensional.

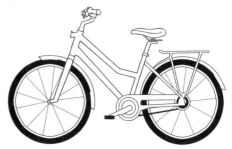

Work on the detail. Give the bicycle wheels spokes and draw in the pedals and bag rack.

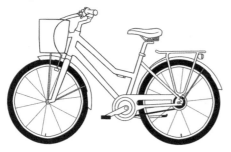

Go over your drawing in ink, adding any last details such as the basket and brake cables.

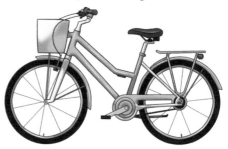

Colour your work, using bright highlights where the metal frame catches the light.

MOTORBIKE

The principles for drawing a motorbike are very similar to those for drawing a bicycle. It simply has a larger, more solid frame. Sometimes, the engine is exposed.

Using a pencil, sketch a basic outline of the motor-bike using simple geometric shapes.

Work on your sketch to draw the motorbike in more detail, better defining some of the body parts.

Continue to work on the outline. Draw the wheels and exhaust in more detail. Add the handlebars.

Add some finer details – the spokes in the wheels, the brakes on the handlebars, for example.

Go over your drawing in ink, adding any last details such as the rear light and brake cables.

Colour your work, using high contrast to show how the polished surfaces catch the light.

CAR

This saloon car is seen from side on, so is a straightforward project. You can also base a three-quarter view on this model – just consider perspective carefully when it comes to drawing the basic outline. The same principles can be applied to any model.

Use a pencil to sketch a rough outline of the car. Sketch the body of the car as a single unit and draw in the visible wheels.

Refine your basic outline, giving more shape to the front and rear profiles. Draw in the driver's window and the tyres.

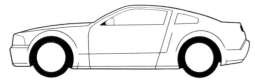

Use ink to blacken the tyres. Draw in the wheel arches and give shape to the rear bumper. Start to mark the individual metal panels of the car.

Draw in some of the finer details: the wing mirror by the driver's window, the front and back lights, and the line of the bonnet.

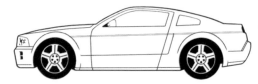

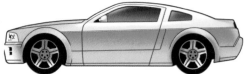

Go over your finished artwork using ink and erase any unwanted pencil lines. Add any last details and finish the wheels.

Colour your artwork, using flat colour to start with. Add soft highlights to capture the gleam of the car and the reflective nature of its windows.

BUS

This is a large-scale American bus. Many European examples are modelled on this type. You can also look elsewhere for inspiration, designing models based on the old London double-decker, open-backed Routemaster or the super-long bendy buses seen in many of today's busy cities.

Using a pencil, draw a basic outline of the vehicle. This model is seen side on and is an almost perfect rectangle. Draw in the wheels.

Work on the outline, drawing in additional rectangles for the windows and doors. Thicken the outline over the top and to the rear of the bus.

Use ink to blacken the tyres. Still using ink, mark out the individual windows along the length of the bus. Give shape to the roof.

Now work on the details of the doors and draw in the rear view mirror to the front.

Go over the rest of your artwork using ink and erase any unwanted pencil lines. Finish the wheels and metal panelling.

Colour your artwork, using an appropriate colour. Lighten up the darker tones in places to keep the image looking three-dimensional.

BULLET TRAIN

This is a state-of-the-art passenger train, based on the Japanese model. It is seen from the three-quarter view, which makes the most of its aerodynamic design.

Draw a pencil outline of the train. Use a simple geometric shape to capture its sleek form.

Give shape to the engine section of the train to make it look three-dimensional.

Give shape to the nose of the engine. Draw in the bubble window and the carriage doors.

Work on the details: the striped logo down the side and the undercarriage of the train.

Draw in the windows. Go over your finished artwork using ink and erase any unwanted pencil lines.

Colour your artwork, using appropriate colours. Add highlights to give the train a glossy, metallic finish.

AIRLINER

You can use the following model to draw an aeroplane of any size, from small-scale two-seater to Jumbo jet. This example is seen side on, so you need to think carefully about perspective.

Draw a basic pencil outline of the plane. Use simple geometric shapes to capture its shape.

Give shape to the nose and tail sections to help make the plane look more three-dimensional.

Continue to work on the tail section and draw the engines under the near wing.

Draw the wings in more detail, adding lines to suggest the movable flaps. Add the nose wheel.

Draw in the windows. Go over your finished artwork using ink and erase any unwanted pencil lines.

Colour your artwork. Most commercial planes are white. Use subtle changes of light and dark.

YACHT

This is a luxury pleasure boat – the sort that you might see zipping along the coast in the south of France. It is seen side on, so perspective is important here. You can upscale this example to draw a cruise ship or passenger liner just as successfully.

Draw a pencil outline of the yacht. Capture its basic shape at first, then work on the outline to sketch the body of the ship in greater detail.

Give shape to the bow of the yacht and mark out the individual decks to make your sketch look more three-dimensional.

Mark out the rough layout of the windows that run the ship's length and draw in the railings around the deck edges. Consider scale carefully.

Finish your drawing by adding any final details, such as the windows to the front of the vessel and the propeller to the rear.

Go over your finished artwork using ink and erase any unwanted pencil lines. Draw in the remaining windows and the yacht's mast.

Colour your artwork. This vessel is predominantly white. Use subtle shades to suggest the contrast between light and shade.

SPACESHIP

You can use your imagination when it comes to designing spacecraft. This example is based on the Starship Enterprise from the Star Trek television series. Quite often UFOs tend to be flat and round, which is how they got the name 'flying saucers'

Using pencil, draw a basic outline of the spacecraft. This is, quite simply, a long, low, flat oval shape. Keep your lines simple.

Give more shape to your outline, to make it look three-dimensional. Start to add more structure at the centre, top and bottom.

Refine the shape of the spacecraft at the top and bottom. Mark out lines across its width. These will eventually act as guides for the windows.

Draw in the three huge engines that are required for driving this craft forward. Now you begin to get a sense of the scale.

Now draw in windows, bearing the scale in mind. Go over your finished artwork using ink and erase any unwanted pencil lines.

Colour your artwork, using a uniform grey. Progress to darker shades in areas of shade and use bright highlights for contrast.

GALLERY

Here is just a small selection of the various vehicles that you can use to illustrate your manga stories. It is useful to consider a scenario in detail before adding vehicles, to make sure you have something appropriate and that suits the character who's driving it forward.

small car

right This two-door vehicle takes inspiration from the VW Beetle, and would suit a young, hip driver.

saloon car

left This is a version of the car described on page 278, sporting a different colour scheme.

electric car

right A futuristic-looking, two-passenger electric scooter, suitable for driving busy streets in modern urban environments.

off-roader

left A hard-working vehicle with four-wheel drive – ideal for scenes with open terrain.

light aircraft

left This kind of aeroplane is the sort used by flying schools all around the world, and is a popular choice for amateur pilots.

superbike

right A modern-day, high-powered motorcycle – the sort that might be used for a fast getaway after a crime.

pedal bike

above A good old-fashioned pedal or bike, like the one demonstrated on page 276. It can be adapted to suit any rider.

jet bomber

below Based on the Stealth Bomber, this futuristic-looking supersonic aircraft will fly undetected over enemy airspace due to its unconventional shape.

INDEX